Ken Done

Ken Done

A LIFE COLOURED IN

ABC
Books

 The ABC 'Wave' device is a trademark of the
Australian Broadcasting Corporation and is used
under licence by HarperCollins*Publishers* Australia.

First published in Australia in 2016
by HarperCollins*Publishers* Australia Pty Limited
ABN 36 009 913 517
harpercollins.com.au

HarperCollins*Publishers*
Level 13, 201 Elizabeth Street, Sydney NSW 2000, Australia
Unit D1, 63 Apollo Drive, Rosedale, Auckland 0632, New Zealand
A 53, Sector 57, Noida, UP, India
1 London Bridge Street, London, SE1 9GF, United Kingdom
2 Bloor Street East, 20th floor, Toronto, Ontario M4W 1A8, Canada
195 Broadway, New York NY 10007, USA

National Library of Australia Cataloguing-in-Publication data:

Done, Ken, 1940– author.
 Title: Ken Done: a life coloured in / Ken Done.
 978 0 7333 3581 5 (hardback)
 978 0 7333 3476 4 (paperback)
 Subjects: Done, Ken, 1940–
 Artists – Australia – Biography.
 Art, Australian – 20th century.
759.994

Hardback cover credits:
Jacket design by Hazel Lam, HarperCollins Design Studio
Front cover image: Ken pictured in front of *Swimming in Jellyfish Lake*. Photo by Daniel Boud.
Back cover image: *Me*, 1992, oil and acrylic on canvas, 102 x 76cm. Collection: National Portrait
Gallery, Canberra.
Endpapers: *Playing the beach*, 2012, oil, acrylic and oil crayon on linen, 122 x 152cm
Paperback cover credits:
Cover design by Hazel Lam, HarperCollins Design Studio
Front cover image: Ken pictured in front of *Swimming in Jellyfish Lake*. Photo by Daniel Boud.
Back cover image: *Swimming in Jellyfish Lake*, 2013, oil and acrylic on linen, 152 x 183cm
Inside cover: *Playing the beach*, 2012, oil, acrylic and oil crayon on linen, 122 x 152cm
Typeset in 12/15pt Bembo by Kirby Jones
Printed and bound in Australia by Griffin Press
The papers used by HarperCollins in the manufacture of this book are a natural, recyclable
product made from wood grown in sustainable plantation forests. The fibre source and
manufacturing processes meet recognised international environmental standards, and carry
certification.

For my family, with love forever

CONTENTS

③ LIBERTY STREET

My grandparents were never married. Yet they had four daughters, my mother, Lillian, being the eldest. I once described my grandad as a soldier, an adventurer and naughty boy. It's only now we are beginning to understand just how naughty he was. As a soldier in World War I, he fought at Gallipoli and Egypt, Number 9 in the Third Battalion, and was an instructor to other soldiers. Most of his early days he apparently spent on adventure and on being rather generous with his affections. He convinced my grandmother Nellie to go with him to Australia and leave her two young children behind with her parents. Mum only discovered Basil, her half-brother, just before Judy and I were to be married in England in 1965. Dorothy, Nellie's other child, we believed worked with the French Resistance as a spy and she sadly disappeared.

At the time of their move to Australia, Grandad was probably unaware he'd got a girl in the next village pregnant, let alone with twins. We've only just discovered more about *this* new branch of the family tree.

In Sydney my grandparents lived in Belmore, which in those days was out in the suburbs, with paddocks with cows and a dairy, but it seems there may have been another relationship with a lady in Newtown. Grandad's proper name was Arthur George Bailey, but everybody called him Bill. People may have sung 'Bill Bailey won't you please come home' but in my grandad's case it was difficult to pinpoint just where that might be.

In my eyes, he was great. He loved me and I him. He was a large figure, mostly seen in a singlet, braces and big trousers. And in my earliest years he was the one fairly constant male figure in a household of women.

I was born in June 1940, my parents' first, and destined to be only, child. I didn't see my father, Cliff, who was a bomber pilot flying Wellingtons and Lancasters and to me, as a little boy, always a heroic figure, until he returned from service in the RAAF in England in 1945. The house at 3 Liberty Street, Belmore was my castle and my life. It was a house full of love and happiness and doting aunts. Though it was wartime, and I'm sure that brought hardship and worry to the grown-ups, there seemed to be lots of parties going on, with soldiers, sailors and airmen in and out of the place, boys on leave or US servicemen. One of these US servicemen, Carmen, married my aunt Nancy and they had a long and happy marriage. I think this may have surprised Grandad a bit as I understand he wasn't too keen on his youngest daughter marrying a guy from another land. Grandad insisted on calling Carmen 'Herman'.

The sisters were very close; my mum being the eldest was pretty much in charge. My grandmother ran a little library down near Belmore Station and I always think of her as a kind of soft person, wearing grey with a beret, smelling of lilac.

I was the only child during those war years, the centre of everyone's attention. I was probably spoiled rotten by my young aunts: Nancy would take me to the pool at Bankstown, Joanie to Ramsgate Baths or Brighton le Sands, and Kathleen once took me on the showboat. I was so excited when she told me the whole boat was made of glass and was very slightly disappointed when I found out that what she meant was it had lots of big glass windows. Mum used to take me to the Botanic Gardens to visit the Wishing Tree. I was told that if you ran around the tree three times and made a wish, it very well might come true. I wished for my father to come home, like lots of kids: most had fathers who were away.

I was sent to a little pre-school place near Punchbowl. Grandma or Mum would take me and I remember not liking it very much. One afternoon it was arranged that I would come home on the bus by myself; I was around four. We would never have done that when our children were young, but things must have been safer. I was so stunned to be on the bus alone that I forgot to get off where Grandma was waiting, and it was only her frantic cries to the driver as he drove off that reunited us.

I went to Belmore kindy with my old mate Warwick. We don't really remember each other from then, but we're still mates 70 or so years later. Someone would walk me the few blocks down to the school and then wait in the afternoon to bring me home … except the day I severely crapped my pants. A super load for such a little boy, and the teacher suggested it might be better if I left early that day. I can remember waddling wide-legged along Canterbury Road to Liberty Street, then a duck walk down to number three (loaded with number two) and around the back path to the safety of home.

Mum and her sisters were sunning themselves on the little back lawn. My presence was announced by the smell that preceded

me so when I waddled into sight they knew what was coming. I remember the commotion – someone yelling, 'What are you doing home by yourself?' and my grandmother running forwards to comfort me. My mum got in first though and quickly turned the garden hose to high. She blasted me around the lawn until I was safe to approach and could blurt out the whole sorry saga.

While we are on that kind of subject, a bit of family folklore concerns a train trip back from the city. All trains went to Central in those days and after traipsing around town for hours (or that's what it felt like to me) we were finally going home. My special treat had been a glass of lemonade, a tomato sandwich and a caramel ice cream at Cahill's Café. My favourite meal. So we're on the train, me on Mum's knee and two of my young aunts opposite. They were all tired. Mum is drifting off to sleep to the sounds of the train. I'm not sleeping though and a set of signals from my body tells me that I'm about to have a Belmore Kindy kind of moment. Or movement to be correct. The passengers in the carriage are suddenly alerted by Mum's exclamations: 'Oh *no!*' she cries as her lap takes on a different colour. My aunts quickly pick up their evening papers and duck behind them to show that they have nothing to do with the exploding infant. All well and good until Mum begins to tear strips off the papers they are pretending to read to wipe my bottom. It's told and retold at various family gatherings that in the end Nancy and Joan were clutching little more than the shipping news while the rest of the paper was in very smelly balls, stuffed inside Mum's bag. I love the story but I fortunately can't remember too much about the actual event.

Mum played the piano and sang – all the girls did. I spent many nights trying to sleep in the front room while listening to the sounds of music and laughter from a party. Sometimes I cried

loudly and would be taken into the bright light of the room and I'd be allowed to stay up for a while. Sometimes though it was just too much and I'd try and grab my mother's hands and take them from the piano. Long fingers, bright nail polish. Long flowing hair. I was jealous of the attention she was getting and giving to others. Was I a spoiled little bugger or is that just a kid's natural response?

My grandfather had the top missing from one of his fingers. He told me it had been blown off by a German bomb. I believed him, but maybe it was from a revolving door to one of his assignations. I also thought that my uncle Carmen who had been in New Guinea had personally despatched at least a hundred Japanese in World War II. He showed me a big long knife he'd had during the war and I imagined that's what he used. Likewise, I thought that my dad had personally bombed Hitler and had almost single-handedly won the war. You want to think of your father as a hero, and I still do.

I remember the end of the war. My father had been demobbed at an airport out near the western suburbs, either Bankstown or Richmond. I was very excited and a little bit apprehensive about meeting him after five years. Who was this man? I'd received some postcards from him and three Rudyard Kipling *Just So* books that I treasured, and a little bright blue postcard from the Devon village of Clovelly that showed the steep streets and a little sailing boat below. There were pictures of him beside Mum's bed, but I didn't really understand who he was. What would he look like and what would happen to me when he came home to Mum?

What I do remember was that Mum had a very bad asthma attack and we left her wheezing and coughing in the front room. Clearly the stress was just too much. I was a bit scared about meeting this person called 'Dad', who I'd only ever seen photos of. I remember the day being hot. My grandma and grandfather

on Dad's side were there, as was his sister Eileen. I was hiding behind Grandma's skirt. The person called 'Dad' seemed to me to be pretty tall, and had a navy-blue uniform and a hat and a little leather suitcase. It was quite a morning.

I loved my father and we got closer and closer as he got older. But in those first few years, I'm sure it was strange for both of us. I don't think I really felt close to my dad for many, many years, although I always looked up to him.

My father and his mates didn't talk about the war, so there are lots of questions I will never know the answers to. His flight crew stuck together and saw each other mostly on Anzac Day and remained mates their whole lives.

I remember the big march along Macquarie Street to mark the end of the war – it must have been late 1945. Mum and I and Grandma and Grandad had a spot outside the Sydney Hospital, and I recall the flag waving, the sounds of the bands and the sounds of the marching feet of the returning troops. When the march had passed we went to the hospital to meet up with Dad and my uncles in the Domain, then headed home to Belmore for a big party. There were lots of blokes in Liberty Street who'd been away. A banner had been stretched across the road and I remember a big cricket match out on the road itself. What a night that must have been. I was five, so I had to go to bed.

Dad used to help Grandad and Carmen in Grandad's plumbing and drainage business. The pipes were stored up the side path and Grandad kept his beer in them. If he was home and felt like a beer he would send me out to get his 'bottle of bombo' from the pipes. It was the era of 6pm closing so around that time I would sit on the front steps, waiting for them all to come home from the pub,

the George. (As a boy, I thought it was named after Grandad. It should have been, considering the amount of time he spent there.)

Friday night around 6.15pm they would come wobbling around the corner from Canterbury Road and make their way carefully home. Grandad sometimes had a bottle or two of oysters in his back pocket. Those long, thin bottles were great for handlines. They would all have bottles of beer in paper bags too, and if Grandad had had a really good week in the drainage business, I would be sent up to the little corner shop for a small tin of crab. This would be carefully divided among the whole family, with even a little bit for me.

After the old kitchen table was cleared, a blanket was spread across it and out would come the cards for a game of pontoon for threepences or pennies. Everyone played, even me. It's wonderful and comforting to sit around playing games with your family; we still love it. I was surprised and thrilled when I sometimes won. There may have been a little outside help but, even so, you learned a little about winning and losing and luck.

Grandad and most of the family smoked. Rollups, thin ones. I would sometimes sit on Grandad's knee and, with little bits of cigarette paper on the ends of his fingers, he'd say a little rhyme for me: 'Two little dicky birds sitting on a wall, one named Peter, one named Paul. Fly away Peter, fly away Paul. Come back Peter, come back Paul.' He ducked his fingers below the table when he said the rhyme and it made me believe that there really were little birds on the end of his hands.

One Christmas I recall standing up in the back tray of his little navy-blue ute, bringing home a Christmas tree, flying along Canterbury Road on Christmas Eve singing Christmas carols into the wind. Does childhood get any better?

Huck Finn on the Clarence

Mum, Dad and I moved to Maclean late in 1945. Past Newcastle, up through Bulahdelah, across the river at Taree, up to Kempsey, past Nambucca Heads, north to Coffs Harbour, along endless dusty roads through the bush to Grafton then down over the mighty Clarence before we saw the hill that sat above the little town of Maclean. I spent my boyhood there, in a town of mostly dirt roads. Those years from five to ten really form you; it's the age before the pressures of high school or the hormones of adolescence. Fishing before school. Mucking around. Dreaming.

When we first arrived in Maclean we stayed for a few weeks in the Argyle Hotel. There were three pubs in the town then, and the Argyle was the middle one. It had a veranda upstairs where I could sit with Mum after school and look down the main street to see the occasional car going past. Out the back was a big kitchen where sometimes I would be made to stand on the table and sing 'Goodbye Little Yellow Bird' to the delight of the cooks. My

grandfather had given me his big penknife. I found it very hard to open; it had two big blades and a pointed thing to stick pigs with. The only thing that was ever stuck was me. The wild pigs in the bush were quite safe.

Out in the backyard I made a little garden, mostly out of weeds stuck in the dirt. Late one afternoon as I was sitting in the dirt, admiring my weed garden, suddenly a big kid rode straight through it, knocking over all of my carefully placed weeds and, worse still, he was riding my little bike. We found the bike later at the edge of the river, half-submerged. I was most upset and in tears. Also in tears and very upset was the boy's mother after my mother gave her a tongue-lashing.

The first house we lived in had a faded red tin roof with a door in the middle of the front. We never used that. There was a shabby red wooden fence with stuff growing on it, and a little concrete path up to the rarely used door. A covered tin veranda ran around the left side. A hall went down the middle. If you did open the rarely used front door you could see straight through to the back door. On the right was Mum and Dad's bedroom. Beside Mum and Dad's bedroom was my little room. Down the side there were three windows covered by a curved tin awning. And all the way along there was a wooden pergola covered in an old grapevine. I could reach through my window and pick the grapes – sweet muscatels, which are hard to get in the shops now. Opposite my bedroom was the lounge, with one big overstuffed settee, two overstuffed armchairs and a huge wooden radio cabinet.

The ceiling was pressed metal and the whole room was painted pale chartreuse. A single light hung in the middle of the ceiling and there was no carpet on the floor, just painted boards. Next to

my bedroom was the kitchen. A table under the window. A meat safe hanging from a hook, and an old sink.

Mum cooked on an ancient wood stove. As I was too little to chop kindling she would simply shove one end of a long branch into the fire and rest the other end on a chair. As it burned she pushed it further into the fire.

It was a big day when we got our first second-hand ice chest. The ice man would come sprinting around the back with a hessian bag wrapped around the block of ice and sometimes as a treat he'd break a bit off for me to lick. The dunny man also used to visit every few days but there was no sprinting for him. From my window if I'd woken really early I could just spy the black top of his big can of number ones and twos as he carefully made his way to the dunny cart. I write these last few paragraphs for my grandchildren: they of mini-bars and flush toilets, of mineral water and iPads, of babyccinos and smoked salmon. You don't know what you missed!

Next to the kitchen was the laundry, down a couple of wooden steps. It had a dirt floor, an old concrete tub and a big copper. I used to love to feel the smoothness of the copper stick, veteran of a thousand boiling washes, smooth and solid at the same time. The smell of hot sudsy water being thrown onto the backyard will always stay with me.

Down the end of the grapevine was the garage where Dad kept his tools and tins of petrol and stuff. And lots of old hessian bags chucked in the dark corners. That's where my mates and I played, oblivious to the snakes and spiders.

Behind the garage was a bit of a rough garden. One fruit tree. A few scraggly lettuces. A carrot or two and some rarely mown grass. There were people much better than us at growing

vegetables and flowers, and Mum would send me down on my bike with Peter, my red kelpie, to bring back a huge bag of vegetables and a big bunch of dahlias or gerberas.

Dad was the one who took me to a little farm on Chatsworth Island where a litter of kelpie pups had been born; I still can feel the warmth of Peter's little body squiggling away in my arms as we brought him home. A boy and his dog have great adventures, and although Peter sometimes went on the truck with Dad to Grafton, he always seemed to be there when I got home. Dad had started a carrying business, delivering things from Maclean to Grafton then other stuff from Grafton back to Maclean.

Once Peter helped me make a considerable amount of money. It was the weekend of the annual highland gathering, when people and Scottish marching bands came to Maclean. Lots of those North Coast towns have Scottish connections, and boys learn bagpipes and girls practise Scottish dancing. The morning of the parade down Main Street there was a fete beside the river, under the old camphor laurel trees. I'd gone down for a look around with a few mates and Peter. There were lots of stalls, and clowns you could put balls in and maybe win a prize, and a booth selling pale pink delicious fairy floss. Delicious I'm guessing, as none of us had any money. I was hanging around a stall selling homemade things when I saw something I'd never seen before and which I knew my mother would love — a large jar of rosella flower and passionfruit jam. Deep pink, studded with passionfruit pips. Priced at two shillings and with red-and-white gingham around the lid! I knew somehow I had to buy it for her. I asked the lady to put it aside and told her I would be back with the money.

I knew that there were a number of competitions being held down one end of the park. Wood-chopping was not really a

possibility, nor was Scottish dancing, but in the competition to give prizes for kids with their pets I reckoned we had a chance. Peter was resting under the ramp down by the river in the coolness of the dark chocolate-brown flood mud. So instead of a rich glowing russet red, he was kind of a piebald red, with dark brown and blackish stripes. I was wearing shorts and a reddish striped T-shirt. We kind of matched. We came second. We won two shillings. Mum loved the jam.

Peter was bitten one day by a snake and disappeared under the house. We were all shattered to see him in such pain. Dad had to borrow a gun and take him away to end his suffering. Only now do I understand how hard that must have been.

The little golf course at Maclean was the centre of social life in the town. Early on a Saturday morning Dad and some of his mates would go out and mow the fairways and I would be given the task of helping to rake the sand greens. Back home for lunch and then a round in the afternoon. Sometimes I'd hang around the golf club or other times just go fishing or play cowboys with my mates. On Sundays we'd play out the roles of whatever cowboy film we'd seen on Saturday night. We'd be Hopalong Cassidy or the Durango Kid. Often we would play cattle rustling – round up as many stray cats as we could (we didn't hurt them) and keep them in a mate's chicken coop. By lunchtime, we'd have got bored with that, so we'd have an almighty cat stampede, running beside them, yelling and hollering as they fled to safety.

To help the finances of the golf club, Dad and some friends bought a poker machine from the back of a truck. It sat on our back veranda for a few weeks while Mum put lots of threepences through to see how it worked. This was dangerous business because this strange machine sat on a bench on the back veranda

that also housed the homemade ginger beer that she'd made. Now and then a bottle would explode, mostly during the night. And explosions could also come from the beer that Dad unsuccessfully tried to brew.

Most weekends or sometimes after or even before school, we'd go fishing in the Clarence River. For bait we boys could ride down to the fish factory for a tin of mullet guts, good bait for bream or flathead. Very smelly though and in the bottom of old army haversacks we all used for our fishing gear there was also usually some rotting bait, a few hooks and an old rock-hard bit of cheese that had been there for months. We caught quite a few fish though and even scooped up the odd catch of prawns close to the river's edge. The mighty Clarence flooded every few years so the edge of the river was thick with squelchy dark flood mud. The mud went up to your knees when you tried to walk on it around huge bunches of bright green hyacinths that clung to the reeds on the river's edge. Once we saw an old wooden dunny float down the river. It kept us in floods of laughter. We thought you could never see anything funnier than that.

One day Dad got a job taking a group of scouts from Grafton down to camp for a few days at Angourie. It had not yet become the surfing mecca it now is: just a collection of a few houses, a shop and a few huts around the amazing blue pool. It was a dirt road and we twisted and turned under overhanging trees, through some sand dunes and then arrived at the camp. The young scoutmaster explained that we were to come back in three days, and that he and the boys were going to live off the land, foraging edible plants and catching fish.

We said our goodbyes and I was disappointed I was too little to have such an adventure. When we pulled up at home the hospital

had already phoned Mum and she ran out to the truck — we had to go back and pick up the scoutmaster. His first bite of an edible plant had turned his face a strange shade of purple and his head had swelled up. I didn't want to look at him so I sat up the back with the dog. The purple head sat next to Dad. We got him to the hospital in Maclean and even took him back down to Angourie a couple of days later when he'd recovered. The boys were happy to see him. Remember the scouts' motto of 'be prepared'? They had been prepared. Prepared to exist on a Spartan diet of hamburgers, pluto pups, lollies and lemonade.

In Maclean, I'd do almost anything to get out of going to Sunday school. Sunday morning you could go fishing. Or ride your bike, or play cowboys, or chuck stones at bottles as they floated down the river, or go up to the lookout with your dog. But no. Most Sundays I'd have to put on a clean shirt and tie and trudge up to the little brick annex next to the church to spend an hour or so reading the Bible.

Fortunately there was colouring in. And finally, after a last prayer, you were released. Kids jumping on their bikes, yelling instructions of where to meet, and down the hill to home and off to the river. Most Sundays Mum and Dad would have gone to golf. There'd be a sandwich or two on the kitchen table and Peter and I would be left to our own devices till dusk. If it had been raining you could hunt for big green tree frogs and put them in the neighbour's letterbox. Or try and catch some prawns for bait down near the old rowing club. Or if you had money, you could buy the most delicious fruit-packed homemade ice blocks from Mrs Scott at her little shop beside the river. And then, with my red kelpie by my side, I could spend the afternoon just sitting beside the mighty Clarence River and dreaming.

* * *

I was always drawing as a kid. I was continually encouraged by my mother and father, but most children love to draw. It's only when logic gets in the way that some people think they can't do it. What they mean is they can't make a drawing that looks like something. But kids have no such inhibitions and most great artists want to draw with the simplicity of children. At the gallery, I receive many emails and letters from teachers here and overseas. They will often send children's versions of some of my more popular pictures. Almost inevitably they are better than mine. Given that nowadays so many kids spend hours looking at a TV screen, I think it's important to encourage them to paint and draw to find out what's in their head. Being a before-TV child, I used drawings all the time to communicate what I felt about something. Mum bought me a rubber stamp set once where you could make jungle scenes with lions and tigers, but the heat made the stamp pad dry up. No more Tarzan pictures.

* * *

Mum read to me a lot when I was a little boy. Often English children's stories: *Milly-Molly-Mandy* and *The Adventures of Rupert Bear* or *Robin Hood*. I loved the concept of Sherwood Forest and all that went on there. I remember recently though, seeing a cartoon of the big trees in Sherwood Forest and, if you looked carefully, various couples of Merry Men sitting among the branches were holding hands. Maybe they were a bit more merry than I knew.

Although Mum felt great affection for England and was a totally committed lover of the royal family, there were some things

Australian that came first. Once, in the late forties, the Duchess of Grafton in the UK came to visit Grafton in northern New South Wales. All the local big wigs and dignitaries were invited to the civic reception. Dad had become well known and well liked in the little town. He was the secretary of the golf club and had even been elected deputy mayor. He went to lots of meetings. So he had to be there, but not Mum. The final episode of her favourite morning radio serial, *When a Girl Marries*, was to be broadcast at the same time on the ABC, with a huge audience of country mums. And my mum was certainly not going to miss the climax.

* * *

On the first Christmas holiday trip back to Belmore I'd seen a silver toy gun with a white plastic handle that I just had to have. It came with a fringed pouch and a belt and it was just the thing for a five-year-old cowboy. The problem was, I didn't have any money. I explained this predicament to my grandfather and he said he'd be prepared to lend me the money to buy the gun, but only if I agreed to grow some tomatoes when I returned to Maclean and send him back the money I would earn from selling the tomatoes when they were ripe.

This seemed like a pretty good deal, so on our return to Maclean I completed my end of the business arrangement.

Around this time my father had bought a block of land up on the hill overlooking the Clarence River, and he was building our very first home. Mum had organised to buy a black bath (an unbelievably exotic move in those days). As the water was not connected I can remember sitting in the bath but not much more. It took a couple of years for the house to be built.

* * *

While living in Maclean, Dad and I were once each accused of murder. Dad was on his way to golf on a Saturday morning in his truck. Where the road branches from the Pacific Highway to go over the old Clarence Bridge to the golf course he had a small accident. He cut the corner a bit and a bloke on a motorcycle drifted a bit wide. They collided. The bike rider came off worse and broke his arm. News travels fast in a little country town and the next morning at school some kids came up to me yelling, 'Your father is a murderer.' Even at seven I thought that might be a slight overstatement, but they taunted me with it all day.

A few weeks later Dad had to go to court in Grafton. I sat in the front of the truck next to him, and Peter the red kelpie sat on some old tarpaulins in the back. It was a very hot November day, and all the glorious purple jacaranda trees had covered the streets with a carpet of pale mauve flowers.

Dad told me to wait. He didn't know how long it would be so he just said stay in the truck. He gave me a whole packet of Arnott's Orange Cream biscuits. Peter and I got under the tarps. Too hot. Got out again to try and catch jacaranda blossoms as they fell. A few more Orange Creams and I was starting to get a headache – I felt really ill. Eventually Dad returned. I was so glad as I thought him being found a murderer would have meant they put him in a cell straight away. At seven I'd had a few goes at steering the truck while sitting on Dad's lap but I knew I couldn't reach the pedals and Maclean at twenty-eight miles down the river could pose a bit of a problem. I don't think I've ever eaten an Orange Cream biscuit since. I was sick on the way home.

The second murder accusation was directed at me. I was around eight, and we were all playing cricket on a dry old dusty tennis court next to the school. Lots of kids crowded around and I had the bat. Some kid hurled down a super-fast delivery.

I swung. And missed. I swung again and hit the kid behind the wicket on the head. He fell to the ground, blood spurting from his forehead.

'Yer a murderer!' the cry went up. A teacher was summoned. Then the ambulance.

I was rigid with fear. They're right, I thought, I am a murderer. This could be trouble. When I rode my bike along the dusty street to home Peter came bounding along with his 'welcome home from school' bark. He sensed something was wrong. And so did Mum. When I blurted out what had happened she quickly rang the hospital then told me to go there. I rode my bike as fast as I could with Peter beside me. I laid the bike down near the entrance and told the kelpie to stay.

Hospitals always seemed to smell of chloroform or some other strange things so I was full of even more fear as I went in to the ward. What I saw struck me not with fear but with shock and deep sadness. There, sitting on the bed beside my victim, was my girlfriend, Patty. She had curly blonde hair and kind of cute rabbit teeth. We hadn't exchanged notes, although we had 'starred' in the end-of-school play. I could tell by the way she looked at me that this could become a serious and long-term relationship.

The patient had a small bandage around his head and was sipping from a large glass of lemonade. With a straw! My girlfriend was on the bed reading him a comic. I should have realised then that girls can break your heart.

I also remember sending money to the people who published *The*

Phantom comics. This was in reply to the captivating advertisement on the back page that offered a real genuine phantom skull ring with all its magic powers for the small sum of one shilling and sixpence. I eagerly waited its arrival. When it finally came in its little cardboard envelope I was delighted to find it was adjustable. You could squeeze the two sides together to make a snug fit. It needed to be tight because powers could only be unleashed if you pressed it into some kid's arm hard enough to leave an impression of a skull. Naturally you have to try it a few times on your own arm before creeping up beside some unsuspecting enemy and pressing it into him.

The mark of the skull didn't seem to stand out for too long on our puny little limbs so that's maybe why the full magic powers didn't work. I should have just hit the kid with the cricket bat again!

* * *

We were within a few weeks of finally moving in to the house on the hill with its black bath and its lovely river views, when my grandfather, Dad's father, had a severe stroke.

I know Dad loved living in Maclean and I'm sure it was a wrench for him to leave everything he'd achieved in that little country town. But he saw it as his responsibility to look after his mother and his ailing father, and to see if he could run my grandfather's business. He did all of these things brilliantly but, nevertheless, I'm sure he always felt deep inside a slight sadness of never living in that first house.

We left Maclean in February 1950. I remember sitting up on the tarpaulin on the back of the truck, wondering what would happen next. But I was ready for Sydney. I was ten and a half, with high expectations – and I had my cowboy gun.

From the MOUNTAINS to the City

My father's parents had arrived from England in the early 1920s. They moved to Australia for the sake of their eldest son. His name was Norman, and he was a tall strapping young man, but suffered from a chest condition, and it was reasoned that the air would be better in Australia. The family came to Sydney and then when Norman was a young man he went out to a farm in the country. Tragically he bled to death after a shooting accident: he climbed through a barbed-wire fence carrying a loaded shotgun that exploded. My dear grandma had to go and accompany his body back to Sydney. What a tragedy. He had a daughter, Judy, who was only nine months old when he died. I'm sad I never knew her dad.

Grandad Done was an engineer who imported Swiss and German machinery for the car industry, and he was once sent to the USA to work on the famous Bluebird car that set a land speed record on the Daytona Flats. They had three boys, Norman, Howard, and my dad Cliff, and a little later my aunt Eileen. I remember them most from wartime visits to the house on the

top of Fairy Bower overlooking Manly, and later after Grandad's stroke, when we stayed with them in Springwood.

Before Dad came home, it was a real adventure for me to visit his parents. First Mum and I would catch the train to Central, then a bus down to the Quay. I would rush to get the front seat upstairs and couldn't wait to see the first glimpses of the harbour as we drove down Pitt Street. The Manly ferry seemed huge and you had to climb up a big gangplank with huge wheels at the wharf's end. This time I would rush to the back outside to see the froth of the swirling water as the big propellers churned away to start our journey. Sometimes a small orchestra played and I loved the big swell we'd sail through as we passed across the heads. In those wartime days there was an anti-submarine net stretched across from Vaucluse to Middle Head and I still remember the sight of it. There was no way of knowing that sixty-five years later I would produce a series of paintings about the attack on Sydney Harbour by Japanese midget submarines.

As a little boy it was an adventure just to go over the sea to Manly. After a walk along the Corso we would always stop at the model of Manly Hospital beneath the huge Norfolk pines and I would be allowed to throw a penny into the little wishing well. Then we'd walk past the surf club and past the rockpool and up to my grandparents' house. It was high on the crest of the hill and from it you could see all the way up to Palm Beach. The house was made of that kind of knobbly concrete, painted white, with a little steep lawn and a side door. Outside it smelt of lantana and inside of dark furniture polish. I used to love to sit beside the big front window and watch my grandad walk down the hill to the ferry; I strained to catch the last glimpse of him in his white linen suit as he rounded the point where the shark lookout tower used to be.

* * *

After the war Dad's parents moved to Springwood. Some people even moved during the war, as they feared the Japanese might invade Sydney. I'm sure if that had occurred the Japanese would have managed to get over the river at Penrith, so the lower Blue Mountains wouldn't have been *that* much of a safe hideout!

When we came back from Maclean, we lived in Springwood with my grandparents in a cream wooden house with red trim and a nice front garden. It was on a proper sealed road, not like the dirt ones in Maclean, and faced the railway line. After the life by the river, it all seemed a bit neat and controlled. There was no bedroom for me so I slept in the sunroom at the front. My grandfather of course had had a stroke, and wore a calliper on his leg and needed a stick to get around.

Grandad was a rather imposing figure and always seemed to be in a suit. He was Charles Wade Done, his second name being the same as my dad's and my son, Oscar's. Somehow, I missed out. My grandma was Alice May Done. She was a small, sweet lady, who had developed a rather pronounced stoop as she aged. She had thin, grey hair. We loved each other enormously. She always encouraged me to draw. Years later, her last words to me when I saw her in hospital were, 'Don't neglect your drawing.' She was right.

I didn't see much of my dad as he had to leave very early to get the train down to Sydney, where he was running Grandad's business, the Mechanical Precision Machine Tool Company. The train was called 'the Fish' and the slightly later one 'the Chips'. He went one way and I went the other to get to school, chugging up the mountain on the steam train to get to Katoomba High.

You could hear the mighty 36 engine coming up through the hills from Valley Heights. My mates and I would stand on the station at Springwood in the freezing cold, waiting for the train to arrive. Behind the giant engine was the coal truck and then a special carriage reserved for the schoolgirls. Behind that were three or four carriages for the general public, then the goods van, then the boys' carriage. We were placed as far away from the girls as physically possible. The boys' carriage was a series of box compartments, individual sections that each had its own toilet. I'm still proud to say I was in the very last compartment, which was like the chairman's office. After school, on the way back down the mountain from Katoomba, the worst thing that could happen was that you would see your or one of your companions' mothers walking along the platform towards your carriage. Fortunately most days this didn't happen.

Many afternoons my mate Michael and I played 500 on a little pull-out table. Our other travelling companions had felt the power of hormones and often would spend time giving a degree of boyish pleasure to one another. This was slightly disconcerting, and my mate and I tried to concentrate on our hands and not theirs.

Sandra, a girl I was to take to the movies one Saturday morning in Katoomba, lived in Leura, which meant she got off at the first stop. I'd always hang out the window to wave goodbye or try and touch her hand as the train sped away. As the girls' carriage had been up the front, by the time my carriage passed the train was going at a pretty fair speed, so sometimes the gentle touch on her fingers could be more of a full smack on the shoulders and she would fight to retain her balance as the train thundered down the track. I often looked back to see a little whirling figure, spinning out of control. That's young love!

On approaching Springwood, any boy whose house was close to the railway line took the opportunity of throwing his school case out the train window into the bushes. This saved carrying it back from the station and only occasionally did these missiles threaten ladies on their front lawns, hosing their gerberas.

I started my first business in Springwood. I had a billycart with old pram wheels on it but a mate had a set of ball-bearing wheels – the real deal in those days, and highly desirable. I said to him that we could put the ball-bearing wheels on my billycart and go into business collecting manure on the weekends. My prime customers were to be my mother, my grandmother and maybe the nice old ladies next door. I produced a poster with drawings of animals down one side and the various prices I thought we could charge for their droppings. Old cow manure was the cheapest as it was easily found. Then the prices rose through fresh goat right up to the most expensive of all, which was lion poo (just in case a beast might have escaped from the lion park). The business was quite successful, and ran for at least two or three weekends. Early on Saturday morning, my mate and I would start by simply watching various animals from a distance and waiting for the inevitable to appear. We would then run out, bag it, and take it home to sell. Everything went well until my mate decided he wanted his wheels back and I saw our partnership and the future of a global manure business grind to a halt. I think I vowed from that time that I would try to be in total control of what I was doing – no partners.

In our backyard was a little flat where the gardener lived, a European man whose tongue used to hang out a little bit. I think he was from Yugoslavia or somewhere like that, and he lived in the little shed out the back for a year or so. He did very detailed

paintings of the parrots and the gum trees. They were nice but I found him a bit scary.

There wasn't much to do on the weekends. There was the manure business, or you could wander down the gully to try and catch yabbies. The bush was dense and dark and the little pools mossy and slippery; it was all big ferns and steep rocky hillsides – no wonder people got lost. Once another kid lent me his air rifle. I crept through the deep bush, trying to find something to shoot at. No luck.

Most afternoons I had the job of riding down to the shops to get stuff for the two old ladies who lived next door. Their house was gloomy and dark with rooms that looked like nobody went in them. They gave me a shiny two-shilling coin for each delivery and a fresh peach from their old tree if it was in fruit. I saved up at least six shillings before blowing it on a packet of unfiltered Camel cigarettes and that Saturday morning date with Sandra at the Katoomba Pictures. I was around thirteen at the time.

It's very different when you catch the train on a Saturday. No school uniform, no other kids around, so you feel quite grown up. I think I was wearing my brown corduroy trousers and a green corduroy jacket over a yellow short-sleeved jumper with a complex Fair Isle pattern that my mum had knitted. I had lit up my first unfiltered Camel of the day, and sat waiting for the train with high expectations for what was my first real date. It would have been spring, 1953. Fortunately I wasn't wearing the little black skullcap with the embroidered flags of all the Swiss cantons that my father had brought back from his travels for me. Had I been, I'm pretty sure I'd have been picked up by the authorities and sent straight to the home for wayward gnomes. I thought I looked pretty cool. I didn't.

We met outside the old picture theatre near the station. I was hoping to hold her hand when the lights went down. She, being almost a year older, had marriage on her mind. As soon as the lights went out, she lunged for a kiss. This came as a great surprise and inconvenience as I was just about to go to the toilet to throw up. It may have been my Camel breath, or the colour of my face, but she never tried that manoeuvre again and just rested her hand provocatively on my knee. Again, no go. I'd yet to develop the first adolescent stirrings of desire. I just felt ill.

* * *

In 1954 we moved to Cremorne, to a little semi in Rangers Road. Sadly, my grandad had passed away and we left the house in Springwood to be nearer the city. Aunt Eileen, her husband John and their children stayed in the mountains to look after Grandma. Dad was running the Mechanical Precision Machine Tool Company from a small office in Bridge Street. I was excited to be living in Cremorne as it was near Balmoral Beach and the zoo at Mosman. I mostly slept on the veranda.

We'd inherited a little brown and white fox terrier from the lady we rented the house from, Porky in name and shape. He and I spent many happy hours down at Cremorne Point, fishing for leatherjackets or mackerel. He had a funny walk and I remember talking to Mum many years later about him only having had three legs. She assured me that he had the correct number of legs for a dog.

The semi is still there. It had a little backyard and a girl in the house behind us kept a horse in a back shed. Probably the

last horse to live in Cremorne. Dad bought a beautiful silver Sunbeam-Talbot sports car. I was thirteen and could not drive, but I understood how stylish that little car was.

Mum and Dad had made enquiries about what school I could go to, and it was suggested that I enrol in Shore. I only knew one kid who went to that school but I didn't really like him and I wasn't all that keen on the uniform, so it was decided I would go to Mosman High.

Most weekends I'd go down to Balmoral by tram. First up Spofforth Street to Cremorne Junction then down to Mosman, past the school and on down the hill through the cutting to Balmoral Beach. Along the Esplanade were a butcher's shop with sawdust on the floor, a chemist, a fruit shop and a couple of little mixed businesses where you could buy ice-cream and drinks or sandwiches on the weekends.

When Mum and Dad built their house above Balmoral, The Grove was a dirt road. There were three blocks of land for sale. Dad bought the middle one, on the high side of the road with a big old flame tree in the middle. He spent months clearing out that tree and as much of the block as he could. Then he made a model of the land out of a big bar of soap to work out where the house could be sited.

One day Dad was driving to work through Cremorne and picked up a man who was looking for a lift. The man was a young architect, recently arrived from Hungary. Dad liked him and decided to let him design our house. It was a very modern house with a stone fireplace, and split level, with two terraces to get the most of the view. There was a geometric pattern of glass at the front with a couple of panes in red and yellow, a bit like a Mondrian painting. Peter Kollar was the young architect, and he

went on to have a distinguished career, becoming a professor at the University of New South Wales.

I painted a little mural of a French wrought-iron lift on the wall joining the two floors. As it was next to the stairs I don't know what I was thinking. I also painted the door to my bedroom black and nailed a real rat's skull to it. I was a teenager. What else could you expect? Of course, my parents thought the lift and the drawing were great. But they would, wouldn't they?

I lived in the house from when I was sixteen to when I was twenty-four. I bought my first car when I was twenty; I was already working at the Jon Hawley Studio in Edgecliff and doing freelance illustration and design work. It was a second-hand white MGA with two blue stripes. Then I bought my second car, a new little Lotus Elite, in 1962. Although I knew nothing about engines, it was beautifully designed: fibreglass body, wire wheels, a small cockpit, made for two. It was only the second one imported into Australia. After a year or so the red paint on the fibreglass faded in the Australian sun, so I had it resprayed silver. Judy and I had lots of fun in that car. I wonder where it is now.

Although it was built in 1956, the house on The Grove is still great looking, and I'm so pleased the present owners didn't knock it down. We see the woman who owns it most mornings when she takes her two dogs for a swim in front of the Cabin. She's told me about all the changes they've made inside and offered to show me, but I don't want to go in. I want to remember it as it was when Mum, Dad and I lived there. All my cousins would come to stay at various times, and when Mum passed away in 2008 it was they who came and helped me move everything out. I know they too had many days of love and affection there.

* * *

I've never been much good in the garden, but I used to love to stand beside Dad and help when he shovelled leaves, branches and any garden rubbish that would burn into our backyard incinerator. Everybody had one in those pre-climate change days. It was an Aussie ritual. Your dad in his singlet, leaning on the rake, a beer in his hand, and you sticking a fork into the burning embers to get a few more sparks going and send a good amount of smoke drifting across into the neighbours' yards.

Then Sunday-night dinner: cold lamb from lunch. A beer or two for Dad. A Barossa Pearl for Mum and a Coke for me. One of my old friends and I used to walk along Balmoral Esplanade with a family-sized bottle of Coke shoved into our jeans pockets. From there, through an arrangement of straws stuck together, we could sip and stroll, as it were. In between the sips, we could puff on a Craven A unfiltered ciggy. We thought we looked pretty cool. We weren't.

I worked at David Jones in the summer holidays, like lots of students. I was at the old George Street store and I was lucky enough to be on the cigar counter. Wonderful smelling balsa boxes with exotic labels from faraway lands. Sometimes, with my employee discount, I would invest in one of the single beauties. Encased in a metal tube, these were the ultimate gentleman's after-dinner pleasure. I unfurled one once in Jerry Carney's Steakhouse, upstairs in King Street. A mate and I had consumed a dozen oysters, then a delicious Steak Diane, the house speciality. And a bottle of Coonawarra claret. A couple of deep puffs of my giant stogie and I rushed, green-gilled, into the gentleman's convenience for a quick hurl down the dunny. The concept was OK. You just needed to be closer to manhood to really enjoy it.

On Saturday mornings during the year I worked at Coles in Spit Junction. One particular burning-hot summer morning, I remember ducking down beneath the counter to sip from a stolen container of lemon juice. I was on the drinks counter, where I was able to offer the occasional beverage on the house, as it were, to girls from Queenwood and Mosman High. To avoid being caught, one day I quickly wrapped a half-consumed Lemon Crush into some lady's shopping bag. Fortunately she didn't come back and dob me in.

I was clearly chairman material to the management's eye, and was trusted with the late-morning task of taking the cardboard rubbish out to the big bin and then watering the plants to keep them alive over the weekend. The big garbage bin was made of hessian, and once I jumped up and down enough there was enough space for me to get down and have a bit of a rest among the cardboard. I used to stay there until I heard some commotion and then would emerge to become Mr Flower Waterer. The seedlings had to be taken out to the back lane and placed carefully up the tiny side passage. Then I could stand back with the hose and blast them from a distance. You needed to aim the hose against the back wall and hope the water would ricochet enough to wet the seedlings and not blast the soil out of their boxes.

One of the girls who worked there had spectacular breasts. I could not take my eyes off them and would almost faint when she pushed past me behind the counter. I dared to invite her one night to come to the pictures at the Cremorne Orpheum. She wore a low-cut black dress, and although she told me she had a boyfriend, I was prepared to chance my arm as it were. That arm in question spent most of the evening slowly, slowly, ever so slowly creeping around her shoulders for a last-minute grab of the prize, or prizes, so to speak.

We went to the Coles Christmas party together. It was great. Then I found out her boyfriend was less than amused at my interest in his girlfriend. She had omitted to tell me that he was a big footy star from Marist Brothers College (who would go on to become a famous Rugby League player, but thankfully I didn't know that then). The next Saturday morning, a mate came into the shop to inform me that this bloke and some of his mates were waiting for me across the road, and were going to get me when I finished work. What the hell could I do? I was overwhelmed with fear.

When the shop finally closed and the door to let the staff out opened I had begun my run at the back wall, so when I hit the pavement I was already at top speed and racing towards the safety of home down Awaba Street. I think it must have been that I caught them by surprise, or maybe they had decided to spare me, or she had told him he had nothing to worry about. Who knows? In any case, even though he represented Australia and was one of the fastest wingers the sport has ever known, on that particular Saturday arvo he'd never have reached the speeds I achieved.

One morning I was thrilled to find we had a delivery of underwater masks at Coles. No one had snorkelling gear in those days, apart from frogmen and people on television. It was expensive and unavailable to the average person. But suddenly, at a price I could afford, there was a whole counter of gleaming blue masks. I bought one and couldn't wait to rush home early on Saturday afternoon to try it out.

I grabbed my swimming trunks and ran down to a spot at the northern end of Balmoral called The Fraz. This is a large rockpool open to the sea, filled with seaweed and the occasional rock cod.

While I was preparing to take my first proper snorkel, I noticed a girl who went to my school sitting on the rocks. She was probably just in her teens, and pretty well developed. She asked me what I had in my hand. I explained excitedly it was an underwater mask. She said that she would love to have a go. I quickly agreed but asked would she allow me to see her breasts for this deal. Here is a great lesson about the power of women. She quickly agreed, but stipulated that she would have to have the mask on during this showing. We jumped into the water, she slipped off the top of her swimming costume and I was confronted through my stinging eyes with these pale pink wobbling things. I stayed under the water for as long as possible, just short of drowning or before the bends took over.

* * *

Most kids played tennis in those days. I did, at a couple of courts at Neutral Bay where the big Woolworths now stands. There were lots of tennis courts in the area before the price of land made the ownership economically challenging. After tennis a couple of mates and I would walk along to Cremorne Junction for a milkshake. It was all houses with gardens between Neutral Bay and Cremorne and all the way along Spit Junction and down to Mosman. After the milkshake we would creep up the stairs of the Orpheum picture show and tiptoe past the candy bar to slip in the upstairs theatre via the far stairs. Almost inevitably we'd be caught by some usher who'd seen the shaft of light as the door opened, and the fact that we were all wearing white and carrying tennis racquets didn't help – not much of an outfit for a daring commando movie raid.

There was only one theatre there in those times; it wasn't the multi-screen complex it has become. You can occasionally see Mike Walsh, the owner, sitting alone up the back. I did some work with him when he was at Channel 9 and topped the ratings with his daytime show. He's taken over a number of cinemas in Sydney and I'm glad he's preserved the Orpheum.

2015

A few weeks ago I was asked by the director and actor John
Bell to be part of a group of artists to make a work relating to
a line from a Shakespearean play. The works will be shown at
the Sydney Opera House and then Melbourne and Canberra as
a fundraiser for the Bell Shakespeare Company – a good cause
and a nice problem. I considered two lines – 'Come unto these
golden sands' (*Tempest*) and 'A woman is a dish for the gods'
(*Antony and Cleopatra*) – and decided on the woman.

I started with a small number of drawings. Not bad, but
not good enough. A couple of hours later, I liked one. Slightly
funny. Big Cleopatra. Nude. Red heels. Standing proud
on a boat. Cleo looking strong, bold, sexy. Tried four big
canvasses. Different versions of the figure, all disappointing.
Washed everything off.

Even though painting takes intense concentration there
are always parts of your mind that can drift into other areas.
My current real concern is that over the last few days we're
all struggling with the news that our much-loved grand-
dog, Bexley, has cancer. People who don't have dogs don't
really understand how devoted you become. We've had the
gentle Sammy, the famous Spot when the kids were little, and
Indi the Blue Heeler, who fiercely guarded us for years and
although gentle and loving to us was a streak of blue lightning
to any other dog that came into our orbit.

I've been down in the studio for a couple of hours. Picked
up a new canvas, 80 x 100. Worked on a kind of Matissian
figure on a striped Egyptian rug. Hot colour. Rich pattern.
Maybe it will work but the larger 150 cm x 120 cm canvas

lies in wait outside the studio. May force me to try again. The large nude Cleopatra in the boat. I want to please and surprise myself. Not repeat something I can already do. As a painter, that is the drive. So many artists of my age in Australia repeat themselves in the last few years of their work. Nothing wrong with that, there are no rules in art, but for me, I like to try some new things.

I go back into the studio, put on another recording of the English Comedy show *I'm Sorry I Haven't a Clue* that my daughter Camilla gave me for Christmas, or some rhythm and blues or jazz. Ray Charles or James Morrison. I'll just put up the canvas and start.

No preliminary drawing. I want to not know how it will end. Maybe good, maybe great. Maybe another trip to the high-pressure hose, and watching the paint wash down into the garden bed. Hope it doesn't kill the parsley or agapanthus.

ART SCHOOL

After I left Mosman High on a special exemption in 1954 my father took me to the Education Department in the city. He helped me apply for entry to East Sydney Tech in Darlinghurst, the main college that taught art. It's all I really wanted to do. The entrance exam was purely practical. I remember sitting in a big long room upstairs. Everybody had been asked to bring a large drawing pad and some pens and pencils. We were asked to make some different kind of lines, some interesting marks, draw something and show a portfolio of things we'd done at school or at home. Pretty basic stuff: no theory, no artspeak.

At that time I was fourteen and a half – the youngest entrant they'd accepted. The first year you spent four days at the North Sydney Technical College then, one day a week, I think Wednesday, you went to East Sydney. I loved it from the start. At North Sydney we had Peter Laverty, a wonderful English painter who went on to run the Art Gallery of New South Wales, and Frank Norton, a distinguished war artist, who would take us on outdoor drawing trips to Lavender Bay and Balls Head. I guess

there must have been about twenty students, mostly girls. Freed from the confines of school we all tried to look like art students. We carried our portfolios proudly and I even once wore a smock my aunt Joanie had made. Only once.

When I was about fifteen I received my first real commission for a painting. It was for a friend of my Uncle Hubert. Hubert was a sign writer and I have his mahl stick, used for many years of his working life. He had a mate who had travelled to Norway and had come back thrilled with his experience of the Northern Lights. I of course had not seen that heavenly phenomenon so when this mate asked me to produce a painting of the lights, I should have known that the whole thing would end in tears. He promised five pounds for the job and set a deadline for a month. He explained to me what he'd seen. We were sitting in Uncle Hubert's shed during this briefing and he and Uncle Hubert were polishing off a few bottles of KB lager. Uncle Hubert liked a drink and so did most of his mates. So armed with the bloke's memories of the Northern Lights I went home to commence the painting. If I remember correctly it was about four feet by two feet in the old measurements. I'd made the sky kind of stripy colours and in the foreground I'd painted an old gnarled dead tree. We went over to Hurstville to present the work. I was nervous. I unwrapped it carefully and waited expectantly for Uncle Hubert's friend's reaction. I could see by the look on his face that he was not too happy. In fact, he didn't really like it. He said it didn't look like the thing he'd seen. I was shattered. But he gave me the money. I've never done a commission since that time – it's hard enough to find out what's in my head and be pleased with it, let alone trying to second-guess someone else's mental image.

As my father was in the machine tool business he had one of his Swiss assistants make me a case for my art materials. It was

lovingly crafted by a man who was used to making cases for metal tools. It was quite large, and painted grey inside, with a number of compartments for paint, brushes, paper etc, and covered with a kind of forest-green vinyl. A thing of precision and beauty. But also very heavy. I used to struggle with that big case onto the tram in Cremorne and then struggle up from St Leonards Park to the Tech.

I was best friends there with Margaret Forsyth, who now runs the family real estate agency in Willoughby. And it was around this time I became friends with Barry King, who drove a 1910 Garford fire engine. Barry was a bit older than all of us but liked to hang around the art school. Once during the winter he invited me and a mate and a couple of older blokes to come with him on a car rally to Katoomba. We were thrilled and set off, sitting sideways on the top of the fire truck to make our way up the mountains. We made it to Katoomba. It was freezing cold.

Some local newspaper took some shots of us. Barry booked a room in a little guesthouse and the rest of us climbed through the side windows when it was dark. All good until the lady who ran the place knocked on the door in the morning with one cup of tea. A boys' adventure. No worries.

The worry came some time – years – later when one of the local rag's photos of us appeared on the front page of a Sunday paper. We were there not because of the guesthouse scam but because sitting next to Barry in the front section of the fire engine was Geoffrey Chandler, who had become the major suspect in the deaths of his wife, Margaret, and Gilbert Bogle.

The next year I went full time to East Sydney Tech. I met a couple of boys who have been my friends for life, Neil McCann and Ric Hedley. Neil was a few years older than me and in the

class next door. We hit it off with a shared love of jazz and jokes. Neil was so grown-up that he had his own little flat opposite the college and could even cook. I was most impressed.

Ric was a teacher trainee and was with a group of students who came there four days each week. We shared a love of girls and cigarettes. He was Mr Marlboro. He went on to become a great art teacher and spent many years at Killara High and Hunters Hill High. In recognition of his time at the latter school they named their gallery after him. He has done some terrific paintings, especially one inspired by the music of Paul Grabowsky's *Disappearing Shoreline.*

There were some great characters at tech and the atmosphere was heady with the spirits of all the artists who'd studied there in the past, and the memories of all those poor buggers who'd languished there or worse still been hanged there when it was a jail.

One of the things that had most excited me about going to art school was the concept of seeing a totally nude woman. It turned out though that you had to spend the first year drawing from plaster casts and statues and that the real life class would start in the second year. As I remember, the class was to be held on a Thursday, starting at nine. I think I was there at twenty to seven. You sit around in a circle on wooden things called donkeys with your drawing board in front of you. The model comes in, naked, and you commence a series of drawings. First quick drawings of a minute or so, then a series of five-minute drawings, leading up to a longer study of maybe an hour. All during this time, the art master walks around the students, leaning over and correcting the pose or the anatomy. He spoke to every student except me and I was getting very worried. At about five to twelve, just before the

class finished, finally he stopped to examine my work. He then leaned over and whispered so the other students couldn't hear: 'Ken, don't you think it's about time you attempted the head?'

One lunchtime a student sidled up to me and whispered in my ear that he had a bomb in his pocket. This is decades before the threat of terrorism, but I was still a bit concerned. I looked at his wide grin and figured he must be joking. A minute later when the cafeteria was filled with smoke I realised he hadn't been. Just a prank, with no harm done to the pies and pastries or his nuts. We were a gentle lot, really. Only one demonstration against the removal of an old tree outside the art material store. It was the 50s, after all: not too much to get overly excited about. Endless long hot summers and the rest of the world a long way away.

We were given a club room near the little art material store. We were supposed to use the space to meet and discuss art. We didn't. Rock and roll had just hit the airways so most lunchtimes we pulled down the blinds, set up an old record player and danced the lunchtime away to the sounds of Bill Haley, Gene Vincent and the incomparable Little Richard. I remember thinking I couldn't imagine a time in my life when I wouldn't like to dance.

* * *

I did a few different things to make pocket money during my art school holidays. Because my uncle Carmen worked at the *Herald* in Wattle Street, he was able to get me a temp job as a copy boy. I felt very grown up and reported for work early each day.

I had a number of tasks: to take messages to other departments and generally buzz around the place on various chores. The whole place smelled of the hot metal type being set for the evening

edition. My most important and slightly frightening task was to phone through the lottery results to the *Newcastle Herald* each afternoon. A nice lady at the other end of the phone told me how to read out the numbers – say: eight seven six two, not eight thousand, seven hundred and sixty-two – and you had to do it quickly. I'm sure that in the slightly hypnotic state I entered while reading out so many numbers I must have made some mistakes. I was convinced someone would come round to our home at night and I'd get into trouble for awarding someone a prize who shouldn't have got one.

Maybe they were just making up things for me to do, but it was fun and I always felt a little proud when I went home with a still-warm copy of the latest newspaper and a feeling that I had contributed to it.

* * *

I fell in love for the first time at art school. There is nothing quite like that first innocent love. Charmaine Cassidy had big soft dark eyes, a serene face and long straight hair. She was in another class but we spent most lunchtimes together and went to dances at the St Ives Community Hall and a couple of art student balls.

The art students' ball was the highlight of our year. I'd done the poster for it – 'Saucy Maids and Saucy Blades' – and it was a sell-out.

By 1957, I had passed my licence, and often drove my dad's blue-and-grey Customline. The night of the ball, Dad had agreed to lend me the car, and I waited in a fairly bad pirate costume for him to arrive home. Finally, much later than expected, the car came round the corner and Dad jumped out.

'Sorry –' he started to explain.

'Don't worry, Dad,' I said, and jumped in with just enough time left to pick up Charmaine and get into town.

The do was at the old Trocadero, then home to endless balls, dances and parties since well before the war. Many a young fella climbed the stairs to have a quick chuck in the men's loo, and many a young couple was photographed sitting on the round banquette in the centre of the foyer. Two bands played on a revolving stage. The mighty Frank Coughlan Orchestra then coming round some rock and roll band. Lots of tall bottles of pilsner and lager were consumed. Boys tried funny moves on the floor and many simply slipped under the tables for a quick nod-off or a pass out, depending on how much they had drunk. No dope or booze buses in those days. Beer for the boys. Sparkling burgundy for the girls.

Fortunately for me and my passengers, I could get the feeling of being quite plastered on a small glass of sherry, so when it came time to leave I felt OK. I'd offered to take a couple of extra girls home to Hunters Hill, on the way as Charmaine lived at St Ives. We negotiated the windy roads of the Hunters Hill peninsula and wound our way to the girls' house, down by the waterfront. There was an obelisk in the centre of the road outside their front gate. When we'd said our slurred goodbyes, I attempted a bit of backing up and reversing around the garden bed. Seemed a bit tricky, but I figured with a few tries I could make it. On one of the reverses, I just clipped the edge of the garden bed. Thought I'd better get out, just to see if everything was OK, and to my horror I found the near-side fender smashed and only just hanging on to the bodywork. Bugger me – I thought I only just touched the stonework. What's this bloody car made of?

After dropping Charmaine home, I drove in shattered silence, trying to work out what I could say to my father. I got home about 2.30 and looked again at the back of the car, wishing desperately that it somehow wasn't there. But it was. There was nothing to do but to wake Dad and tell him. I couldn't face a sleepless night to tell him in the morning.

Both Mum and Dad woke up when I turned on their bedroom light and blurted out the sad saga of my damage to the Customline.

'Well,' Dad said sleepily, 'if you'd just waited a second when I got home, you'd have given me the time to tell you that *I* was in an accident on Parramatta Road on the way home and that's why I was late.'

Oh joy, oh joy.

* * *

Sadly, Charmaine died when she was nineteen of kidney failure. All of us who knew her will never forget her. Her mother had lost her husband during the war; to lose a daughter as well – it is hard to imagine such a blow.

Rites of Passage

Towards the end of my time at East Sydney Tech, a few mates and I started a band. It had the improbable line-up of two drummers, of which I was one, a piano accordionist and a Hawaiian guitarist. A French boy, whose name escapes me, was the other drummer, and the other two were Bill Ghan and a Chinese boy called Wilfred Pong. Willie became a great friend and I often played cards with his family on a Sunday. Wilfred changed his name to Willie Glenbrook and he was one of the best rock and roll dancers I've ever seen. The band would practise some lunchtimes in an upstairs room at the tech and managed to play a couple of songs. Filled with the optimism of youth, we called into the Taboo Nightclub at Kings Cross and played 'Malaguena and the Peanut Vendor' to the management and asked if they had the possibility of work for us somewhere.

To our surprise, they offered us a chance to play at a coffee shop in Bondi Junction. We were thrilled and my aunt Joanie made us all frilly shirts in the kind of Xavier Cougat / Ricky Ricardo look. The night of our first performance (no one used

the word 'gig' in those days), my mother asked what time I'd be home. 'Mum!' I exclaimed. 'We're musicians. I have no idea. We might be there all night.' We arrived at the coffee shop at around 7.30, set up our instruments and began to play. To our surprise and relief, a few people actually got up to dance. After the first couple of numbers we took a break. And faced the problem that we didn't in fact know any more than those first two songs. We took the stage, attempted to do 'Peanut Vendor' slightly faster than our first effort and were fired on the spot. I was home by 9.30. My parents were still watching television. My musical career was very short-lived.

* * *

One of the rites of passage in a young man's life if you lived in Sydney in the 1950s was a trip down Chapel Lane. Just looking, you understand. This was a little lane filled with tiny terrace houses where all the Darlinghurst prostitutes plied their wares. Friday night would find a large group of men and teenage boys walking up and down the lane, looking at the girls. They all leaned seductively up against the doorways, offering a tiny glimpse of the bed behind and a tiny glimpse of themselves. The passing parade would fly into action if the police arrived at one end of the lane, and scurry along to the main street. I'm sure no one was ever arrested as the girls or their madams were paying the local constabulary.

Late one Friday night, me and a couple of mates and a slightly older art student were trying to pluck up enough courage to have a go, as it were. Well he was, your honour, we were just the urgers. He stopped by a door, eyed the young lady and we saw

him in brief conversation before a wink to us over the shoulder and he disappeared inside. We were rigid with excitement. It seemed only a minute or so and he was back at our sides.

'What happened?' we enquired excitedly. 'What was it like?'

He looked a bit downcast. Finally he blurted the sorry story out. 'She asked for a quid for a short time or two quid for a long time. I asked for the long time,' he was clearly thinking of an evening of sensual delights with his Darlinghurst damsel, 'but when she started to try and undo my fly buttons, it was all over!'

We left the lane, him with his tail between his legs. Not the outcome he'd hoped for. Poorer but wiser, and a chance to try again another day.

There were illegal gambling places up at the Cross that we sometimes found ourselves in, and some notorious coffee shops. The Arabian, decorated by the self-proclaimed witch Rosaleen Norton, and the great Veneziana restaurant in Darlo, where for a few bob you'd get a huge plate of spaghetti, chunks of bread and glasses of rough red wine. Restaurants like Beppi's were there, as was the Chaliss in the Cross, but they were all too grand and expensive for us.

Once we art student boys had to appear in a line-up at the Darlinghurst police station. The old law courts were across the road at Taylor Square – they're still there. We stood nervously in a line, terrified somehow that the sins we'd committed as kids would catch up with us, but relieved when we were finally dismissed. The station was run by the notorious Bumper Farrell, known for administering a regular kick up the bum to people he didn't like. We smiled innocently as we silently walked past his office.

On most afternoons I'd take the tram back down to the city. What a loss those lovely old trams are. Rattling down past

Hyde Park, along Elizabeth Street, down Phillip to the Quay. Dad's office was in Young Street so sometimes I'd wait and go home with him, or get the ferry to Cremorne and the bus up to Rangers Road where we lived. This was before the Opera House was built. Bennelong Point was the big tram shed, and the tallest buildings were just a few storeys high. You could hear the music from the big ferries. Piano, violin and drums, echoing across the harbour as they travelled seven miles to Manly and a thousand miles from care, as the slogan went.

I used to take out a pretty little dark-haired girl called Wendy. She lived a couple of streets away and she wore wide 50s skirts with ropes and bobbles around them. One evening I took her to radio station 2UE in Bligh Street, where a teenage program was recorded live at their city studio. You were ushered into a soundproof booth with some other spotty and excited kids and asked questions by the announcer on various pop music topics. The announcer was Howard Craven, a long-time Mosman resident and a charming man who I got to see now and then in his later years. After it finished, about 6pm, it was back down to Circular Quay for the ferry ride home. I suggested to Wendy that we sit right at the back, away from the prying eyes of the public. Even though I'd made what I considered to be my best moves, Wendy was less than receptive. Funny, I thought, because I'd heard women lose all sense of control on long sea voyages. But maybe twenty minutes to Cremorne just wasn't long enough! Mind you, Judy, who I began to take out several years later, when she was about nineteen, lived at Manly. But by then I had a car!

2015

I have just come back from a walk along the beach, looking at
the Cabin and the house above it. It took so much to get them.
Not just the money, but the twists and turns of fate until finally
we could call them ours. The Cabin, which I first saw when I
was fourteen, is built right down on the waterline, on the rocks.
Only a handful of houses are still left that close to the harbour.
I can swim on a high tide to the steps just down from our
front door. There is a tiny rockpool beside the stone steps and
each morning I float a fresh flower in it as a kind of offering to
Mother Nature and a hope that all our dreams might come true.

I did a couple of interviews in the last few days and read
a couple of pieces about artists. So much artspeak, so much
rubbish. Look at what an artist does, not what he or she says.
Matisse said an artist should cut out his tongue, yet he went
on to write one of the most important art books ever, *Matisse
on Art*. To me, words seem so inadequate when describing the
act of seeing. The artwork is half the conversation; the other
half is filled in by the viewer with the feelings released when
viewing the work. This differs from person to person, and is
very hard to put into words.

WORKING MAN

In 1958 at the end of my fourth year at East Sydney Tech I was offered the chance to work in a design studio in the city. They'd asked for the best student and I was very excited to be given the opportunity. The studio was run by a wonderful art director called Arthur Holland, who was the best in town in those days.

They offered no money, simply the work experience, and for me it was more than enough. Arthur asked one day whether I could do cut-out lettering. I didn't really understand what he meant until he showed me some Matisse lettering. He had me cut out some letters and then asked me to do a drawing on blotting paper of a didgeridoo. A week later my lettering and the didgeridoo drawing were on a large poster for the ABC.

I was thrilled. And it showed me something of the speed in which the real art world worked. Arthur had *Vogue* magazine as a client and one day he told me he was running late for a deadline and asked would I cut out a small tear shape from blue paper and

stick it under his eye. He used this graphic device to explain to the editors from *Vogue* that the job was not yet finished and that he was sorry. It was a salutary lesson in client relationships.

Then, halfway through my final year, after I'd experienced a bit of the 'real world' at the Arthur Holland Studio while still attending classes and completing assignments, the then principal of East Sydney Tech, Roy Davis, came to me and said there was a job available at the Smith & Julius Studio and that I should take it. Smith & Julius were very famous and had employed Roland Wakelin, Lloyd Rees and a number of other famous Australian artists in their early days. It seemed too good an opportunity to miss, and although there were six months left to go in my course, I took the job.

The studio was in Devonshire Street, Surry Hills, and within the first few weeks I'd done ads for the Australian Wine Bureau and a number of drawings for various clients. I was excited to be in the real world of art and design. My time at Smith & Julius, however, was short-lived. After I'd been there for only two weeks, I was offered a job as an art director in a proper advertising agency at twice the salary Smith & Julius were paying. But the real clincher was that I could paint my new office whatever colour I wanted. This was 1959. I painted the office purple.

For the final examination at art school you have to mount an exhibition of your work. At this stage, I think there were only six girls and me in fifth year. We had been given a series of set pieces to do – posters, book illustrations, advertising design etc. I'd been working for six months so my final exhibition consisted of the opening titles to the TV show *Bandstand*, a series of posters for a car manufacturer, ads for the Australian Wine Bureau and fashion illustrations and design. In those days, you had to wait until late

in January for the results, even though the exhibition had been in November.

On the morning of the results, I rushed eagerly to the newsagent. I was shocked to find my name not there. I'd worked so hard during those years and I figured it must be some kind of mistake, because I knew no one in my class had achieved some of the things I'd done. When I finally got through to the relevant person in the Education Department, they told me they had decided not to review my work as I had not completed the same tasks as the other students. I understand their position now, but at the time, at nineteen, it was a blow, and now, fifty odd years later, I've *almost* forgiven them.

The agency where I painted my office purple was called Australian Amalgamated Advertising, on the corner of Pitt and Bathurst Streets in the city. Like I said, it was a proper advertising agency, so now I was a proper young art director. The creative director was Jon Hawley, still a great mate and a wonderful designer and lover of all that life has to offer.

When Jon decided to set up his own design studio in Edgecliff, he asked Dinah Dryhurst, my friends from art school Ngaire Davenport and Neil McCann and me to join him. He was a good boss and a creative inspiration to us all. He devised a pay structure and bonus system that was fair and encouraging. I purchased an old barber's chair to sit on – I had it for years. Ngaire could do the most detailed renderings. In those days clients needed to know what an ad or a TV commercial would look like and Ngaire was one of the best.

We did everything by hand – lettering, illustration, annual reports, posters, ads. The discipline leaves you with a great visual understanding of things. Nowadays, even with computers, I

still think young designers need to work with pencils, crayons and anything that makes the mark directly. You need the tactile feeling of the materials. I think you need your brain to feel the shapes and the spaces. You should rely on your feelings, not the computer.

* * *

Next door to Jon's studio was a photographic studio run by Geoffrey Lee, one of the city's top fashion photographers of the day and lorded over by his mother, who sat regally at the top of the stairs to vet any visitor to the establishment. Working with Geoffrey was John Pearson, a lifelong friend, and he and his wife, Jean, and Judy and I spent some great holidays together.

On one trip we went north to Nambucca Heads and Coffs Harbour. By then I was driving the little red Lotus Elite — a car never seen before in those towns. (Judy and I spent our first night away together in a motel outside The Entrance. I think there might be a blue plaque if you look closely enough.) Anyway on to Nambucca Heads and Coffs Harbour. The Pacific Highway was winding and rough in those days and the Lotus was showing signs of something being wrong in the engine or the clutch. I had no idea — I only bought the car because of its stunning design. We got into Coffs on a Saturday morning and I left the car at the local garage to see what they could do. The mechanics had crowded around the vehicle when I first arrived with great interest but they assured me they could probably fix it or repair it in some way.

We went to the local pub that hot Saturday morning. A group of bananas cutters in blue singlets were at the bar downing schooners. John and I approached the bar. After a while the

barman left his banana-farmer mates and sidled down to see what we wanted. John sensibly ordered a beer.

I was a bit into my junior James Bond stage and ordered a vodka and lime. The barman looked perplexed. What mate? A vodka and lime I said. Just vodka, ice and a little slice of lime.

He looked at me and then towards his banana-farmer mates. 'This bloke wants a vodka and lime,' he said incredulously.

They all looked equally surprised. John got his schooner of beer and I was presented with a schooner of vodka with just a touch of chemical-green lime cordial. No ice.

The banana-farmers looked on as John took a fair swig of his beer. I took a fair swig of straight vodka. They returned to downing their schooners and John finished his beer. I finished my vodka schooner and we walked out into the blinding Saturday morning sunlight. I fell to the pavement. Must have been the cordial.

John managed to get me back to the motel, where I slumped beside the pool, my head spinning. Late in the afternoon I heard the unmistakable sound of the little Lotus coming up the hill.

'Great,' I slurred, 'they've fixed it.' I waited a minute or so to hear it turn in to the motel car park, but no, it just went past. Fast. It must have been almost an hour and a half before we heard it returning. Just had to take it for a little test drive, the grinning mechanic explained.

* * *

Back in Sydney we all used to go to Castle Rock Beach near Clontarf. They were the long hot summers of our youth. The Pearsons, Neil and his girlfriend, Miriam, Denis Power, Rod Phillips and his latest girlfriend and lots of old mates. We played

beach cricket and had a barbecue on an old bit of tin we hid in the rocks. We took turns sitting on a high rock looking out for sharks. As I am writing this I can look out and see it. We could not have known that one day we'd own the pink villa and studio opposite across the bay.

After a couple of years Jon Hawley decided he wanted to go overseas. John Pearson had left Geoffrey Lee and set up a photography studio with David Hewson in Sussex Street, and offered me space there to start my own business. Ngaire came, and so did my art school mate Neil McCann. We were there a couple of years.

I worked for a number of clients around the city and many a boozy Friday-night party was held. Ad man John Singleton would turn up with a couple of slabs of beer: one for himself and one to share. What a career he's had — a masterful operator with a great understanding of the Australian psyche.

Ross Renwick, who started *Billy Blue*, came sometimes, and a mate of John's once arrived in a clown suit. He'd had a little car accident on the way down William Street heading to the party and was about to take offence when the other driver accused him of being a bloody clown. He realised he was.

There were no drugs of the kind that are widely used today, only alcohol in all its forms. Lots of beer. Some unsteady driving home. I am grateful that we managed to arrive in one piece. A note here for my grandchildren. Don't worry: this will not happen to you because you won't be going out until you're twenty-five and only then with your father and doddery old grandfather as supervisors. (Who am I kidding?)

It was around this time, the early 60s, things were changing, people were going their separate ways, and I wanted to travel and

start a business offering freelance creative services with my old school mate, Bob Mitchell, who was a young art director at McCann Erickson. As a side note, the great painter Guy Warren was the art buyer there and had given me quite a bit of freelance work.

We called our business Visual Communication. We tossed a coin to decide our titles and, fairly pretentiously in a business of two people and one secretary, I became the Chairman and Bob the Managing Director. We offered creative ideas and services to a number of agencies. This was a fairly new concept in those days as most agencies kept their creative resources internally. We had a lovely little office on the top floor of a building in Rowe Street in the city. Rowe Street had a wonderful history and had been home to a number of artists and writers in the past. Only a little part of Rowe Street still exists, from Pitt Street up to the Theatre Royal, but during the 20s, 30s and 40s it was one of the most stylish and fashionable parts of the city. We shared the top floor with Jack Hudson, then a very debonaire shirtmaker who'd learned his craft in London and for many years worked with Richard Hunt in Australia. Below us was the hair salon of Lloyd Lomas, a great old mate, who's still Judy and Camilla's hairdresser. On the ground floor was the famous Galleria coffee shop, run by Mervyn Horton, who'd been the editor of *Art and Australia*. And in the basement, the super-cool menswear shop, run by the late John Lane and Tony Yeldham.

Opposite the top of Rowe Street, in the Carlton Hotel, was a small bar called the Jet Bar. A few years previously, I'd actually met Judy at the top of Rowe Street, when she was around fifteen, standing with a friend – she was in a school uniform and I stopped to talk to her briefly on my way down to the Galleria coffee shop. But our first proper meeting was in the Jet Bar a few years later.

It was named the Jet Bar because of the models of planes hanging from the ceiling and the number of clocks on the wall giving the time in other countries. In those days, we thought it immensely sophisticated to be able to glance up and remark, 'Oh, I see it's 9.30 in Tokyo!'

One Friday night, I'd had a drink at the long bar in the Australian and was thinking about going home, when I decided to cross the road and have a look into the Jet Bar. I saw an old mate with two girls, one of them Judy. She was even more beautiful than I remembered from the first time.

I asked her out that night, but as she was with a girlfriend, I offered to take them both to see *Breakfast at Tiffany's*, then playing at the old Prince Edward Theatre. The famous organist, Noreen Hennessey, rose from the theatre's floor, her handbag at her side, and after a few stirring bars from the mighty Wurlitzer, the movie began and we were enchanted by Audrey Hepburn's performance.

Jump ahead ten years and we're in Paris, on our honeymoon, and we see a film crew working halfway down the Champs Elysees. It's Audrey. Jump ahead another decade and Audrey is in my arms. We are dancing. Audrey had been involved with UNICEF years before Judy and I were, and had done a wonderful job. We had the great pleasure of spending time with her on the last trip she made to Australia. What a wonderful experience to have had.

When this book has been published, Judy and I will be well into our fiftieth year of marriage. That's really something. We've grown together and shared all the joys and heartbreaks of a lifetime relationship.

It was love at second sight. From the night at the Jet Bar we spent as much time together as we could. Judy lived at Balgowlah

and was already a great designer. She would make all her clothes and I was always eager to see what she'd created when I climbed the back stairs to her little house down near the harbour. She made everything from overcoats to bikinis. While writing this, I glance across to see her at her desk. She's probably looking at some fashion on the computer. Still beautiful. She is much more practical than me. Much calmer. We share a love of good design, of colour, of good food, of travel and friendship. But most of all a complete devotion to our children and grandchildren.

TAKING ON THE WORLD

I knew I wanted to see more of the world. Bob and I decided to travel and wanted to go to Japan. On that first trip, in 1962, the exchange rate was such that we could stay in the very smart and stylish Hotel Okura in Tokyo. Classic Japanese design, with an exquisitely manicured garden, a pool full of carp and our room had a paper screen dividing the bedroom from the living area (unfortunately we crashed through it when attempting a rather boyish imitation of the sumo wrestlers we'd been watching on TV). Wonderful Japanese food. Our first encounter with sake and my birthday at a Japanese bathhouse. There was not much of the body that wasn't tenderly washed. And although there was not a cake and candles, I went to bed happy and contented.

The next day we had lunch with some bright young Japanese designers. A lunch of many new tastes including a form of clear seaweed that spent a very brief time in my body before bubbling and churning to get out. This meant that I had to

ask if any bus had a toilet. Our return journey to the hotel was marked by numerous stops. No panic handles. No warning. No doubt my choice of the blue and white seersucker trousers was a bad move.

We took a bus to downtown Kyoto, past the big Buddha at Nara, and were thrilled to see the windswept pines that cling to the rocks and sea of Japan. Since then I've visited Japan many times to visit good friends.

On our return to Sydney, we took on an extra partner in Visual Communications, which was doing well. We had a number of clients ranging from radio stations to fashion designers. Bob was looking the part – cigars, briefcase. We also took on a young English designer, very talented but occasionally he got very pissed and a bit hard to handle (I once saw him eat money – notes not coins – in the backyard of a party at Newport. Don't ask me why.) Me, just doing the work, doing well but not so well that we could eat the profits.

We did well enough that I sold the red Lotus and bought a new Daimler saloon. My partners insisted that for the first few days I should wear a dark green chauffeur's outfit they had hired for me and that they sit in the back as I drove them around the city.

My dad helped me buy it, and it was agreed that he would have the car when Bob and I went on our next trip, this time to London.

We had talked a lot about more travel after our trip to Japan and like lots of young Australians we figured we'd probably go to England. But at the last minute Bob declined to go, and I decided to go to America first, on my way to London. Mum and Dad had friends there and Dad had travelled through the US on his way to the war. I had all those visions of America that I'd seen in *The*

Saturday Evening Post and it meant I could go via Tahiti, which had always thrilled my imagination. I was sad to leave Judy again, but I needed to see a bit more of the world.

The summer of 1964 was a blur of parties and farewells and, before I knew it, I was at the overseas terminal at Mascot. The old terminal was a two-level building and I was upstairs with lots of friends, drinks all round, and when the flight was called, I kissed Judy goodbye and started down the stairs.

Suddenly I was stopped by a reporter and a photographer for the *Sydney Morning Herald*. After a few rushed and excited words (let's face it, I was overwhelmed that the paper would be interested), the photographer asked me to pose at the top of the stairs, where he pointed a rather bulky and slightly old-fashioned-looking camera at me. I gave my best 'Young Aussie Kid off to take on the world' look and as he pressed the button I was hit in the face with a stream of water. Stunned surprise. Great set-up though, and I therefore joined the Air France flight to Tahiti dripping wet and clearly put in my place.

The flight was scheduled to go to Auckland, Tahiti, Acapulco, Mexico City, Bermuda, London. It was called the Fiesta Route, and it was filled with French servicemen.

Papeete in January was hot, humid and wet, unrelenting wet. Still, it was great to be there, in the land that had inspired Gauguin and Matisse. I had visions of dusky maidens with firm breasts clad only in richly patterned pareos, of Quinn's Bar where you could dance with those maidens and maybe find yourself in some grass hut beside a turquoise lagoon.

I went to Quinn's Bar on the waterfront at 5.30pm, perhaps too expectantly early or, more likely, twenty years too late. I met a couple of nice Canadian guys who had just arrived. They were

going to hire a car the next day and asked if I wanted to be part of that. I agreed and they arranged to come to my motel in the morning, so I returned to my miserable motel to unpack. Still pouring. I undid my suitcase and found to my surprise a package on top of my clothes. Great, I thought. Something from Mum or even Judy. I couldn't wait to unpack it and stunned to find inside a number of pieces of marble. Another great set-up from my friends.

It had happened at a house in Whale Beach that we were staying in over Christmas. A small marble table was accidentally broken (wasn't me, your honour) and the bits of marble were used as a recurring joke. Found in someone's bed. Found in someone's golf bag (I thought that thing felt heavy). And now, in Tahiti. It brought a tear to my eye and I suddenly felt very sick of the torrential rain.

Bugger this, I thought. I rang the airport and found out I could get a seat on the next plane to Acapulco. I paid my bill, left money for my share of the car hire for the Canadian boys, braved the deluge to the airport and was on my way to Acapulco by 12.50am.

Years later, while walking around Speakers' Corner in London's Hyde Park, I was approached excitedly by a couple of guys.

'Are you Ken Done?' one asked.

'Yes,' I replied.

'We're the Canadian guys you met in Tahiti. We couldn't believe you left the money!'

It was great to see them again, and it shows that it's better to always pay your way.

* * *

Acapulco was then one of the great playgrounds of the jetset – hot, dry and exciting. And that's only me! I'd been booked into a new hotel down by the beach, so new that it wasn't really finished and not really by the beach. Such are travel agents' claims. Anyway, after unpacking, I needed to use the toilet. Here I discovered the first problem. There was no air-conditioner installed in the wall, simply a large hole where the appliance was at some time to be installed. This was no problem if you simply wanted a quick leak, but more of a problem if you needed to sit a while, as the hole faced the lift. So you had to watch the lift button carefully and hopefully time the motion to happen before any passenger alighted at your floor. No one wants to be confronted with some bloke trying desperately to whip up his strides.

After a day or two I decided to move.

The Hilton was then the newest and flashest of the hotels so I headed there. At the desk they said that they had nothing available and I was about to turn away sadly when the assistant manager suddenly said, 'Well, you could take the cabana by the pool.' What an offer. Not cheap, but who cares? A great opportunity to enjoy a little bit of the glamour of Acapulco.

Off we went, the assistant manager, the porter and me. Through the heady smells of the tropical garden, across a little bridge, through the nightclub past glamorous couples dancing to a Latin beat, across another little bridge over the pool that circled the island nightclub and finally to my room. Hot and humid outside, and suddenly icy cold inside. Very Mexican decorated room. Carved wooden furniture. Mexican coloured fabrics. Big mini-bar. Very cool.

I left the bag with the porter and went out to explore the nightclub, the gardens, the beach, still lots of people, lots of

drinking, lots of music, lots of great smells of Mexican cooking. Finally about 1.30am I decided to go to my room. To my horror, I found it had been burgled. Well, not everything, but my new Remington electric razor that my parents had given me as part of my twenty-first birthday present had gone. I was so angry, I stormed over the bridge, through the nightclub (slow and romantic at that hour), across the other little bridge over the pool and through the gardens to the front desk. Only a sleepy bellhop still around, but I demanded to see the night manager. He was summoned and I poured out my anger, disappointment and downright shock that something like this could happen when I'd only just checked in.

So off we set once again. Through the tropical garden, over the first bridge, through the moonlit late, late dancers, now very intently involved, across the next bridge and into my cabana. The night manager stood by the door. The porter went into the bathroom. Touched the mirror. The mirror opened, a cupboard was revealed and there, in all its glory, sat my razor.

Embarrassed? Well, yes.

I tried to explain that in Australia cupboards came *out* from the wall. The concept of the flush mirror with the concealed cupboard inside was, well, new to me.

I guess partly from the constant embarrassment of the staff looking at me and sniggering, and partly because it really was an expensive place, I decided to look for somewhere else to stay.

I found it just next door. There, on the beach, was a kind of beach hut, with lots of hammocks and a nice old lady who, if she liked you, would let you stay a day or two. Fortunately, I'd met a couple of girls who were staying there: a Mexican doctor's daughter and a girl from Texas. Not only did they put in a

good word for me, they also asked if I would like to drive with them in the Texan girl's white Thunderbird to Mexico City via Cuernavaca. My eyes out on stilts, the car and the girls, I accepted instantly and cashed in part of my ticket.

Soon I found myself in the back of a Thunderbird, cruising up the lovely golden hills above town, on the way to the delights of Mexico City. It takes a day or so. Overnight with the girls. One night at the doctor's daughter's grand house and then just me and Miss Lone Star State for the last few hundred miles to a hotel that had been booked near the centre of the old part of Mexico City. I wish I could think of its name. Very highly decorated in an Aztec style, brightly coloured tiles, lovely room, lots of ornamental pools and real Mexican food…

The sight of people crawling on their knees in the main cathedral to be blessed by all the powers of the gods was eye-opening to a kid whose only real contribution to Sunday school was the colouring in. (Many years later, when I was asked to do a set of Christmas stamps for Australia Post, I remembered those bits of Sunday school colourings. Among the set was a classic baby Jesus in the manger illustration but if you look really, really closely you'll see I've put in our dear little dog Spot. He deserved to be there.)

Quite a strange thing happened one night at the hotel. I'd arrived back from a pyramid visit to find I'd had a phone call from a guy in Chicago. This bloke had visited my studio in Sydney, sent by a director of one of the world's top ad agencies. I was rather touched by the call and when I reached him he said he just wanted to welcome me to this side of the world, and if I could, he'd like me to visit a friend in Hollywood if I was going that way.

As it happened, I had decided to go to LA to see if I could get some freelance work and then to see where that might take me.

Little did I know. I was twenty-four and looked twelve, with a Samsonite briefcase and a seersucker suit.

My parents had friends in LA I knew I could look up. Off the plane I jumped into a taxi and asked to go to Costa Mesa. It's near Anaheim, about fifty miles away. The driver looked perplexed. Explained it would be a long trip and said we'd have to go past his place because he'd have to get something to eat.

The woman I was to see was an old Aussie friend of Mum and Dad. She married a US serviceman during the war and decided to live in the States. Nice family. They were kind to me. I had a bad cold, jetlag and the feeling that if I was going to experience all these things, Judy should be with me too.

I'd received a letter from Judy in Mexico. I wrote back, explaining all that had happened and suggested that maybe she should consider coming over to be with me so we could share all these adventures. Long-range courtship is complex. Letters are eagerly awaited. Heads are spinning. Hormones are jumping. And I kind of agreed that we would meet in London and that we would get married. No living together in those days – marriage was it. So, at different ends of the world, we began to plan it.

One of my main uses in LA was to buy booze for the daughter of the household and her friends; you have to be twenty-one in the States to buy liquor. They took me to a few parties. The boys confessed they were beaver hunting. Took me a while to get it, but as I was now kind of engaged I didn't get it, if you know what I mean. Now, at the ripe old age of seventy-four, there's been beaver, fox, wolf and grizzly, but that's not for my grandchildren's ears.

The guy from McCann's in Chicago had wanted me to make contact with his friend Bobby in West Hollywood. I was staying in a rather crummy motel near Hollywood and Vine. I'd visited a few of the famous places on the strip – very keen to see a place I'd read about in *Playboy* where all the waitresses were topless. Alas, a bit like Quinn's Bar in Tahiti, at 9.30am everything was well and truly covered up, including the front door, and when I found out that it didn't even open until 11pm, I gave it a miss. Well past bedtime, even then.

I called Bobby. He invited me over to his apartment, said we would be going to a club for dinner and we'll just have a drink before we go and what would I like? 'Well, I'd like a vodka and lime,' I said, confidently. 'No problem,' he replied, 'but I'll just have to send out for some vodka. Won't be long; just make yourself comfortable.' Mate, I was impressed. Sending out for a bottle of vodka. That's cool.

We chatted. He said we were going to take the girl who lived in the apartment opposite. She was an actress. I was really impressed. He said that the guy from Chicago (let's call him Woody) loved my work and hoped I would come and work for him.

I was flattered.

'By the way,' he said, 'did you get a chance to sleep with Woody when he was in Sydney?'

I was momentarily stunned: I'd not been asked a question like that before. All I could think to mumble was something like, 'I really love the wallpaper in this room.'

The vodka arrived, as did the actress, and soon I found myself at the aptly named 'Daisy Club'. I actually think it's still there. I took the opportunity to dance with the actress, the waitress and the coat-check girl – anything to show my interest in girls.

In those days, I was a pretty good dancer, even if I say so myself, but all I could feel were the hot, lustful eyes of my host at the table. We finally left about 2.30. He was very insistent and begged me to go to his place. I had no alternative but to use the 'I have a bad headache' excuse.

About 3am, I'm back at the motel. Phone home. Don't know what I expected Judy to do, I just had to share the experience. By 4am I'd checked out of the motel, caught a taxi to the bus station, bought a ninety-nine-day bus pass for $99 to travel across the US and was headed for Elko, Nevada. Elko is not the most glamorous of towns. There's a big stuffed Kodiak bear in a glass case at the bus station and a seedy collection of casinos along the main street. I got off the bus. I went to a casino. I lost. I booked a room in a hotel. I went to sleep. Alone.

That trip across America in the bus taught me a couple of things. How beautiful that country is, and how insular the middle parts can be. The bus station is mostly in the poorer and rougher parts of town, and a few times I was a bit scared of some of the situations that developed there. Not many people were going coast to coast. Sometimes students to the next town for their vacation. Sometimes farmers. Sometimes lonely characters looking for work. The bus at night across Montana and Wyoming. Stops for cherry pies and Cokes and early morning frosts, and we rolled from desert to mountains to plains. Late at night, sitting next to a Japanese boy, I explained that if Indians attacked the bus, we make a circle with all the cars on the freeway. I think for a moment he believed me.

Finally to Chicago. Very early morning. Very cold. I ducked down in my seat just in case I was spotted. Then on to Detroit. My dad represented a number of machine tool companies.

One of these was LaSalle Machine Tool Company. The company was headed by Bob Satler. The Satlers lived in a very modern home beside the lake at Grosse Pointe, then the most fashionable part of the city. He took me to lunch at his club – very exclusive, very stylish, very discreet – and bugger me, somebody stole my overcoat! I'm sure it was a mistake; someone simply took the wrong coat from the cloakroom, innocently. Bob was most distressed and insisted I go the next day to a big store in the city and pick out whatever coat I wanted. So I left Detroit with a stylish black raincoat lined with a kind of fake fur that kept me warm and dry for many years.

MADMEN DAYS

It was thrilling to see the New York skyline emerge while going across the Brooklyn Bridge.

The bus depot is downtown, again, not the most glamorous part of the city, disgorging people from all of the states to the excitement and expectations of the great metropolis of Manhattan. I was booked into a west-side hotel. Stayed for a few days. I went to The Met. MOMA. The thrill of seeing paintings you'd only seen in bad reproductions.

During the war my dad and his mates had travelled across America on their way to the UK. They were billeted with a number of families who became lifetime friends. A family in Princeton and a wonderful woman in New York, who showed me around and took me to the family home in the Hamptons. We had a picnic beside the Atlantic. First time I'd seen it, obviously. A kind of green grey. Windy. Choppy sea. She bought chicken stuffed with ham – first time for that treat also.

I had another contact in New York, Jules Divette, who I'd known in Sydney. He had just married and was a copywriter at J. Walter Thompson. It was great to see him again and he quickly suggested that as they had a spare room, maybe I could rent it out and move out of my expensive hotel. I was delighted. Somewhere around 88th Street, as I remember.

I had one other contact. A man who ran a design studio a bit like the one we had in Sydney but bigger and grander. I arrived eagerly for our appointment around 11am and he was very complimentary about my work. As it turned out, he was going to a lunch that day at the Plaza Hotel with the heads of the major design studios in New York and asked if I would like to join him. By 12.30 I found myself at pre-lunch drinks with some design heroes I'd never imagined meeting – Milton Glaser and people from the Push Pin Studios.

We sat for lunch. Maybe thirty people. I'd taken some of my work in my inside pocket so that when someone asked me to pass the salt or something, my drawings would fall on the table and I could grab the opportunity to explain what I did.

The upshot of the lunch was that the bloke who sat on my left offered me a job starting the next day. I was thrilled. The studio had offices next to the Rockefeller Center, just beside the ice rink. I was there at the crack of dawn, ready to go. What seemed to impress them most was the variety of things I could do. In Australia, we had the opportunity to do a number of things – posters, annual reports, advertisements, illustrations, lettering, small line drawings. In America, there great specialisation, so for a car illustration, say, somebody might do the body, someone else the chrome and yet someone else the tyres.

It was fun to work there but I knew I couldn't stay long, because I didn't have a green card.

Jules, the friend I was staying with, suggested I should visit him at JWT and bring my folio with me and he'd see to it that I could meet with one of the top art directors.

They offered me a job and an office on the eighth floor where all the top creative people worked. They said they wanted to have me work on the Ford account and that they would see what they could do to get me a green card.

This is 1964 – *Mad Men* for real. Girls with bras so pointed they could take your eye out and, in each office, a bar and furniture chosen to complement the image of the individual art director. For example, the bloke next to me had a special woodblock floor, models of yachts, a ship's wheel and wonderful bits of sailing ephemera. Further down the corridor, you could find a whole western cowboy theme. Ah, advertising in the 60s. Glorious wankers.

They couldn't get me a green card. They asked if I would go to JWT in London. I thanked them, but I didn't want to commit to London before I'd had the chance to see some other agencies. In those days in New York it was great fun to arrive at Grand Central Station and go up to the Graybar Building where JWT resides, and settle down to my grand office. Black leather lounge. Big desk. No bar.

Because, as I've said, I'm mechanically a dope, it was surprising to be working on the Ford account. I loved New York and it was sad to leave the jazz of the Village and the glorious countryside upstate, where we would go for the occasional trip. I remember one cold and frosty morning when driving slowly across a bridge beside a lake, I saw a man hunting fish with a bow and arrow

from a little row boat. Quiet. Soft grey water. Dark emerald and lime-green trees. I know it was a scene the brilliant Milton Avery, a wonderful and sensitive painter, would have loved. Rothko said of his friend that Avery was the link between Matisse and all the American Colorists.

2015

I just looked out the window. A really pretty little sailing boat gliding past. Black hull, brown sail. Slightly old-fashioned rigging. Kind of Dutch looking. How lucky we are to live here. It's disappeared now behind a frangipani tree. It's in my head; maybe it will be in a painting one day.

AD-World

Goodbye New York. Hello London. In those days, most Australians headed first for England – home, as my mum and dad really would have thought. I first stayed with my old friend, Dinah Dryhurst, a wonderful illustrator who I'd worked with at the Jon Hawley Studio in Edgecliff and of course we had been at East Sydney Tech together too, although she was a year ahead of me.

JWT New York had organised an interviews at JWT London in Berkeley Square, but I decided I'd look around and got some freelance work for a little studio near St Paul's, thanks to Dinah. I had an interview with David Ogilvy; Ogilvy and Mather were next door to the Savoy and they made an offer. Very tempting. So I had another meeting with JWT, who made a counter-offer of a bit more and I willingly accepted.

And I'm so glad I did. In those days, JWT was the biggest and best ad agency in London. And I met people who were to have a huge impact on my advertising career. First, the creative director, Jeremy Bullmore, a brilliant man who all in the creative department just loved. He wanted to continue to make ads rather

than simply inspire, edit and direct other people, and to my great delight, decided he wanted to work with a young writer and a young art director as his group. The young writer was a rather pale, skinny-looking bloke with slightly poppy eyes called Llewelyn, and the young art director was me. It was only after I'd been there a few weeks that I discovered that Lew was actually Dylan Thomas's son and, like his dad, liked a drink or five. Often we would slip over to the Coach and Horses in Hill Street to kickstart the creative juices at about 11, Lew with a bracing G&T and me with a lager and lime. Wimp.

We were a good team. We worked on a cigarette account for the British Tobacco Company, Bacardi Rum, Campari, Gillette, Silhouette (a bra and girdle company) and Bushmills Irish Whiskey.

Those years in London were great. I rented a surprisingly large flat in Old Church Street between the Kings Road and the river, quite close to the very fashionable Cheyne Walk. I decorated the flat with lots of coloured paper flowers and design bits and pieces and eagerly awaited the arrival of my bride-to-be.

* * *

Judy, her bridesmaid Janet and my mother had all travelled via the Panama Canal in a small three-berth cabin for six weeks to come to London. Now, six weeks in a cabin with my mum would be quite an ordeal for anyone, let alone as your future mother-in-law, who let's face it, wasn't completely convinced that the adored only son should be married anyway. I still see that as an amazing commitment by Judy and the fact that we have survived fifty or so years together is testament that it was worth it.

We were married in September 1965, in a lovely little Norman church in the quaint village of Cranford, near Kettering. My grandmother had lived there in a little street of thatched houses and my dad spent time there when he could get leave during the war. As well as Mum and Dad in attendance (he'd flown over closer to the day), there were a few Aussie mates including my old school friend and business partner in Sydney, Bob Mitchell, who was the best man.

We drove up from Chelsea in the morning. Judy had spent the night with my relatives in Burton Latimer. We had asked a photographer friend to take some pictures. Lots of second and third cousins we'd only just met. I realise now how selfish the whole thing was, especially not to have Judy's mum and dad and her family there. But we were young and couldn't see much other than each other. And besides, there was no living-together hanky-panky in 1965.

The wedding photographer, Billy, was short. Very short and very clumsy. He often knocked things over accidentally. I once saw him reach up to put a glass of red wine on a shelf in a pub while trying to chat up some girl. Anyone of normal height could see that the shelf wasn't flat, but on more of a 45-degree angle, and almost in slow motion I saw the reach up, the tip over and the saturation of the white top the girl was wearing. Billy seized the opportunity to explain that not only was he very sorry, but he knew precisely how to remove the stain and if the girl would come home to his place, he'd show her. I hope it worked, Billy.

We'd had to meet with the vicar who was to marry us a few weeks before. You had to post the banns. Nice old bloke who'd been a prison chaplain over the last years. He and I and Bob waited expectantly at the altar of the little stone church. Judy

arrived on the arm of my father. There are tears in my eyes as I'm writing this and remembering and there were tears in my eyes on the day. She joined me at the altar. The congregation sat. There was a silence before the vicar started to speak, broken only by the not entirely unexpected sound of Billy Angove, his camera and the tripod tripping over the pews in the back row.

After the service, the bells were rung and we walked arm in arm as a married couple over a little bridge, over a little stream, through a field of daisies and little lambs to a little bar in the Woolpack pub for a little sherry. Then on to the local Reading Room for sandwiches, cakes and jellies. I'm sure there must have been speeches. All nice I'm sure. I've got to admit to not remembering too much about it. Mum wore an emerald green hat. Dad beamed. All the new relatives seemed to have a good time and after only an hour or so, Judy and I set off for Heathrow to board the last flight to Paris. Sitting at the airport, confetti in our hair, looking like two twelve-year-olds escaping from a home.

We arrived in Paris well after midnight and took a taxi to the Hotel St Germain des Pres, on Rue Bonaparte in the heart of the left bank. A sleepy night porter took us up a little winding staircase to our room. Both exhausted. Heads spinning. Deep sleep. I woke first, and after briefly gazing at my new bride, I went to the window and threw open the curtains. I expected to see a view over the old church of St Germain and the little park that surrounds it. Instead, to my and his surprise, I was confronted with a bleary-eyed Frenchman cleaning his teeth.

'Bonjour,' he mumbled.

Our room faced an airshaft – common in old French buildings, they should be avoided on trips to that lovely city. Nothing to do other than get back to my beautiful bride.

We had arranged to travel through Switzerland, Germany and France with Mum and Dad to visit some of his clients. Seemed like a great idea at the time. And we did have a great time. We stayed in Zurich, then down the Neckar River to Heidelberg. Then through the mountains on the way back down to the south of France and then back through Paris to London.

Swinging London

Unlike my first business, Visual Communications, where there was just Bob and me and then Billy too; at JWT I was in an environment where there were copywriters, planners, typographers, art buyers, media buyers, researchers, etc. Around six hundred people worked there and it had its fair share of titled blokes and debs. Most days started at a civilised 10am or thereabout. I'd take the number 19 bus, up Sloane Street to Green Park and a brisk walk through Berkeley Square. Past the Colony Club, haunt of George Raft and Francis Bacon, and up past the super fashionable and very exclusive Annabel's, where a few couples in evening dress would be waiting, bleary eyed, for a Bentley or Rolls to take them home. In fact, you only had to cross the park to Jack Barclay to buy a new Rolls Royce, as I once saw one of The Stones do.

My office was on the third floor, overlooking the park. An old plane tree signalled the seasons by the colour – or lack – of leaves. In summer, when the temperature could reach a staggering 75 degrees F, you could look down on a sea of people, trousers rolled

up, knotted handkerchiefs on the head or just gasping in the heat. But to be fair, London can be very hot and stifling, on some very rare occasions.

A few months after I joined, I was given the task of designing a campaign for Bacardi. Up to that point, Bacardi used small black-and-white ads, with the bottle surrounded by cartoon characters. The fourth Bond movie, *Thunderball*, had just come out and had been shot in Nassau. It was sexy and stylish, just what Bacardi should be about, and I wanted to go there.

I designed a concept of the Bacardi bottle being stuck in the top of a coral head with a bottle of Coke beside it. Around the bottle were lots of bright coloured fish and two figures were diving down underwater to retrieve them. The client liked the idea. The brand manager asked if I could do it. I assured him I could and then privately faced the problem. I'd never scuba-dived in my life and I'd never been involved in underwater photography. But he didn't need to know that. It was suggested that if I went to the Caribbean I could find some girl to be the model. I countered by saying it would be so much better if I took Judy as the model, and they didn't need to pay either of us to do it.

A few months later, in the middle of a freezing London winter, Judy and I passed our bronze diving certificate in the indoor pool of the White House Hotel and not long after that found ourselves on the way to Nassau. The photographer I'd chosen was the bright and talented David Lowe (sadly now deceased). He was accompanied by a pale Scottish assistant, Roy Baxendale and we had Tom Rayfield from the agency to represent the agency and the client.

We booked a Mustang convertible at the airport and set off to find a boat and a guide to help us get to the right location. We hired a yacht and a very tough-looking skipper and, armed with a

supply of Bacardi and Coke bottles, set sail to find the appropriate coral head. The deal was that we were to process a few frames of the film each night so we could see what we had, and at the end of the shoot, Judy and I were to call in to Bermuda to see one of the heads of the Bacardi family at their seafront villa, predictably called Bacardi on the Rocks.

After a few days' work I was unhappy with what we'd achieved. Either the water wasn't clear enough or the coral head too deep or the position of the figures not quite right. I certainly didn't feel confident enough for the impending Bermuda meeting. Then a storm came. Seas choppy and dirty. Impossible to shoot. Budget getting low. There was no alternative but to wait it out. I went to the little casino one night with Judy. Miraculously we won $1000. Fell into bed happy and relieved, woke up an hour or so later to hear the door slamming, footsteps receding and the $1000 gone from the table we'd left it on.

The storm finally abated; we had one day left. The skipper suggested the only place we could try where the coral was close to the surface was near the end of a jetty, beside a refinery. Only problem was it was where they dumped the garbage each day and there could be a few sharks. Trying to tuck the natural Australian fear of sharks in the back of our minds, we decided to go for it. Find the coral head. Get the scuba gear on, get the photographer in place with the specially built underwater housing for his camera. Dive down. Tuck in the bottle. Shove a tin of sardines behind the bottle. Stab it with a knife so the rising oil will attract the little fish and begin a number of sequences to get everything right. Today of course you'd do the whole bloody thing on a computer and it wouldn't actually matter if you were in a garage in Chatswood or a hotel room in Glasgow.

We did one hour underwater. Still not happy, I asked that we put on new tanks and continue to dive. Suddenly I noticed, to my surprise, halfway through the second dive, that Roy the assistant had ripped off his mask and was looking at me stupidly, forgetting to breathe. I shoved him up to the surface where he regained his senses and swam for the boat. Not long after David the photographer showed signs of distress and we had no other choice but to conclude the job.

There was just enough time to rush to the motel, grab our gear and the test shots and jump on the plane for Bermuda. The crew went on to London and Judy and I were booked into the grand pink Princess Hotel. We arrived about midnight and I could see that Judy was very distressed and having trouble breathing. Knucklehead (me) was convinced it must be because her bra was too tight. So in a fit of worried anger, I tried to rip it apart (she had taken it off) and said she should never wear that stupid bra again. Of course, it had nothing to do with underwear and everything to do with under*water*. We had simply been under for too long and learned the hard way to rest well before dives. We called a doctor. He arrived from a party about 2am wearing Bermuda shorts (formal black ones). I don't know why that was funny but I started to laugh when I should have been worried about my newish young bride. It didn't take long for him to explain the risks of diving and promise Judy would recover so, after a deep sleep, we arrived at 'Bacardi on the Rocks' mid the next morning for a light morning rum, a delicious breakfast and the family's acceptance of the snaps.

Not only did that campaign run and win prizes for the ultimate ad, but over the next five years, we were able to shoot an annual Bacardi campaign. Lots of exotic places in the world –

Antigua, Acapulco and even Australia, on Dunk Island on the Barrier Reef.

The father-in-law of an old mate, Denis Power, owned Dunk in those days. It was idyllic. We chose to work on Bedarra, a small islet close by, inhabited by a real castaway called Jimmy Singer who lived in a wonderful rickety old shelter, under the palms, close by a stunning little inlet. We had arrived with a case of Bacardi for the shoot. Classic 60s idea. Sexy girl stretched out on the beach, with a collection of Bacardi mixes in front of her. Bacardi and Coke, Bacardi and Tonic, Bacardi and Lime, etc. Always complex in the heat and the sand, hard to get the light, the ice and the model all in the right places. No complaints though (someone's got to do it).

We shot in the early morning light and in the afternoon returned to the main beach on Dunk to shoot in the sunset. We left the case of Bacardi under the palms while we had a quick lunch. When we returned to work we found the case of booze had been stolen – but we were not as disappointed as the thief would be when he discovered that the bottles had been filled with seawater on our arrival from the mainland to save weight and not waste the rum!

At the same time (as JWT were kind enough to send us around the world, if I agreed to come back for a further two years) we planned to shoot some fashion in the outback at Uluru – I'd told them it wasn't really that far from Sydney – and we could do another Bacardi shoot in Acapulco on the way to London.

To do a fashion shoot properly, you need a model, photographer, photographer's assistant, makeup artist, stylist and maybe someone to be a runner and look after food and drinks, especially in the searing heat of the outback. There was no such team: just Judy and me, and a simple little 35mm camera. In those

days, you landed on a rough airstrip, quite close to the rock. We woke very early. In the dark outside, huge flocks of rainbow coloured parrots swooped and dived in the pre-dawn light as Judy struggled into the underwear she was to be photographed in, and I struggled with the tripod, the camera, the reflector and the bits and pieces I'd need.

The shoot in Uluru was hard. Judy posing. Me shooting fifty yards away on the long lens. I was running across the sand dunes to adjust her hair or her pose etc; shouting at each other; trying to look relaxed and glamorous (that's just Judy); and me in a lather of sweat, loading and reloading 35mm film and constantly having to secure the tripod in the desert wind.

In the end we got the shot and flew to Sydney, where I attempted another shoot for Sunsilk. We used the top model in Sydney at that time and photographed it in the gardens of my parents' house in Mosman. Beautiful colour, top model, but the light was too strong and when the film was processed back in London the shiny hair mostly reflected the Aussie sky and needed to be heavily retouched to match the hair colourant it was supposed to illustrate.

* * *

On the way home to London from Australia I had organised to do another Bacardi Rum shoot. We needed a couple of days in Acapulco. We were met at the airport. A rather pushy young paparazzi stood at the bottom of the stairs to shoot Judy as she got off the plane. I was at the bottom of the steps first and quickly could see what this guy really wanted was a shot up her legs to catch a glimpse of her knickers. Nice try, mate, but the

accidental-on-purpose swing of my Samsonite briefcase to his knees ended that.

We had arranged to meet the English photographer David Lowe, with whom we had done the first Bacardi job in Nassau. He was there with his girlfriend and they spent a bit of time at the then very chic and super cool Villa Vera Racquet Club in the hills above town. They took us there for lunch. Lots of glamorous types around the pool and an amazing topless dame floating in and out of the turquoise water. The 'in' bit was her; the 'out' bits were her spectacular breasts, which stuck triumphantly to the sky. Must have been one of the very early boob jobs and she was clearly very proud of them. All the blokes around the pool noticed, some discreetly from behind their daiquiris, some glancing from behind their *Variety* or *Financial Times*, and some, like David and me, who were open mouthed and staring.

I dragged my eyes away. Copped a smack on the head from Judy and lay back, luxuriating on a poolside lounge and feeling rather pleased with how things were going. David disappeared. We dozed in the Mexican heat. We ordered lunch. Still no sign of David. An afternoon coffee and a couple more daiquiris. Where's David? Well, here he comes, but why are those two burly guys flanking him? They were chucking us all out, as we soon discovered. David had chatted up the pneumatically enhanced swimmer and he had enticed her to pose topless in the garden of the club. Turned out not to be such a good idea, as unbeknownst to us, a recent article had appeared in *Life* magazine, intimating goings on of topless ladies, naughty boys, maybe drugs and 'hide the taco' parties etc, and this just seemed like another attempted expose.

They deposited us outside, destroyed David's film but fortunately not the camera, and told us in no uncertain terms that we would not be welcome again. David's girlfriend was less than amused. We've never been back. We'll never see those shots, and David sadly as I mentioned is dead so we'll never hear what he and Miss Supertits might have been up to either.

* * *

The Uluru shoot had been for an account we had pitched for a year or so before. The company and the brand were called Silhouette. Based in the UK, they made swimwear and a range of underwear including a famous girdle called the 'Little X'. That was the symbol of the company and I was asked to be part of the team that would create the pitch for a potential new account.

Our success with Bacardi gave me a bit of extra clout, so when I suggested we do a number of shots of their symbol (that is, the girl in the girdle with arms raised and legs apart) in big outdoor posters and full-page ads, they listened. The agency allocated £500 to cover the cost of the pitch. They suggested we might go to the beaches and cliffs of southern England. I suggested we go to Turkey. They were shocked, but I knew that if I could convince a photographer to do it on spec, that I could use Judy as the model and if we travelled as cheaply as possible we could get to Istanbul and then south and inland, we could shoot in the ancient amphitheatre at Ephesus then travel inland to a place called Pamukkale. I'd seen a small black-and-white picture in *Vogue* of an amazing set of limestone pools hanging on the edge of some remote cliffs there. Even in black-and-white it looked amazing. There had been baths there since Roman times, and I

figured that if we could get there it would be the most spectacular location for some fashion shoots.

The photographer was Jimmy Wormser, a wise-cracking New York ex-butcher who I'd done a couple of fashion jobs with in London. We became great friends. He was up for the challenge so we three set off early one summer morning for Istanbul. Lower economy, if there is such an airline class. The airport at Istanbul in those days was little more than an old crumbling concrete shed. Very humid, very noisy, very chaotic. When we finally made it to the domestic terminal (just as hot, humid and chaotic) I confidently approached a swarthy bloke behind the counter and asked to buy tickets to fly south to Izmir, where I was going to hire a car for the rest of our journey.

From the minute Mr Counterman began to slowly shake his head, I felt we might be in trouble. He announced with a confident finality that we could not fly to Izmir. In fact, he stated no planes go to Izmir and no matter what, we could not (twist of the moustache, shake of the head), no way, no way, no way. I was shattered. The prospect of not being able to get to the location was a real blow and I couldn't believe our predicament.

I started to get really annoyed with this guy. 'Look,' I said, 'on the map it shows an airport at Izmir. Do you mean the airport is closed or is there a bad storm or what? Why the bloody hell can't we fly to Izmir?'

'Sir,' he replied, stone-faced by this time, 'no planes go to Izmir. You cannot go there. End of story.'

I stood steaming that our trip should end like this and that the plans I had for the stunning (I hoped) photography were dissolving before my eyes. I turned away to give the bad news to

Judy and Jimmy and begin to try and work out what the hell we do next. We picked up our gear and headed out of the crush of the terminal into the hot morning sun.

Suddenly, I heard a call behind me. 'Sir, sir, come back!' It was Mr Counterman. 'Sir, sir, there *is* a way.'

'What?' I said. 'A way to fly to Izmir?'

'No sir,' he excitedly exclaimed, 'but there *is* a way, sir.' A pause as he drew himself up to his full height and proudly announced, 'My brother will drive you!'

Wow, amazing, saved. I couldn't believe it. And before you knew it he'd escorted us away from the terminal and had us stand with all our gear in the blinding light. He looked towards the line of old taxis waiting for passengers and simply whistled loudly to the first cab on the rank. It was an old Dodge, green with black-and-white checks down the side, driven by another bearded, moustachioed, swarthy Turk.

At this point, I can only guess the exchange went something like this.

Counterman: Listen, I've got a real pigeon here and I've convinced him that he can't fly to Izmir and I've told him you are my brother and that you'll drive him and his crew.

Taxi Driver, Mohammed (as we were to learn): Are you stupid? It would take bloody days and I'm buggered and just about to knock off.

Counterman: Look, I reckon we could make a deal where if you offer to go there and do the whole trip, we could really make a killing. I'll split it with you.

Mohammed: I don't know, I'd have to go home and tell the missus and do you really reckon they'll fall for it, especially when I have to go past the airport in Izmir?

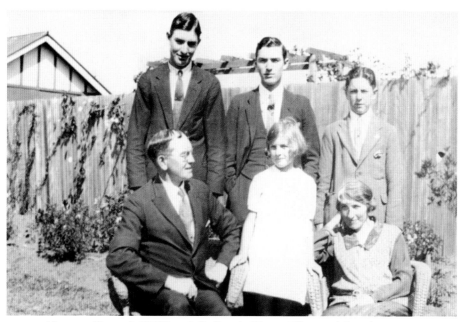

Norman, Howard, Cliff (my dad), Grandad Done, Eileen and Grandma Done
when they first arrived in Australia.

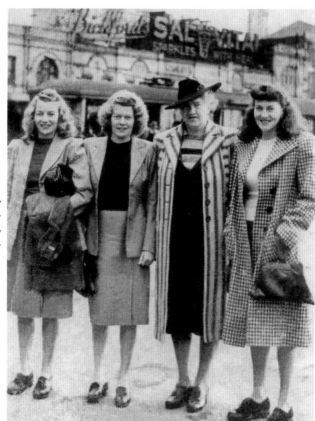

My aunts Nancy and Joan,
Grandma Bailey and Mum.
Down by Circular Quay,
during the war.

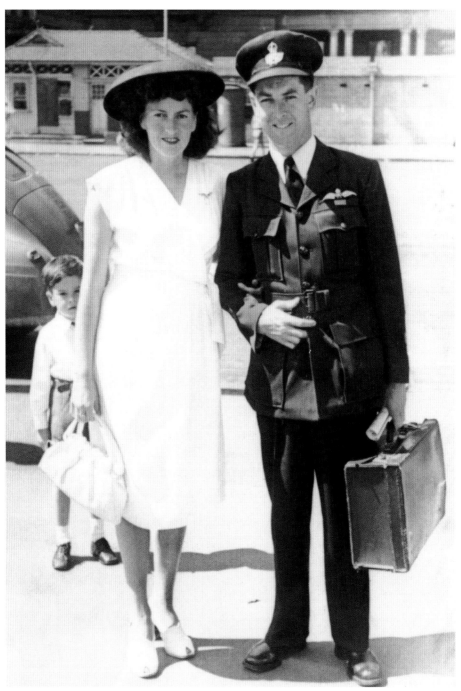

Mum and Dad at the end of the war. Shy me behind: I never wanted to have my photo taken. How times change.

Grandad – Arthur George 'Bill' Bailey.

Nellie, my beloved Grandma Bailey.

Me. Just looking around.

Camping in the backyard in Belmore, around 1943.

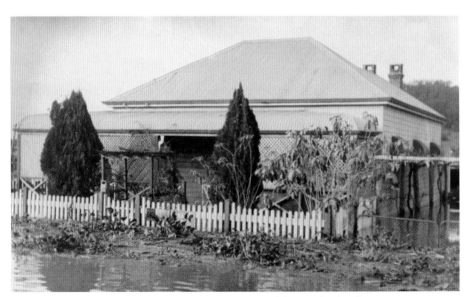

Our home in Maclean during one of the regular floods.
The grapevine down the right side was outside my bedroom window.

Early works. *Sunrise* and *Sunset*, and I guess your life is
somewhere in between. Around 1947.

At Yamba, circa 1946.

First long pants,
Cremorne
backyard, 1953.

Art student days. A celebratory lunch – me and my stuffed rooster,
a few beers and a couple of cokes. How sophisticated.

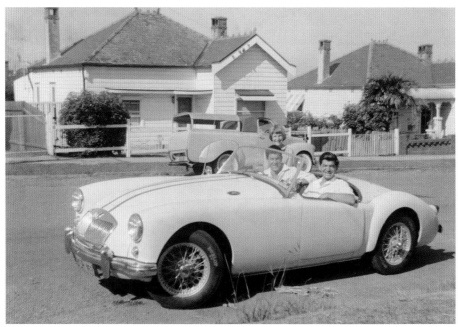

My first car. The beautiful MGA, white with blue stripes!

Our first date. Mother's Kitchen in Kings Cross. Look closely – lobster and white wine.
Judy wore a chocolate brown knitted dress and I wore an expression of expectation.

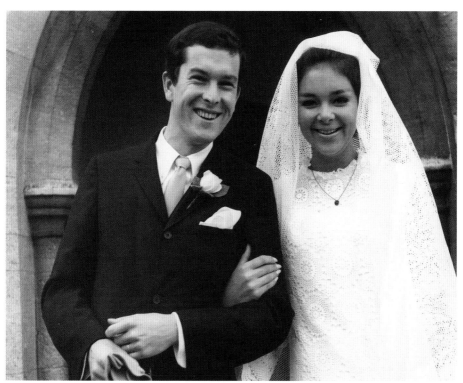

Wedding Day at Cranford, Northamptonshire, September 25, 1965.

Art Director and Ad Man, Berkeley Square, London 1967.

Me and Judy, underwater in Nassau for Bacardi Rum. *David Lowe*

Judy for Silhouette bras and girdles on the edge of the pools at Pamukkale in Turkey.
Jimmy Wormser

In Rome, dinner with Claudia Cardinale.

Helmet shell, 1979, pencil on paper, 18 x 28cm.
This was one of the first limited edition prints.

'The Sydney Shirt' by Ken Done

This seasons most exclusive T shirt.
Hand printed in 'Sydney Harbour Blue' on white $15⁰⁰ *
Available in all sizes but only from
The Art Directors Gallery
4 Ridge Street North Sydney.
9223621. Monday to Friday. 9 to 5.
* add $1⁵⁰ for postage anywhere in Australia.

First ad in *Billy Blue*.

First t-shirt design, white on blue.

Inside the Cabin studio, the building and the view, still a constant source of inspiration.

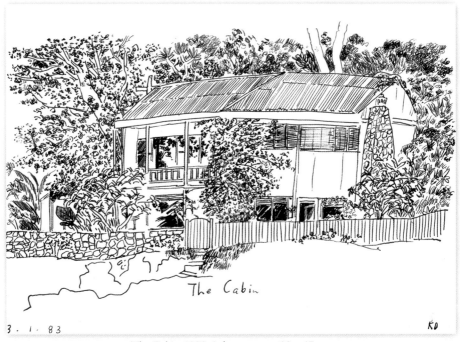

The Cabin

3 . 1 . 83 KD

The Cabin, 1983, ink on paper, 29 x 17cm.

Art to wear. *Anna Bertalli*

One of our bedlinen designs. These products had an amazing impact at the time, and people still ask us for them.

Counterman: No worries, mate (or the Turkish equivalent), the kid's young, he'll go with it. Make it look like we were agreeing on a price and don't forget you're supposed to be my brother.

All this was well over our heads; it just seemed like a couple of brothers doing all they could to help and I was happy to agree on the price. Even I knew I probably should have tried to bargain it down but I was desperate and relieved. So smiles and handshakes all round, off we went to Mohammed's house. Tea in his backyard. A chat with his wife and one extra pair of underpants for him and off we set across the old Galata Bridge and on to the ferry. South through the mountains to Bursa and onwards to the amazing countryside of the Asian side of Turkey.

Mohammed's English was very limited. So, it also turned out, was his driving ability outside of the city. But he turned out to be a nice bloke and he *loved* to eat. For our first big meal, he ordered the most delicious and mouth-watering collection of Turkish delicacies – and announced it was just for *him alone*! For us, he ordered three chip omelettes. We were in shock. He haltingly explained we wouldn't really like what he was eating and that he knew that English people liked chip omelettes. We emphatically and swiftly put him right and from then on enjoyed some wonderful Turkish delights.

We travelled through the night after a stay in the mountain town of Bursa and onwards towards Balikesir. I sat in the front. Eyes glued to the road. Jimmy and Judy dozing in the back. Mohammed concentrating on the winding road. There were no streetlights and it was very dark. Around 3am we wound down through the pines to a huge double-lane highway leading into a military area. Almost blinding lights illuminated the roads around the military base and slap bang in the middle of the road was a

roundabout dominated by a large statue of Ataturk. I wondered briefly which way Mohammed would travel around this statue, when to my horror, realised that unless we changed direction very soon, we would go slap bang into it. I don't know if it was the bright lights or Mohammed had just nodded off, but we did indeed smash straight into it. After the slap, bang and steam from the old Dodge, I was very relieved to find no one was seriously hurt. Not much damage to the statue either.

We couldn't be repaired at the military base so we limped on to the next small town, where Mohammed found a little hotel and asked when a garage opened that could repair the Dodge.

We were exhausted by this time and after surrendering our passports at the shabby front desk we went upstairs to an equally shabby bedroom to try and get a little sleep on an equally shabby bed. What felt like minutes after our heads hit the pillow, there was a frantic knocking on the door: Mohammed announced it would be unwise for us to stay in the little town and for our safety we should get out. Grabbing the passports from the front desk and our gear, we were out of there and bumping onwards through the dawn to the next town. We never satisfactorily found out why we had to leave so quickly – maybe Mohammed was not receiving any kickbacks or maybe it simply was not the place for women to stay. As the dawn finally broke, we saw a little roadside stall and stopped to take breakfast. Slightly sour feta cheese, a boiled egg, flat bread, black cherry jam, coffee. Apart from the fact that the boiled egg was boiled for only about ten seconds and had to be sent back a few times, we to this day enjoy that kind of breakfast.

Then, with the car finally patched up, by mid-morning we were coasting through the city of Izmir. Past the large

international airport, full of planes and travellers. I could only direct my eyes away and put the whole episode down to the rich fabric of experience.

We shot at Ephesus: the wonderfully preserved amphitheatre, warm yellow ancient stones and the little X figure in the Little X girdle! Wonder what the ancient Romans would have thought. The ruins at Ephesus are wonderfully preserved, as are the old streets, the library, the temple, the amphitheatre itself. There were no tourists around in those days. What a treat to be there.

The next day we arrived at Pamukkale. A stunning location. Limestone cliffs like wedding cake cascading down the mountainside, filled with shallow water reflecting the evening sky. In those days, there was only one motel. Now I hear there is a whole town of hotels, motels and boarding houses, but not then.

We set the alarm for 4am to be able to shoot the next morning in the early light. It was pitch black when we staggered out of bed and set out into the darkness. We passed rows of deep dark oleander bushes as the first rays of the soft morning sun touched the hills above us. Suddenly something moved in the bushes, and we were stopped by a small boy signalling us to be quiet. There was still not much light but I could see he was roughly clothed and looked pretty poor. From beneath his ragged coat he pulled out a little bundle, and in halting English explained what he had to show us. He said that after heavy rain, sometimes coins could be found. Old Roman coins. Very valuable coins. But we mustn't tell anyone that he had one, and more than that he was prepared to sell it to me for around twenty pounds. Wow, I couldn't believe our luck! Did I mention it was dark? He quickly showed me the coin, I agreed on the price and off he scuttled into the bushes. By now the sun had risen a bit higher and I could begin to see the markings on

the coin. Even I could see it must have been from the time of the Emperor Kellogg and could be traced back to about last Thursday. Yes, there is one born every minute, and that minute was mine. You wouldn't even try to put it in the parking meter!

The early morning soft light touched the water of the limestone pools, with the hills behind still in pale mauve shadow. It was time to pose the model and start work. A little older and a little wiser.

I positioned Judy at the edge of the pools. She was wearing the girdle and white leggings that we would colour in postproduction, leaving the pure white girdle, which looked like modest but very tight knickers, covering her from her waist down to the tops of her thighs. She was topless, but wearing a long dark wig that modestly covered her boobs. Jimmy started to shoot. I directed various poses, everything was finally going to plan.

Plop, plop: what the hell was that? Angry shouting came from behind me as I turned to find a motley collection of bearded men in traditional outfits throwing their arms into the sky and throwing stones at Judy.

I threw stones back…not a wise move. Clearly we had offended some of the older locals, but they didn't realise who they were dealing with – a bloke who had been ripped off at the airport, almost killed by running into a statue and earlier that morning had been deceived by a teenage coin forger. No: we were working; we were not showing any private parts; and we needed those shots.

After a bit of a stand-off, they left. Scowls and threats. Angry dark faces. Bugger off. I must have been braver then or just naïve, or filled with the blind confidence of the young Australian male, who figured that he could overcome most obstacles. That part of

Turkey is very pretty. We shot a few more sequences in Pamukkale then several outside some brilliant blue-painted houses that had bright green tobacco vines drying against the walls. Then some shots with Judy in an old rowing boat, which we'd found in some reeds beside the mirror surface of a little lake.

Back in London, we printed the shots and I designed the posters and the ads. We made the presentation to the client – and we got the account.

2015

I can't wait to start writing again. It seems my brain is just wanting to churn it all out. Maybe it knows something that I don't. I think I'm going to be here forever but maybe my brain knows differently. I'm writing this on the back of a bit of paper, covered with concept designs for a new Australian flag. More about that later, but enough to say, we need one. We deserve one, and when we become a republic, I hope I'm involved with designing it.

I plan to spend the morning painting a half-finished picture of Cleopatra for the Bell Shakespeare Company fundraiser. I've got a large triumphant nude on a golden boat. Egyptian headdress, being rowed by slaves, a man on the stern, beating a drum. Big tits. Cleo, not the drumming man. And I just found a bit of plastic on the beach that looks like a crocodile's head that I might use on the bow.

The Goldfish that came in from the cold

Back in cold, grey London, we'd rented a new flat in Lincoln Street, just down from Sloane Square. We had the front two rooms of a little terrace house. Our landlady was a Jordanian princess. We had a few bits of slightly palace-type furniture, including an overlarge lounge with curved gold arms, where, as we had only been married a few years, we spent many blissful hours in each other's.

My Berkeley Square office was large enough to be divided in two. On one side was my desk, facing the window, and on the other side I'd set up a kind of painting studio. Such was the style and understanding of the creative process that no one in management objected – not that I heard about, anyway. Or maybe that 'do not disturb' disk on the door really did work. I remember there were a few works I was happy enough with to leave them as a farewell gift. To Jeremy Bullmore I left a kind of black-and-white drip painting, like a small Jackson Pollock. To Jean Currie, the account executive for Silhouette, I gave a brightly coloured very decorative kind of flower power sixties girl portrait. There were two or three more I can't really recall, but I do remember

one that I finished in the tiny studio I'd set up in Chelsea. I think it may have been done on the back of a noticeboard. This was a landscape – a yellow brown dusty memory of the Australian outback. I brought it home and gave it to my old mate Ric Hedley.

We went through a few crazes in the creative department. At lunchtime you could find a few people playing poker in a smoky spare office or head down the corridor to a darts game. Or sometimes up on the roof we'd fly paper planes down to the park. JWT had a small supermarket in the building so we could grab a sandwich instead of going out for a pub lunch. There was nevertheless a regular group that could be found each day at the Coach and Horses in Hill Street and a stream of directors with their clients and dollybird PAs off to dine at the Connaught or even Claridges or any number of flash restaurants you could find in Mayfair.

Some days I liked to wander across to Bond Street to see the galleries there and in Dover Street or to pop into Sotheby's to lust after some precious artefact. Or maybe down to Piccadilly to the old soda bar at Fortnum and Mason, then along Jermyn Street to stare longingly at some old oak refectory tables or exquisitely detailed English sailing pictures.

After work there was a small exclusive bar at the top of the building. Called 40 Above, it was the domain of the directors but occasionally we lads would get an invitation for a gin and tonic or two or three. Then with the familiar chugging of a black cab, I'd head home to our little flat in Chelsea. In summer, when the light softly faded into dark, at about nine we would go around to the old Cross Keys Hotel near Cheyne Walk. There was a little back courtyard where we could have a plate of smoked salmon and a lager and lime for around ten bob. We were in our twenties. We

were full of the joy of love and life. We saw no sadness ahead. At that age you never do.

I stayed at JWT for at least another couple of years and I really enjoyed it. The Bushmills account took us to County Antrim in Northern Ireland. You could smell the peat from miles away.

Llewelyn was the copywriter, but he slept in and missed the plane, arriving late in the afternoon. There was the obligatory tour of the distillery, where I was able to sample lots of different whiskey blends. One problem was, I don't really like whiskey and tend in fact to get a little out of control after a couple of wine gums. Lew arrived in time for a bit of a catch-up and we retired to a local pub that had been booked for us to spend the night. However he was still jumping and suggested we should take a car to whatever was the best restaurant in the county. I'd had a couple of drinks so it seemed like an excellent idea.

We were directed to a place in the countryside, up towards the Giant's Causeway, a restaurant-cum-nightclub. We were the only patrons. They gave us a table up the front, near the piano. We dined on some classic Irish fare and enjoyed a bottle of excellent wine. Lew's disappointment on missing the tour of the distillery was more than made up for by his personal commitment to sample as many Irish blends as he could to truly understand the product.

Research – someone's got to do it. And that someone was going to be Llewelyn. I had had a drink or two by then so I was not surprised when he took it on himself to berate the abilities of the piano player. He hated the songs, he hated the sound and he hated the whole bloody thing.

As you know, there are many kinds of drunks; the 'I'll just slip under the table and have a little rest' type, that's me. Or the

'I think you and your repertoire are all shite and I'm about to drop my tweeds and show you my bum' type. That's Lew. The management and the handful of other patrons were less than amused. We were escorted out. I slept in the car to Belfast and Lew got himself topped up with a few travellers.

It was such a relief to get back to our lodgings. I collapsed on the bed, only to be blasted awake by the noise of the cacophonous tuning-up downstairs. We arrived on rehearsal night for the local pipe, whistle and drum band. Lew went down to join in but I stayed in bed.

Lew and I worked together for more than five years in London. We were a great team. He was a brilliant writer and did wonderful things. He wrote a wonderful spoof of a John le Carre story that he called 'The goldfish that came in from the cold', a long copy ad for the *Sunday Times* where I needed a shot of a goldfish in a bowl in a certain position. We set up in a studio not far from Harrods and found very early on that the real problem was getting the bloody fish in the right spot. I rang Harrods and asked if they had any dead goldfish in their store zoo. I was politely admonished: Harrods, I was informed, had no dead things at all and would never sell them if they had.

To my endless shame, I realised that I needed to either glue the fish in place or maybe stick a pin through it and then into a lump of plasticine, hidden in the back of the bowl. Maybe, I thought, the thing to do was to go to lunch, leaving the goldfish out of the water, come back later, and have my wicked way with the poor little creature.

We lunched. We had a Campari or two, as that was what the ad was about, and got to the studio close to 4pm. I set up the camera. Reach for the fish and, bugger me, it's still flapping. I take

no pleasure in revealing that we gassed it on the photographer's stove. I got it in position, did the shot and went home. I hope my grandchildren will forgive me when they discover this rather shabby episode in my career.

I convinced Lew to come to Australia in 1972. He was hesitant at the start as he was convinced that all Australians were big and bronzed and he wanted my assurance that there were lots of 'weedy' people there too. He came via Bali, although set himself the challenge of avoiding hearing any Balinese music while he was there. He was that kind of guy.

One night we asked him to dinner. Judy is a great cook and had prepared some wonderful dishes. We asked him to come around 6.30 or 7pm. He finally arrived at about 11.30pm. Pissed.

* * *

But wait, there's more. I'm writing this in a very beautiful resort in Bali. We're here for a few days before flying to Sulawesi. Last night I was talking to the family about something that happened in London when I was at JWT. It was about a competition that Llewelyn and I had conceived to announce the launch of a new silver Gillette razor blade. To shave a long story short, the concept was: tokens to be buried in sand on a beach. All prizes either silver or some silver connection. Tokens for ten silver Mini Coopers, bars of real silver and silver jewellery. It was such a big deal that people had to first enter a competition just to compete in the final. BBC2 did a little piece about some bloke in the north of England who'd been lucky enough to be in the final and showed that he'd spent endless hours digging up his small front garden to hone his digging skills. The competition was called the Gillette 'Big Dig'

and I'd based it on the kind of things we did as kids in Australia. It's recorded in Tom Rayfield's book about JWT London with a brief reference stating that the early parts may not have gone entirely to plan. How right he was!

The final was to be held on the beach at Camber Sands, with the famous English comedian Kenneth Horne as the MC. It was to be televised. It was decided that we should have a trial dig. The plan was to leave Berkeley Square at about 7am, pick up some representatives from the Gillette factory at Isleworth then drive down to the beach with a couple of blokes from the agency who would film the whole thing. The beach area had already been prepared with yard-squared plots roped off, and the whole exercise would be under the command and direction of an ex-wing commander. Oh, did I mention there were a couple of crates of good champagne on the backseat of the bus to celebrate the anticipated successful day? The champagne was to be consumed on the way back to London, in the late afternoon.

Strangely, this became the reason for the disaster that occurred and it's easy in hindsight to say that the drinks should have been locked in the luggage compartment. We'd picked up the Gillette contingent and were travelling south through Sevenoaks. It was a clear, crisp spring morning. We were all bright and excited. A day at the seaside, what fun. I'm not sure who suggested maybe opening a bottle of champers, your honour, but it seemed a perfectly good idea at the time. When we finally arrived at the beach, the entire busload was a) pissed, b) desperate to go to the loo – and c) entirely without any further champagne.

The ex-wing commander, ramrod straight, wearing jodhpurs and carrying a megaphone, was not in the slightest bit amused. After we had relieved ourselves in the bushes, we were marched

to our allotted squares and ordered to dig. The young cameramen were put in a kind of sand foxhole to shoot the performance, and we began. A number of the 'diggers' simply took the opportunity for a bit of a lie down and a sleep and the film, reviewed a few days later, was excruciatingly embarrassing. Partly because only the top quarter of the frame had any action in it, and even then was completely out of focus, as most of the lenses were pointed at the sand.

The next morning we were summoned into the creative director's office and received a severe bollocking for behaving like naughty schoolboys. The account director, who was nominally in charge, was sent to work at a far-flung outpost of the JWT empire and I guess it was only thanks to half the culprits being from the client that we avoided losing the account.

As a footnote, the final was a great success and won a prestigious award. Needless to add, we were not invited to the ceremony.

Booze and The BEATLES

In the opposite corner from the goldfish disaster (for the goldfish that is) are the cinema commercials we made for Campari. Originally, they were conceived as radio ads, and Jeremy Bullmore commissioned the then fresh-out-of-uni Tim Brooke-Taylor and Graeme Garden to devise them, well before they became the famous Goodies. It was decided to produce them as a series of sixty-second cinema ads.

I was most unimpressed when I saw the TV producer's first go at the image and I begged to do it in a different way. I wanted the picture to be so close up on the table that you couldn't even see the bottle, just a glorious pink image that would allow you to take in the funny words. When the two pieces were put together, we knew we had something special. Imagine a full screen of pink, and after heavy breathing a man's voice asks seductively, 'How do I undo this?' More heavy breathing. A woman's voice, even more sensually replies, 'It screws off.' Of course, they were talking about opening a bottle of Campari …

After seeing the image, the boys went on to create six more variations on the theme and it was a great joy to hear the audience reaction when they were shown in our local Chelsea cinema. They went on to win the Gold Lion at the Cannes International Advertising Festival in 1967, the top prize for their category from entries all around the world.

We were all thrilled. We met the soon-to-become-Goodies for a very long and expensive lunch at the then newly opened and super exclusive Alvaro's on the Kings Road, home to people like Michael Caine, David Bailey and Richard Lester, who went on to direct The Beatles movie *HELP!* and who I had the opportunity to work with five years later in Rome.

JWT, being the number-one agency in London, often had people from 'the city' for private boardroom lunches. We had our own kitchen and a number of dining rooms in Hill Street in Mayfair. Brian Epstein, then the manager of the Fab Four, was invited to one of those occasions and when it was time to launch the *White Album*, an advertising campaign was planned as a joint promotion between The Beatles and EMI. The task was given to JWT.

The creative directors passed the problem on to Lew and me. I thought a bit about what the image could be. The Beatles were so famous across the world that no use of those faces was needed, and because I knew that the album would have a plain white album cover, it seemed to me that you could have no image – just a full page with some tiny words centred on it. The ultimate example of visual confidence.

Now for the words. Lew's area. He came up with the brilliant idea of writing the copy to reflect the publication itself. Here is an example as I recall for a full page in the *Financial Times*. Tiny words. Centred:

Today at 9:00am,
the new Beatles White Album will be released.
The albums will be numbered
and it is confidently expected that
the lower numbers will increase in value.

Great concept. So armed with a dozen or so examples, we set off from Berkeley Square with a young Australian account guy and one of the most venerated directors of the agency. We went across the Square to the Apple headquarters on Savile Row. I was nervous and excited. They had the whole building, four or five floors as I remember, and we were escorted up to a meeting room near the top. The main promotion manager was Derek Taylor, and the PR bloke was Peter Asher, Jane's brother and rising pop star in those days. Jane Asher was dating Paul McCartney. We were seated, maybe thirty people, around the room. Very Carnaby Street outfits. Lots of mini skirts and skinny tops. And that was just the blokes. No, just kidding.

I was just about to start my presentation when Peter Asher stopped me in mid-hello and said he thought Paul should hear this. I thought it must be another one of his PR team but to my surprise Paul McCartney breezed in and sat down beside me. I remember he was tossing a green apple in his hands as I spoke, a tiny bit pretentious and unnecessary, but he's Paul McCartney and can do whatever he bloody well wants.

They all seemed to like the ads, said they would call us and we soon found ourselves out on the street. Not only did we feel quite chuffed, Lew looked down and found a £5 note on the pavement in Savile Row. We needed to celebrate, needed a drink, but the pubs didn't open for an hour or so. If you know your way around,

you can always get a drink in Mayfair. And the nice director of the agency knew exactly the place. We headed down to Shepherd Market, rang a discreet bell on a nondescript door and climbed the stairs to find a very well-appointed Gentlemen's Club. An old, old geezer was playing the piano. A fairly blousy madam pouring the gin and tonics. A most agreeable place to spend an hour or so with a drink or so.

Sadly, over the next few weeks, EMI decided to pull out, so the ads never ran. It happens in advertising, often, but just to have been involved in the creation of those ads, meeting Paul McCartney and taking that unexpected trip to a club still firmly fixed in the 1930s was great fun.

* * *

1967 was a hotbed of activity. We worked hard, but had plenty of good fun too. Some of the directors became great friends: Andrew Wilson, who made the Bacardi trip happen and trusted me to make it work, and an associate director called Herbert Sawyer, whom I corresponded with over the years. Herbert was short, portly and always wore a bowler hat and carried the obligatory furled umbrella, even through the summer.

Among the accounts Herbert was responsible for were the liquor importer, Hedges and Butler and a South African sherry named Emva Cream. Herbert would often set a meeting with Lew and me for about 11.30am.

Not long after 'Good morning, boys,' Herbert would reach down into the bottom drawer of his desk and bring out a bottle of sherry, all in the name of research into the product. Over the next hour or so, we would chat until Herbert took us for lunch at his

favourite restaurant, the Old Vienna, just off Bond Street, where waitresses wore classic lederhosen outfits – embroidered skirts, long socks, braces, low-cut white blouses.

Herbert said that just after the end of the war, he would often dine in similar establishments in Austria. He reckoned in those times the girls were dressed exactly the same but without the crisp white blouse. Maybe the braces were quite wide. Towards the end of his life, when he was in a nursing home, he would get someone to reply to my letters. In the last one, when he was well into his nineties, as a postscript he wrote, *Give my love to the beautiful Judy…Does she still call my name in her sleep?*

We miss him.

Margaret and ME

Because of the success of the Campari films we needed to work out a new print campaign, full pages in the *Sunday Times* and *Observer* magazine. I wanted to work with some of the great London photographers of the day – Norman Parkinson, David Bailey, and the most famous of all, Antony Armstrong-Jones, recently married to Princess Margaret and given the title of Lord Snowdon.

We didn't know whether he would want to work in advertising so a lunch was set up in the Grand Dining Room in Hill Street and I was instructed to bring up the problem and see if he would, in fact, be interested in doing the job. Maybe a dozen people. Big table, best silverware, best suit, best behaviour. After the quails egg entrée, I asked him about the Campari films and I was pleased and encouraged to hear how much he liked them. So quickly I got to the proposal. A shoot for Campari. Full page. *Sunday Times.* Brief: whatever he wanted to do. A picture about the feeling of Campari with his signature. He seemed very interested and simply suggested that I should come to his place and we could discuss it in detail. Whacko.

The following Thursday afternoon. Best suit again, been going to the loo lots of times. Everybody in the agency knowing I'm off to the palace. Just before 5pm, I get into a cab outside 40 Berkeley Square. 'Kensington Palace, please,' I say through the little glass window.

'OK, guv,' replied the cabbie. 'That'll be Kensington Palace Hotel, will it?'

'No, mate. The palace. Up that little road beside Kensington Palace to the real thing.' We both sat a little taller and off we went. Naturally, you are expected by the man at the gate and then you are escorted to the front door. A discreet knock and the butler confirms your name and leads you to Snowdon's study. I politely decline tea and just want to get down to the brief. Seems he's not really so interested in talking about it straight away. It's a comparatively small room. Lots of pictures of Princess Margaret, the Royal family, and so on. Photos from Japan and a rather nice little Nolan painting. As I'd also been in Japan, we chatted about that and a bit about the Nolan. Talked about our recent marriages…I knew a lot about his and he knew nothing about mine. Anyhow, he asked had I heard anything about the moving platform he'd designed. Fortunately I had. He'd designed this low flat thing with a handle so that if you had difficulty moving around you could simply take a chair you were comfortable with and pop it on the platform. Grasp the handle, press the correct button and a little motor would be engaged to convey you around the room.

'I'd love you to look at it,' he said.

I mumbled something about not being an industrial designer but it would be impolite to refuse. So the butler was summoned and he arrived with the object.

'Take my chair,' Snowdon said, 'and drive it round the room.'

Not being Mr Mechanical, I was very worried about smashing into some priceless object in the study. So carefully, very, very carefully, I drove up to the bookshelves and back. The phone rang and he answered before I could comment and to my stunned surprise, a door opened beside me and Princess Margaret walked in.

She was wearing a black kind of cocktail dress. Frills. Tight. Very low cut. And the reputation she had as a bit of a party girl preceded her. I found myself jumping up from the wheelchair contraption and making a move that can only be described as a half-curtsey, half-limbo. Just something to signify respect.

She rather politely enquired, 'And who are you?'

And I heard my voice say, 'I AM AN AUSTRALIAN.'

Just that.

I really meant to say, 'I'm an Australian art director and your husband and I are going to work together.'

But no. Just 'I am an Australian' as if to cover any eventuality. If I was sick, or farted or inadvertently grasped her spectacular breasts, 'I am an Australian' should cover the lot.

I regained my senses and some control over my mouth, and we chatted a bit until Tony (I could call him that by then) hung up. Then they started to talk to one another, gently at first and increasingly loudly – quite embarrassing as it was a very personal argument about the fact that although he'd planned to motor down (in his Aston Martin) to Wales the next day, she simply didn't want to go. The discussion reached a point where I was looking for a way out.

Princess Margaret moved first. She swept out and slammed the door. As if nothing had happened, Snowdon concluded our talk

and said he'd shoot next week and could I arrange for a couple of bottles to be cut near the neck so he could do a shot of the feeling of the liquor pouring out. Nice idea. I said I'd arrange it and get the bottle to him in a day or two. And that I really looked forward to the result.

I grabbed a cab to get home to Chelsea to tell Judy all about it: Tony, the princess and me. My gushing on and on was interrupted by the phone in our little flat ringing. It was an Australian model friend — Judy had told her all about the afternoon at the palace. She said she'd like to come over with her photographer boyfriend and play cards after dinner. 'Great,' replied Judy. 'It might shut him up.'

They arrived at about 9pm. We played for a few hours. I tried not to go on and on about the experiences of the afternoon. Close to midnight, the phone rang. Our flat was small. Small living room. Small bedroom. Phone in the bedroom. I closed the interconnecting door. A phone call at that time of night could be a real problem.

I answered and a rather gruff voice enquired if I was Ken Done.

'Yes,' I answered.

'Number 2 Lincoln Street, Chelsea?'

'Yes.' By this time expecting the police or someone with bad news from home.

All the frightening possibilities flash through your mind. The man said that he was from the post office and that he had an urgent telegram for me, but that they could not deliver it until the early morning. Or he could read it to me now over the phone. My heart was in my mouth.

He began to read (and I must say I still have this telegram): *'Can't get you out of my mind. Must see you. Alone. Tomorrow. 3pm. Side entrance of the palace. Signed, Margaret.'*

Your breathing stops. Your heart is thumping. Your male ego says, 'You'll have to go – maybe you'll get some kind of royal stamp on your winky.'

The more logical part of your brain screams, 'It can't be true!' Your ego jumps in thinking, 'Wow, I was only there a few minutes.'

All these games in my head took a second or so. I slowly opened the connecting door. The card players looked over expectantly. And then Judy asked sweetly, 'Who was that on the phone, darling?'

Before I had a chance to tell what could have been a marriage-risking truth, they started to giggle. The Aussie model and her boyfriend had arranged the telegram and Judy was in on it, and then they all cracked up with laughter at my look of confusion, embarrassment and slight disappointment.

That's nothing though to the confusion and embarrassment I'd have encountered when being questioned by the bobbies as I lurked in the bushes beside the palace the next arvo.

* * *

The London years were great and we still have wonderful friends we made there. During those years, we spent most weekends driving in our little Mini Cooper to various parts of the countryside. A favourite spot was a little stream or tributary of the River Kennet that we found by accident one day. You travel an hour or so past Heathrow, turn off a little side road, cross a bridge then walk through willows to an old house with a waterwheel and swans gliding on the stream. Daffodils and bluebells. A hare dancing in the soft summer light.

Judy would always pack homemade paté, freshly baked bread and crisp white wine. Sounds like an advertisement. We had such fun there and most often we'd take friends Warwick and Appley Hoare, Bob and Brooke Mitchell, Dick Williamson, Ken and Trish Hobbs. Both Warwick and Bob have remarried since then, Ken is sadly not with us any more and Trish has found her life partner in the super chef Dany Chouet. They just published a great book on French cooking and we always visit them when we are in France. And Dick has married a lovely Turkish girl called Lalé.

Yeah, the classic English stream. On one side, a number of gentlemen fishing with long rods, grubs for bait, trying to hook a monster say about seven and a half inches long from the River Kennet. On the other side, just us. I have to admit that some Sundays after maybe a little too much wine and the rare heat of an English summer, we could not stop ourselves from sliding into the stream. The gentlemen fisherfolks weren't overly amused at this but we assured them there would be no running and bombing, tempting as that would have been.

Just writing about it makes me long for those warm English summer evenings, getting home to our little flat in Chelsea at 55A Old Church Street, where we first lived, next to a grain store. Our bedroom was on the first floor, level with the branches of the plane trees outside. The grain store attracted many pigeons to the spilt grain and oats in the street so that we often saw totally stuffed birds lying comatose on the branches. About the size of ducks. Fat. Full. Helping each other up between the leaves.

The very flash shoe designer Manolo Blahnik had his shop and studio downstairs after we left. When we were there, the

downstairs tenant was Clytie Jessop, who went on to run the S.H. Ervin Gallery in Sydney. She'd appeared in a number of films and was part of the Arthur Boyd, Sidney Nolan crowd.

Often there would be lots of noise rising from downstairs, lots of booze, lots of people coming and going. I remember one night, after Judy had gone to bed, I heard the sound of someone on our landing, trying to open doors. I jumped out of bed, confronted this bloke and announced that this was not a flat. A stupid thing to say, because it obviously *was* a flat.

I attempted to push him away. His excuse was that he was just looking for the loo.

'Well it's not here, mate,' I said in my most threatening voice. 'Get out!'

I'll never know if it was my tone of voice or my nakedness that convinced him to go but I returned to bed feeling quite masculine and proud. Judy was snoring.

Clytie opened a little gallery on the Kings Road for a few months. One day when alighting from the number 19 bus, I was stunned to see panels of Sidney Nolan's *Riverbend* series stacked inside against the wall. I believe these are some of the greatest pictures made by an Australian artist and I'm proud to say that we own a number of works in that series painted at the same time. We also have a wonderful collection of brown goblets by Arthur Boyd and a great sixteenth-century portrait of Sir Francis De Vere that I saw one evening propped in our shared foyer. Over the years we've collected lots of things, some very valuable, some almost worthless. But all of them a joy to us.

* * *

I'd set up a very small studio in our flat in Old Church Street. When I could, I tried to make some paintings at home and in my office. At that stage, I painted some kind of slightly Jackson Pollock abstracts, some sort of American Colorists, and a couple of very decorative things like Peter Blake's cover of the *Sergeant Pepper* album. Thompson's had some great works around the walls too: a wonderful set of David Hockney etchings, lots of traditional sea scenes and a few Bridget Riley originals. She'd been an art director too, before my time. I'm sure she used the old red disc on her door to keep visitors out.

The agency was the first to have colour TV facilities. I remember doing an ad with a black-and-white colouring-in poster concept that stated, *If you want to see what your product would look like in colour, call us.* It worked well. We had a cinema downstairs and often we were used as guinea pigs on the next production. The most memorable and enjoyable was the premiere of The Beatles' *Yellow Submarine*. A real breakthrough in colour animation.

Another memorable colleague was the copywriter Fay Coventry, who, after leaving advertising, married to become Fay Maschler, the most famous and feared restaurant critic in London. I think she wrote for *The Times* and leading foodie magazines. She looked like Audrey Hepburn, wrote brilliantly and had all the young single men in her spell. I was delighted to see Fay not so long ago. She's married now to a well-known writer of thrillers and still manages to put the fear of God into any establishment that hasn't reached her exacting cooking standards.

So Fay and I went up to visit the Silhouette factory in Shrewsbury, an old-fashioned brick building with lots of machinists. The manager's office overlooked the production line.

During the meeting he asked if we'd like to see the new range of bras, and what size would we prefer?

I didn't really want to suggest a size. He flicked on a mike beside his desk that was to communicate to the floor below. 'Send up Doreen, 36B,' he asked, to my delight.

Doreen arrived and as modestly as she could and for as long as I could manage to ask her questions about them, proceeded to show us a whole new line of underwear from the peekaboo to the Boadicea. Someone's got to do it.

We did a couple of location shoots for this company in Crete and Portugal. When you have quite a number of garments to shoot for a catalogue and some to be used in the main advertising campaign, you need to be somewhere where the sun is shining every day. Our first trip was with Jimmy Wormser, client Ron Beckram, Jeremy Uniacke from the agency and a model or two, including Judy. They were more than happy to use Judy as they'd seen her in the Bacardi campaign and naturally it was a great chance for us to work together again.

Jeremy had been to Crete before and assured us there were stunning beaches there. We arrived early in Athens and straight on another flight to Heraklion. He booked a car, so off we set with a suitcase full of swimwear and cameras to visit the first 'stunning beach'.

Well, no. Maybe stunning by English standards but not by mine. There were a few tense conversations before we so much as unloaded our gear.

'Look,' I said. 'Let's just keep driving east – I'm sure we could find something better.'

The client, Ron, sat stone-faced in the back. Jeremy was silent beside me. We drove through amber-coloured hills, studded

by ancient olives. Past fields with goats and the occasional tiny village. No sign of a decent beach.

Up some big hills again, still travelling east. Running out of time and land as we were almost at the end of the island. Then, miraculously, cresting the top of another rock-strewn hill, I saw the sight of a sparkling sea, a whitewashed village and a pristine beach. Thank god. Thank Crete.

It was the little town of Agios Nikolaos, with a tiny resort within walking distance of the little port. We spent a week there. Every morning before dawn, the chef would bake fresh croissants served with thyme-flavoured honey and coffee as we sat awaiting the first glimmer of the dawn light so we could set up the first shots of the day. The light is so strong and clear that by around 10.30 you had to pack it in till late in the afternoon, when it got soft enough to work again. Nothing to do for a few hours but to swim in the glassy, pale emerald water, next to the rocks beside our little house. Then around 12.30, a slow wander into town, past donkeys laden with vegetables and jars of oil and strings of garlic to the one little restaurant by the quay. One of the great joys of eating in that part of the world is being able to go into the kitchen just to see what was available that day. Eggplant soaked in oil. Dolmades. Lamb and tomatoes, octopus and, some days, fresh fish, still clear eyed and firm. And beer. And ouzo. And maybe a bit of a lie-down before shooting again in the afternoon.

One of the shots I wanted to achieve was a couple of models close together, wearing variations of the same print. One in a bikini, one in a one-piece. Strong blue sky and between them, a flash of light. The way we planned to do this was to prepare a number of pieces of mirror cut in the shape of a cross. Someone would then have to be in the water behind the girls and with

the mirror cross on a long stick, try and aim it at the lens of the camera. Tricky, but not impossible, and pre-computer, you had to do it for real. The someone turned out to be me. Man in the water with a cross on a stick. The timing has to be right. The sun has to be behind the photographer, so he's shooting towards the sky in the east. The sun's going down. It takes a bit of trial and error to get all the parts working. When we finally have to stop, the photographer starts to pack up the gear, the models emerge from the shallows and me, the man with the cross on a stick, slowly rises from the sea. During the whole late afternoon shoot, I'd not noticed a number of goat herders and workers in the fields had gathered on the cliffs overlooking our location. They looked a bit perplexed and confused. Enough to say that later that night in the little bar of the town, I was offered a number of drinks. You never know. A strange man carrying a cross?

The next year we chose the Algarve in Portugal as the location. Again Jimmy, Judy and a couple of other girls and Jeremy Uniacke from the agency. We stayed in quite a flash German-owned hotel, not far from some of those lovely little beaches almost hidden in the cliffs and coves of that rugged part of Portugal. Fishing boats that had been at sea for weeks unloaded their catch of fresh sardines and they were bought by little restaurants that hugged the rocks where you could feast on them, freshly grilled, with a crisp Portuguese rosé and hunks of freshly baked bread. I want to be there again!

2015

I was asked in 2014 by the Radio National *Weekend Arts* program to speak about one of my favourite paintings. This was then expanded into a television segment on *The Mix*. I chose Sidney Nolan's Riverbend series.

There are two sets of the paintings. Essentially they deal with the vertical nature of the bush and the horizontal feeling of the river. Kelly and the policeman and the horse are in a number of the panels but you have to search to find them: it's the figure in the landscape with the landscape being really quite overwhelming. But if you drive down to Goulburn, outside town there are some patches of bush that are exactly, exactly like these paintings, which is I think even more astounding given the fact that Nolan painted them in London.

They're great paintings. And even though I was working as an art director in those days, I had a small studio in Chelsea, I was starting to see whether I could paint. Being Australian, you need only be judged by your ability. And I certainly didn't go with any kind of colonial chip on the shoulder. I knew what I could do, because that's what mass communication tells you. You could see whether your designs were as good as what was happening in Belgium or … Baltimore. You knew where you fit. I had very nice accounts to work on and, on the art side, I saw my first Matisse exhibition on a cold grey afternoon at the Hayward Gallery on the south bank. And suddenly, when you're confronted with the real thing, it can be a life-changing event as far as artists are concerned. So, I had a small studio in Chelsea, I had my first view of *Riverbend*, and I always knew that I

desperately wanted to have something that Nolan had done of that particular series.

When I saw it again, which was many, many, many, many years later, it was the big Nolan exhibition that they had here in the Art Gallery of New South Wales. Of the two versions of Riverbend, Rupert Murdoch owns one set – the kind of slightly more yellow-y ones, I understand, in his New York office. I've not seen them there. He's a very lucky man to have them.

The other set is in the Drill Hall in Canberra. I first saw it, or I saw it and re-saw it again with Clive James of all people. We'd met once before, when he appeared at the Opera House. Just before interval he announced to the audience that when he returned he'd appear in a complete change of costume. In fact, the only change was that he reappeared wearing one of my ties. It was a joy to have been invited backstage, what a giant talent he has. One of our most gifted and treasured Australians. Back to the Nolans. There was a big exhibition here in Sydney, so I jumped in my car one morning and drove straight to the art gallery. I was absolutely desperate to see it. Anyway it turned out I was a day early. So I was just standing at the front desk at the art gallery and feeling a bit let down because I was going overseas. Suddenly Clive James walked in and we exchanged pleasantries and he said, 'I'm going to go and see the Nolans; they're letting me see the Nolan exhibition because I'm writing a small piece for the *Sunday Times*. Why don't you come with me?'

And so I had the great experience of spending a bit more time with Clive James and of going down, just the two of us, in this circular space they'd made in the gallery to see the paintings. It was wonderful to see them all again and I spoke to Clive about how, in my opinion, each panel (there were

nine shown but I know that there are more of them) would have taken forty minutes maximum, maybe thirty minutes. You have to work very, very fast to make the marks that he made on these paintings.

I'm sure he made them flat, on the ground: he put down quite a lot of wonderful oil paint and then scraped back into it, with his fingers, with bits of cloth, maybe with a bit of brush. As a painter, you know how quickly a mark is made – it's like a musician knows how a sound is made. Even if you look at the Kelly figure on the horse or the body in the foreground, your eye is filling in all of the details, but in fact it's very, very loosely put in. But to do that in thirty minutes, you have to have been at it for a lifetime. It's the mark of a man who has incredible confidence about what he's putting down. And the only way that you could make a whole series of pictures like this is to lay them on the ground and just go for it, kind of white-hot speed. I've seen a couple of documentaries of Nolan working and I know that's pretty much the way he worked.

I had the great pleasure of meeting Nolan three times. Once in the Northern Territory, once in Alice Springs and then once on the way to Lanyon, which is the Nolan gallery in Canberra, and I made a number of pictures about meeting him. I still do occasionally: I made some paintings the other day that have the Opera House on top of the Kelly helmet because they are two of the great iconic symbols of this country.

We met first at the airport in Darwin, with some very nice people from the ABC who were doing a piece on him, and I'd actually been with another film crew out at Obiri Rock doing a TV interview. Anyway, we were introduced and of course, when you meet someone who's a great hero,

you want to tell them straight away how much you love their work. Obviously when someone says nice things to you, you're going to say nice things back. We were able to talk about pictures for a while and about the Australian landscape.

On the homeward flight, I was up the back, he was down the front, so when we got out at Alice Springs, he'd walked out on the tarmac and I was standing there and we started to talk again. I showed him a small drawing that I'd done on the boarding pass called *Nolan Flying Home* because I'd made the big Kelly helmet flying through the sky, and he always had quite flamboyant ties, so I had the tie as well. He seemed to like it very much and I said, 'Look, I think I'm going to make an etching of it.' (I've only ever made two etchings in my life.)

He asked whether I would give it to the Lanyon Gallery, which I did. So, we had the talk, we got back on the plane, him up the front, me down the back, and then maybe three or four days later I was in Canberra and I thought, Wow, I'd better go out and see the Lanyon Gallery, cause I hadn't seen it. There's a bit of a rough bush road that you go through to actually get out there on the last part of it. I'd been to the gallery, and I was driving back and another car was coming the other way and it was quite narrow so we had to stop. It was Sidney Nolan and his wife. We talked about the incredible coincidence of it happening and went our separate ways. I was grateful for the opportunity to have met him. I wish I'd had the opportunity to have spoken with him more.

In the Riverbend series there are nine panels but I knew that there were more, so in the late 80s or early 90s, before my accountant had lost quite a lot of my money, I had some money and I really wanted these pictures, so I got in touch with some people in Melbourne who know about these things

and it turned out that there were two, in fact three for sale. They were very expensive, even at the time, but I had the money and I wanted them. They've got all the authentication on the back but you only have to look at them to see they were clearly done at the same time. Maybe he wanted to do a couple of them twice to see how they fitted, or he made ten or eleven. I've got two, and to my knowledge there aren't any others, and I'm very grateful to have them. You can hear the cicadas, feel the heat and the crinkliness of the bush, know the muddy swirl of the khaki river. Even without the Kelly figure, these would be major Australian paintings.

Like all great paintings, they don't give you everything on the first viewing. The first viewing might thrill you, but if it's any good, a painting will give you pleasure over time and I'm sure any reader will know that there are some paintings that they've hung in their house that they're bored with, that they don't even look at any more. Well, chuck 'em out, support the Australian art industry, get a new one. It's got to be something that gives you pleasure over time.

Leaving LONDON

Andrew Wilson, the Bacardi account director, had become a great friend. His father, Sir John Wilson, lived in a castle near Glasgow and had the job of overseeing the queen's stamp collection. Andrew worked with me on a number of projects and Judy and I were delighted when he invited us to visit his ancestral home for a weekend of shooting and golf. I hadn't played golf for a couple of years and I'd not shot since Luna Park in Sydney, where I dropped the occasional tin duck with a BB gun, more out of luck than a good aim.

We arrived in Glasgow to be met by Andrew's mum in an old Daimler. Sweet and gentle lady. Bit regal, and as we got closer to her village, members of the public waved with respect. We stopped at a local butchers, picked up a quail egg or two, a venison hind and whatever else you might need to feed the family and a couple of colonials. It was a lovely drive past the gatehouse, up to the castle. Pretty bloody impressive. It was late and Lady Wilson suggested a drink before dinner in an hour or so's time.

For some reason, I'd forgotten my watch, and there was not a clock in the room. The loo made the noise of Niagara when flushed and the icy wind blasted its way around the old windows of our bedroom. We kept peeking out the door and finally heard noises downstairs. Andrew's father was not well and confined to his bed, but we were joined by Andrew's older brother and his new bride. In fact, Andrew's wife, Mia, was her sister. Two brothers married two Swedish sisters. Both lovely. For a family used to living in a castle, it's just another dinner, but for us it was a real treat. After dinner we played billiards on a wonderful old table and then went to bed with the dark hills of the highlands outside across from the woods.

The old local doctor was called the next morning to attend to Sir John and it was suggested by the butler that I might like to do a bit of archery out on the front lawn. Again, I'd not unleashed an arrow since boyhood in Maclean, where as boys we'd make our own bows out of bits of bamboo.

'Yes, I'd love to do some archery,' I told the butler, and a large target was set up across the lawn and a tall bow with an old quiver full of arrows made ready at my side.

I felt I could do this. I set the first arrow, pulled back the bow (quite hard really) and let off the first shot. It flew straight and true. That is if you were aiming about sixty yards left of the target and had your sights set on the garden tap. Most days this wouldn't be too much of a problem, except the lawn was covered in early morning frost. Every embarrassing footprint could be seen as I slunk across to retrieve my shot. I tried again. This time more of a duck hook across to the garage door, where the arrow firmly embedded itself in the old wooden frame. By the time I exhausted all of my shots, there was a pattern of footprints leading almost anywhere but directly to the target. Robin Hood I was not.

After lunch, fortunately the frost had gone. A shooting party in the woods was organised. Judy was to be a beater, walking through the gorse and heather armed with a big stick, and I was granted the use of a classic old Purdey shotgun that had been in the family for years. They were all wearing old and well-worn family shooting outfits. I wore a cream corduroy jacket Judy had made and Judy herself wore a new skirt she'd also made, and the first sheer tights she'd owned. Judy's a great designer and always liked to make clothes. She even made me a very stylish gabardine overcoat, slightly fitted with a kind of tartan lining. A highly complicated garment that I wish I could fit into now.

We set off, the brothers confident and alert in the crisp Scottish light into the deep, leafy, dark green woods. I was directed to make my way through the woods. The brothers went round the other way and Judy left to work on the flank with her stick and stockings. Suddenly, deep into the woods, the flapping wings of something wild flashed past me. I swung the Purdey, let go both barrels and shot, mainly out of self-defence, an old wood pigeon. Hardly much left of him really, but when I finally emerged with my prize, the Brothers Wilson politely congratulated me and popped it into the bag to join the brace of quail or whatever they'd shot. On return to the gunroom we replaced the shotguns in their correct cases and were again summoned for drinks in a half hour or so. I'd been given a pair of gumboots to walk in, so I sat down to slip them off. But now my feet had become so swollen with fear and exhaustion that I found myself writhing around the old stone floor and even with Judy's help I could not dislodge them. More panic. More heaving and twisting so that finally, with a much-relieving squelchy plop, my legs were released.

The next day we were treated to golf at Gleneagles. A glorious course, with pristine fairways bordered by flowering heather. Scotland at its most beautiful. How lucky we were to have had those few days. Years later, we were able to entertain Andrew and Mia in Sydney. A sparkling day on a boat on the harbour, and a backyard barbie. We jumped in the water at Store Beach. A fearless frolic in the shark-infested bay. They were scared and declined. No brace of matching Purdeys so we had little chance of an equaliser for the pigeon fiasco. In fact there has never been a shark incident off Store Beach. The greatest danger would have come from the topless 'white pointers' on the sand.

* * *

We made many trips around the countryside on the weekends. Lots to the Cotswolds. A few south to the sea. Across to Wales. And to Norfolk to see our mates from Sydney, Penny and Earle Bailey. I'd briefly taken out Penny in Sydney in the Rowe Street days and she'd become a good friend to us. Her husband Earle was on radio and they'd moved to the UK to further his career. We went and watched him play rugby on a rough old ground in a little Norfolk village.

Over those last few years of the 1960s, Judy and I became increasingly homesick. Sick of the endless winter days where the sun set at about 3pm, and you went to work in the dark. We longed for the light of Australia and the sounds and smells of the harbour. We'd written letters home and our parents would often send books to remind us of what we were missing. I remember especially David Moore's great books of photographs of the

country and a glorious shot of the harbour in the late afternoon light. We were missing our families and it was time to return.

There were compensations for the weather. Great exhibitions to see, and a pivotal one for me was that show of Matisse's paintings at a gallery on the Southbank I mentioned on Radio National. We went early one Sunday in the drizzling, grey, dirty rain. And stepped inside to colour that was full of joy and almost overwhelming in its impact. I'd seen many reproductions of Matisse's work, but nothing comes close to the real thing. I was thrilled and stunned, and I knew at that point that I'd seen my future. It's a heady experience, your first Matisse exhibition, especially when you love colour as much as I do. I still have the catalogue of that show, dog-eared and much loved.

But the occasional Matisse or David Hockney show was not enough.

One day, we were with our friends Warwick and Appley Hoare, ready to have a picnic in Great Windsor Park. It was drizzling early in the day, grey and cold, and that became heavy rain by midday. There was no chance of getting out, even under a tree. We sat in the car, juggling our picnic on our knees in our little Mini, sick of the grey, cold and wet that had been seeping into our bones for months.

'OK,' I exclaimed. 'That's it. We're going home.' Strangely, the day we left London was one of the hottest on record. As I loaded our few bits of furniture onto the removalists' truck I accidentally dropped a heavy table onto my big toe. I was in agony on the way to the airport and on the flight the hostess was surprised when I asked for a cup of ice and proceeded to try and fit my big toe into it. It was still swollen and aching when we arrived at our first stop in Copenhagen. We were there because Judy's brother Allan and

a couple of his mates had won the right to represent Australia at the World Soling Championship, to be sailed from Marstrand in Sweden. I hobbled around Copenhagen for a bit until we found a cheap hotel. It was very late when we checked in and we had failed to notice that there was a sex shop in front of the hotel. The next morning I witnessed a rather conservative-looking American tourist begging his wife to give him his glasses so he could check the window display. She refused.

That day we found accommodation at a homestay place you could book at the railway station. So, armed with directions, we took the local train to a leafy suburb about thirty minutes from the city. Lovely little house. Nice people. Hearty Danish breakfast. The morning paper featured a full centre page of pornography. Slightly surprising. Didn't seem to turn a hair on our hosts' heads but it's not what the average Aussie bloke looks at over his corn flakes.

We flew to Gothenburg and then on to the little island of Marstrand. It was full to bursting with yachts and yachties. Smooth grey rocks tumbling along a grey-green sea: it was a fascinating little town. We were very pleased to catch up with Allan. Judy had not seen him for years so there was lots to talk about but wait, what about my bloody sore toe? Allan was the bowman, Dick Sergent the forward hand and Carl Ryves the skipper. The boys had already won the 18-footer championship on Sydney Harbour in a boat called *Thomas Cameron*. That kind of sailing involves exceptional skills of seamanship, speed and daring. To get to represent your country you had to be pretty bloody good. But OK, what about my toe? I showed it to them, by now swollen, throbbing and a nasty purple-black colour, and they were very shocked. But they quickly offered to help. They

reckoned if they were very careful, they could get a drill from the toolkits and sort the whole thing out. So with a bit of luck, and a bit of care and a bit of Aussie can do, they did the deed. They drilled carefully through the nail and released the nasty stuff in there. Not very St Vincent's Hospital, but I still have the toe.

We took the long way home, meeting our friends Warwick and Appley in Venice for a few magical days before heading off to the Greek Islands. We went first to Mykonos and met some more Australian friends there, the filmmaker Bren Claridge and his writer wife Berwyn Lewis. Then by night ferry to the little island of Ios. We were looking for a house we could stay in forever. Well, maybe for a few weeks.

We jumped off the ferry early in the morning, before dawn, and quickly grabbed the first taxi driver. There was only one. We told him of our needs and he assured us he had just the thing. A perfect little house at the end of a beach, and that if we unloaded our luggage and waited on the quayside, he would return and take us there. The ferry disgorged all its passengers. The early morning light was rising over the mountain and we waited expectantly for our driver to return. We never saw him again.

We trudged wearily up to the little town above the bay, where all but the baker were still asleep. After freshly baked bread and delicious tomatoes we hired some donkeys. The first rays of the sun were touching the little white church at the top of the village. We loaded the donkeys and clip-clopped along with them through narrow laneways still in cool blue shadow. At the top of the hill, we were able to gaze down to see the narrow path wind through pale yellow grasses, dotted with little red flowers. And beyond, the beach itself. From this high point, the sea was a deep ultramarine blue and there, at the end of the little crescent

of sand, was a collection of whitewashed houses, just waiting for us. We were wild with joy and excitement. This could be it. Our Greek home forever. By the time we got to the start of the beach, the sun had risen enough to make the buildings glow in the early soft yellow light. We hurried towards our destiny.

When we finally arrived, it was crap. The house to let was filthy. The taverna was all but derelict. No toilet facilities. A dirty bathroom and a howling wind. I consulted a cheap map and realised we should go north, maybe to Corfu, as it appeared that there was quite a high mountain and if we could get on the leeside we could escape the suicidal wind. Eventually we arrived in Corfu and stayed at the little village that Gerald Durrell had lived in and it was just what we wanted a Greek holiday to be. Clear water. Kind villagers. Delicious food. Lots of wine. Lots of sleeping through the hot afternoons. It was sad eventually to leave, but Sydney was calling.

HOME AGAIN

It was late 1969 when we landed in Sydney. I was twenty-nine. It was spring. The light was blinding. The sky was a blue we'd not seen for ages and everything seemed new and fresh. Dad met us at the airport and we drove over the new expressway, getting a glimpse of the almost completed Opera House. Sydney. What a joy to be home. The gardens were full of spring flowers as we drove down Awaba Street to see again the harbour at Balmoral and the heads beyond. It was lovely to sink into the arms of the family. Mum did the traditional lamb roast, baked pumpkin and potatoes, peas, mint sauce. Pavlova. We're home! There was a job waiting at JWT so we set about looking for somewhere to live and start a family.

We had about $3000 saved up and eventually found an old Federation house overlooking the park at the back of Chinamans Beach in Mosman. It had a view across to Clontarf and The Spit. We loved it. The sale price was $41,500. With help from Mum and Dad and a $25,000 loan from the insurance company we could just manage a bid of $40,000.

We were shattered to hear someone else had offered more and the house was sold — that old house was just what we wanted. It was the most rundown in the little road, which was then a dirt track. It had a huge jacaranda and a big pine tree in the garden and sat high on a steep block with lots of rough old steps leading up to it. A few days later the agent rang and said there was some trouble with the sale and could we offer a bit more. I told the guy that he could pick me up and shake me but nothing else would come out of my pockets. That was it. We got the house for our last bid.

Even the insurance company said we'd need a bit of luck to be able to repay the loan, but we did. We lived happily there for almost twenty-five years. Carrying sleeping children up those steps was always a challenge and even before the kids arrived it was always a climb. But the view was great. It had a strange room downstairs in the foundations that I turned into a little studio and then into a little office when I left JWT and worked freelance. That meant I had to burrow even further under the sandstone to have a spot to paint.

There were quite a number of young families in the little corner of the valley and all the kids were able to have that park and the beach as their playground. I made a couple of half-hearted attempts at gardening and even laid down some bricks in the damp corner of the backyard to make a kind of little dry area near the clothes line. It was always wet and slippery and the back fence was covered in vines and almost falling down. I might have some skills with my hands, but a handyman I am not. We had guinea pigs, a rabbit, an axolotl, a canary and Sammy the spaniel.

The day we sat in Great Windsor Park in England in the rain and decided we'd come back to Australia, Judy had said she

wanted two things: a baby and a cocker spaniel. I figured I could help with the baby but I managed the cocker spaniel first. On returning to Sydney one of the first jobs I had was to write a commercial for Kellogg's Corn Flakes. A kind of happy family thing with puppies etc. We shot it in a house down near Long Reef. I didn't tell Judy I'd organised a baby playpen of little cocker spaniel puppies, I just called her to come down and see the shot. That's where we first met Sammy. Dogs have been a much-loved part of our family forever. You've got to be a bit suspicious of people who don't love dogs.

Our beautiful daughter Camilla came into our lives on the first day of summer 1970, and has brought warmth and joy ever since. It was love at first sight and I will never forget when I first held her in my arms. She is still there. We'd made a kind of mobile to hang over her cot, a white-painted branch with little white birds hanging from it. We joke that her first word was chandelier.

Most days Judy would drive me down to Mosman Bay and I'd have the great joy of a ferry ride across the harbour to work. Camilla would be a little coloured dot waving goodbye to me as the ferry rounded the corner.

I worked with Richard Walsh at JWT – he was the copywriter – and I then went on to become a group head and the joint creative director of the agency when Bryce Courtenay left. I'd convinced Llewelyn Thomas to immigrate, and we resumed our creative partnership for many years.

It was great to be back in Australia and I had some very interesting accounts to work on, including Benson & Hedges, for whom we made a series of TV commercials and films. We worked a lot with Stuart Wagstaff on those campaigns and, although I'm now very much against smoking, at the time it was good fun.

But I was beginning to feel that my life should be more about painting and that my advertising days would soon be over. Over those last few years at JWT I worked a four-day week and was able to devote Mondays to painting.

Every morning when I went to swim at Chinamans Beach I talked to an older lady near the rockpool. It turned out she lived in the pink villa at the southern end of the beach and she in fact owned the Cabin – the little cottage I had first seen as a boy and dreamed one day of owning. She was renting it to a television executive who just didn't love it. You could see by the way he treated the garden and seemed never to swim or be there on the weekend. Had he looked towards the rocks at the northern end of the beach he would have seen me staring at the little white house and willing him out of it. In time he left, and Mary Thompson, the owner of the house, allowed us to rent it. It was such a thrilling day when we entered the building for the first time. Judy me, and the kids began clearing out the old debris left inside and we spent as much time as possible together in that space. Many years later, we were able to finally purchase the property, and every morning Judy and I swim and breakfast there, and of course it's just a joy when the family comes to stay.

Those early childhood years go so quickly. I want every minute again. Oscar was born about five years after Camilla. There was no way of knowing the sex of your child in those days but naturally we were hoping for a little boy. We didn't get a little boy: we got a Big Boy. I remember waiting in the corridor outside. I'd wanted to be there for the birth but was sent out. All I could hear were Judy's cries. It was quite distressing not knowing what was going on.

'It's a boy!'

I think I was in glorious shock for a few days. I went to the agency for the traditional drinks and cigars and couldn't wait to introduce Camilla to her brother. They have grown up extremely close and work together brilliantly. They are the best things Judy and I have created by far and it's our greatest achievement that we all work together as a family. We've had so many great adventures together. When the kids were little, as I've said, I would drive them to kindy or school with rock and roll blasting from the car speakers. It's exactly the thing to set you up for the day. Nothing gives me more pleasure than to go to the gallery and see them there.

No father could love his children more.

* * *

As the kids grew, all the neighbours' kids were friends and played after school in the reserve. The deal was they had to be home before the streetlights went on. They would play until the lights went on at Clontarf, across the water, a few minutes before the ones in Mosman, then scurry up the bush track to their respective homes. Our old dog Sammy, the ever so slightly overweight cocker spaniel, was always the last to come puffing up the steps.

We'd met a young architect called Glenn Murcutt with his then wife at a mutual friend's house in Balgowlah, and when we decided to do a bit of renovating, we asked if he'd do the job. He designed a new entrance, through the sandstone, moved the kitchen to the front where the bedroom had been, and opened up the attic for the kids to play. We were very happy, and many years later when we purchased an old house, closer to the beach, we got him to design us a new one on that spot. We had always

liked Greek and Mexican houses and Glenn did too. He designed a stunning home with arched entrances, terracotta paving and an internal courtyard. The building took up all the small block, but it fulfilled our needs and made the most of the stunning view.

In later years Glenn became the first Australian architect to win both the Alvar Aalto Prize and the Pritzker Prize. That's like the Nobel Prize for architecture. Our home was part of his body of work and we were very proud that it should be submitted and even prouder when he won.

So you can understand we were, at the time, rather perplexed by the attitude of some of the local councillors of the day, who were responsible for building permissions. The problem had many parts, the main one being that we had taken up all the block and there was a regulation about the garden-to-building ratio. Glenn had solved this by making a large garden on the roof. There were concerns too about the height of the outside wall. We had to submit extensive plans for trees to soften it. There were lots more niggles and angry meetings.

Glenn spent one whole day with the council in a meeting to make them understand his concept. At the end of the day, although a tentative plan had been reached where the design was to be considered by the council as a whole, one councillor insisted that it should be put on the record that if built, this would be the worst house in Mosman! Now that's a big call.

The house is often visited, even now, by many architecture students, and has appeared in prestigious design magazines throughout the world. It wasn't an easy house to build, it cost more than we expected, but we loved it and had many happy years there. We still own it, even though we've moved to the house in front.

The house in front is a kind of 1950s villa. We always loved it, and Mary, the lady who owned it. When we finally purchased it, we said she could stay there for the rest of her days. It was almost a decade later that we moved in. You don't really need a team of muscly movers – you just chuck most of the stuff out the front window and into the garden below.

We love this house and will never move. It's where I'm writing this now, on a little yellow table on the front terrace. We did quite a bit of renovation here too, but the bones of the house are great. It has a long curved wall in the middle, so the two ends get the best view and the sun. It's really only two bedrooms. Or really one: the second small room is a dressing room. Our bedroom overlooks the garden, the beach and the harbour. My studio is downstairs, next to a flat where family often stay, or very close friends.

2015

Our housekeeper, Jill, just walked past.

'Must be fun to look back on things,' she said.

'Well yes!' I reply. 'Keen to remember the good times. Not sure what I'll put in about the bad times.'

Tiring. Think I might stop for a bit and start painting again.

Better still, went for a massage. I think I was lying there, almost drifting off, but I began to think about the future and my ultimate and probably unavoidable dropping off the twig. If some TV station decides to do a program about the studio and the painting, make sure they don't play any of that abstract boring music. No. It should be Ray Charles, James Morrison, arse-kicking rock and roll, or the music I'd play in the car at top volume on the way to take the kids to kindy.

Meeting MR PACKER

When I left JWT in 1975 I still needed an income to support my family. We had the darling and wondrous Camilla, the little dog Sammy, Oscar on the way, and a very big mortgage. I was beginning to tire of solving advertising problems, and I wanted more time to paint. I was feeling that I should work towards becoming a full-time painter. Maybe in time even an artist!

My old mate Bob Mitchell had started an agency a few years previously with a few other guys. Quinlan, Mitchell, Malanot and Stott. For some reason, Bob had decided to leave and Jim Quinlan called with a very interesting offer: money and a Mercedes, and the understanding that I wanted to devote as much time as I could to painting. I said yes – I needed the money and I was still not sure if I could support us with art alone. So I left JWT and started working part-time for Jim and co's agency, even getting the title of creative director.

One of the first things I was involved in was a thirty-second commercial for Johnson & Johnson for Band-Aids, written by Adrian Dames. A little boy walking home from school to the

background music of 'When Johnny Comes Marching Home'. Runs to his mum. Shows her his knee. She puts a Band-Aid on, kisses the kid. End of commercial. Warm, fuzzy, loving, trusting. All the things that company should represent. It went on to win the first ever Gold FACTS Award for the best TV commercial in Australia. We were all very pleased.

This success led to the agency being offered the Channel 9 account. TCN9 was the absolute top-rating TV channel of the nation. It was owned by Kerry Packer and Sam Chisholm was the MD. Gordon French was the program director and they had a great team of the top TV talent on board. Quite a coup to be working for them.

It was the time when Kerry Packer had decided to start World Series Cricket and the whole thing was very hush-hush while the various players were being offered secret contracts to join. I was given the task of creating the first newspaper ads to run just before the first ever game.

I wrote and designed some ads that were just like big newspaper headlines. Bold type: *NO AUSTRALIAN LAWN WILL BE CUT TODAY!* Then some small body copy below and in the right-hand bottom corner the logo for World Series Cricket. Kerry Packer was very, very busy at the time and Sam Chisholm rang to say I had to be on standby: when he could arrange a meeting he'd pick me up outside the agency in North Sydney and we'd go to the headquarters in Elizabeth Street and I'd make the presentation.

The call came. I waited nervously outside. Sam arrived and off we set. Although I'd met Kerry Packer before and found him charming, I'd not been in his office for business dealings. It was a big office. Big man, big desk, big paintings (mostly elephants), big

clocks showing the time in other outposts of the world. Packer was on the phone with his back to us.

When we were seated, he suddenly turned and asked Sam, 'What the fuck are you here for?'

'This is Ken Done,' he answered, 'and he's going to present the ads for World Series Cricket.'

Packer gave me his full attention. The Dragon's eyes.

'Yes,' I suggested brightly. 'I'll show you ads and give you the reason why I think you should run them.'

Mr Packer said, 'The fucking consumers don't get any fucking "reasons why": you just fucking show me and if I fucking like them then I'll run them, OK?'

I placed the layouts in front of him. Some he clearly liked as they remained on his desk. Some he didn't: he crumpled them and threw them on the floor.

'I want this to be bigger,' he said, glaring over his half glasses. He was indicating the World Series Cricket logo at the bottom corner. 'Bigger!' he emphasised.

'Well,' I suggested, 'the problem with making it bigger is that isn't the way the ad should work. You need to read the headline, then move on to the body copy and then find the logo in the corner. That's how the ad is designed.'

Mr Packer: Son, I want it FUCKING BIGGER.

Me: Look, if I make it bigger, the whole thing will become a grey mass: you need to have space around the logo to make it work.

Mr Packer (full dragon glare, steam starting to come from the eyes and mouth): Son, I don't seem to be getting through to you. I WANT IT FUCKING BIGGER.

Me: Well I don't know if it will work as well.

Mr Packer: How big is the space you're working with?

Me: It's a full page.

Mr Packer: IF YOU CAN'T MAKE IT BIGGER IN A FULL PAGE I'LL GET ANOTHER FUCKING AGENCY!!

I gave the only appropriate reply. 'How big would you like it?' I added a mumbled attempt at humour, suggesting I could put it up one side and over the other but his point was clearly made.

He was right. He was the client. And it's the most important lesson in the ad game: a client pays the bill. And if he insists that he wants his logo bigger, you make it so. With as much dignity as I could muster, I left the office with my clear instructions of how I was to produce the ads.

In the next room, I ran into Lynton Taylor, a nice man who had the task of putting World Series Cricket together for Packer. He obviously heard the exchange, as I figured most people around the office had, and even some over the road in Hyde Park.

'Tough meeting?' he enquired.

'Well yes,' I said, 'but I'm still alive. Just.'

The TV ads were created by Mojo. The brilliance of Alan Morris and Allan Johnston created one of the most memorable campaigns in Australia. They were a pivotal part of the emergence of national pride and signalled a decade or so of confident work.

Kerry Packer was a towering figure in the Australian media scene and had a brilliant understanding of the attitude of the average Australian viewer. Underneath, I'm sure he was sensitive and kind. He passed away far too early. He's a hard act to follow.

I mentioned we'd met once before when I was still at JWT. The agency had two creative directors, me and Tony Moon. Tony was responsible for Consolidated Press and therefore the launch of

Cleo magazine. The lovely Ita Buttrose had created a brilliant new magazine for women and the launch and the first few issues had been spectacular. Just after lunch on a Friday, Mr Packer had rung chairman John Sharman in a bit of a lather, demanding that he see the people from the agency who'd worked on the account and they better be able to solve a big problem he had or else.

Tony Moon was away. The chairman called me.

'What's the problem?' I enquired.

'Well that's it,' said John. 'Kerry hasn't really explained that.'

'I don't know what to do unless I know what the problem is, so could you organise a meeting with him?'

A meeting was set. We were summoned to be at Packer's house in Bellevue Hill at six that evening. I went with Llewellyn and a young account director. We arrived promptly at six. The house was not the large compound the Packer family now reside in, but still an imposing pile. We were ushered in by the butler to a smallish room where Mr Packer was watching TV. He was not long back from Africa and his leg was in plaster. The leg was propped up on a stool in front of the TV. You had to be very careful as when he changed position the leg would naturally follow and there was a danger you would be seriously damaged yourself if you didn't get out of the way.

We chatted about many things: Africa, travel, sport, outer space. He was funny and charming. No sign yet or indication of the problem.

The butler brought drinks. Beer and wine for us, Fanta for him. More talk, jokes, reminiscences. No problem so far. We waited for him to bring it up.

We'd been there for a couple of hours before he suddenly changed the subject. 'OK. Let me ask a question,' he said.

Here it comes, we thought.

'What do you blokes like to eat?'

Um, well, we didn't quite know where this was leading. So we mumbled a bit about steak and avocados and stuff like that.

He yelled out to the butler. Gave him a food order and sent him off to Beppi's: we took it to mean we were being invited to stay and have dinner. Great food. Exquisite wine and a few more Fantas. Lots of happy talk, lots of strange subjects and then brandy and chocolate.

No talk of any problem with *Cleo*. What a nice man. Maybe he just wanted company.

* * *

I remember the day when the then Channel 9 program director Gordon French first played 'Still the One', the new theme song he'd acquired for the network during a trip to LA, for the agency. They flogged it in various forms for years. It had been created originally for a US network and was perfectly applicable to Channel 9. Tears welled with pride in Gordon's eyes as he continued to replay the theme. An emotional and dedicated man was Gordon, always a joy to work with, even after one of those classic Channel 9 lunches that started around Friday midday at the old Tai Ping restaurant in Dixon Street and finished some time in the early hours of Saturday morning. I was surprised that such a volatile and emotional bloke would turn his hand to very precise and delicate renderings of early Australian buildings when he finally left the station.

It was the days of Gerald Stone and the first Sundays of *60 Minutes*. I did ads for that. Gerald had said he thought the Australian version of the show should have a digital clock in the

opening titles instead of the classic one with hands and ticking. Kerry Packer thought not. *Tick tick tick.*

David Hill had come from Melbourne to run sport, which I think he now runs for Rupert Murdoch at Fox, and the *Fantasy Island* program was launched at a very boozy and a bit druggy afternoon at Rodd Island in the harbour. We set up some rather bedraggled palm trees and a kind of grass hut with a screen for showing the TV reporters of the day. Originally, I'd suggested we should shoot on the Barrier Reef. After budget considerations that became maybe on the Hawkesbury, but finally on Sydney Harbour.

I remember we left by boat, picking up Mike Carlton at Milsons Point: he went on to win the prize of the day – a trip to London. We had a number of reporters on board. It was drizzling with rain. On arrival at Rodd Island the reporters rushed to the bar, not just to get out of the rain, and a couple of blokes rushed to the loo. I needed a leak also and was a bit surprised to find one of the most influential scribes of the afternoon rags puffing on a joint the size of a banana. No wonder his column was sometimes a bit bizarre.

In those days publicity was essential in the battle between 9, 7 and 10. We had the rights to televise the Oscars and once we took over the old Plaza Theatre on George Street. We set up the place to be a kind of Hollywood theatre where people could watch the Oscars live on a windy Monday morning.

The great thing about working in advertising was that you had to move fast. People made decisions. Unlike later, when I worked on the ABC account, for Channel 9 we went to them, took the brief and got into it, as it was probably going to appear the next day. For the ABC, they came to us. Then to lunch.

When the much-heralded American saga *Roots* was to appear on a rival station, Channel 9 decided to go all out on a media blitz to take the potential audience away. They had decided to run a Howard Hughes / Jane Russell film against it. We ran three or four consecutive full-page ads in the evening newspaper the night before the event. *Sex, Drama, Adultery, Big Boobs, Guns, Scantily Clad Ladies etc etc tomorrow night 8.30. Channel 9.* After the night we found we were smashed in the ratings. Sometimes it just doesn't work the way you hoped. The publicity *Roots* had received from its stunning success in the US was just too much.

They were very good times at that agency. Nice accounts, including Kosta Boda, which would eventually lead to me travelling to Sweden to create a series of glass objects.

I'd never worked in glass before, so it was quite a challenge. The little town of Kosta is in the south of Sweden, deep in dense forests. The whole area is called the Kingdom of Glass, as for many centuries glass has been blown there. I stayed in the company guesthouse, just me, in a classic old red wooden Swedish home. A woman from the village would come before dawn and set up my breakfast and then, just at first light, I would drive through the forest to start work at 6am. They had said I could start later, but I wanted to work at the same time as the glassblowers. I was to collaborate with a very nice Turkish man and his team. I would show him my drawings and he would then try and create them. I designed a series of glasses, ranging from a small liqueur glass right up to a brandy balloon. I wanted them to be colourful, with the stems like spotted palm trees. Also, I designed a glass fish, a bit like the glorious parrot fish you find on the Barrier Reef.

It's great to be in the factory so early. The fires glow inside the big black steel ovens and the glass blowers work swiftly and

confidently, making the glass at the end of their pipe, and then carefully heating it again to bend and to blow to the final shape. The magic of molten glass is hypnotic. Outside, the snow was still heavy on the ground and the girls in the design room told me of the joy they felt when the first little snowdrop appeared, hinting at the end of winter.

The first work session ends at around 8am. As most people live close to the factory, I was honoured to be invited to the glassblower's home for a second breakfast before returning for the next session's work. The pieces I made were crude and naive compared to many of the pieces being created by the famous glass masters that work for Kosta Boda, but people seemed to like them and the glassware became part of the Kosta Boda permanent collection.

Years later, at my gallery in Sydney, we were able to mount a large exhibition of the work of Bertil Vallien. Bertil and his designer wife Ulrika are a couple of the world's most famous artists in glass. It was thrilling to work with them.

* * *

And then there was the Cussons account, which enabled me to write a series of ads for Cussons Imperial Leather involving a plane with a bath – 'Tahiti looks nice' – and a robot handing soap to a woman in a bathroom inside an underwater sea-house.

Advertising before computers. What fun. We had to make a model of the sea-house, and design and construct the robot. A little like R2D2. This was around 1977, *Star Wars* time. Then we had to fly to the Great Barrier Reef to find a sheltered spot in the lee of an island to set up the sea-house in the calmest water

we could find. We left from Airlie Beach. Hard to find very flat water. Hard to keep the bloody model from floating about. It was around a metre or so tall. Tricky. The director and I had already had words during the sequence we'd shot earlier in Sydney, so things were pretty tense. But there can be no excuses. You have to make it work. You have to be in control and take full responsibility.

We finally finished, returned to the mainland and celebrated with relief that we finally got something. Later that night, someone set the robot off to walk down the deserted main street of Airlie Beach. Quite a sight as it disappeared into the darkness of the night. Someone's got it. Somewhere. I'd love to know even forty years later. Queenslanders!

We'd shot the bathroom sequence early on in Sydney. A big set down in Pyrmont Studio. The bathroom was surrounded by a huge glass fish tank, big enough so the whole thing looked underwater. Big tank. Lots of tropical fish. Lots of technical problems. Around 3.30 in the morning (we'd started at midday) tempers were running high and I felt that the director didn't know what he was doing and I think he felt the same about me. Then it looked like the tank might burst and we would be faced with hundreds of expensive tropical fish flapping around the floor and shards of glass spearing the robot, not to mention the lovely woman in the bath. Again, to remind you, in those days you had to shoot the whole thing 'live'. Doing it on a computer might cost about the same, but it'd be much less fun.

The ad ran for a few years, very successfully. A real 'soap opera'.

* * *

Continuing the bathroom theme, during my time at JWT I had the opportunity to work on an international campaign for Lux soap, although 'work' is stretching it a bit, as I hardly did anything at all. The union in charge of film and TV production had decreed that if any ads were to be shot overseas two people from Australia should be in attendance. So I found myself with my producer in Rome, with the stunning Claudia Cardinale. The production was directed by Dick Lester, who'd done The Beatles' *HELP!* film, and the still shots were to be taken by the famous young British photographer David Bailey. The main sequence of the commercial was at night, where we had taken over the historic square in Trastevere. The crew had spent the afternoon setting up the lights and camera position and I went off to buy a new cream linen suit.

When I arrived at the set, a large table had been dressed: the main shot was to be of Claudia sharing an evening meal with a group of friends. Everybody was in place when suddenly Dick Lester spied me in my new suit and insisted I should be the one to sit next to Claudia! Lucky boy. We were not shooting sound, but these things take quite a while to get right. I was quite hungry, so I couldn't help but sample the large plate of grilled prawns placed in front of Claudia as I attempted to chat to her. On the call of 'Action!' the director asked me to offer Claudia a prawn. No problem, but when I looked down at the plate, I'd eaten so many prawns that there were only heads left. So I had to offer Claudia something that looked rather like an old blowfly. Just as this was happening, we heard the sound of shouting, yelling and running feet and suddenly the square was filled with men carrying placards and screaming threats against President Nixon and anyone from the USA. Nixon was visiting Italy and a large

aircraft carrier was moored just off the coast. It could have been very nasty, but was saved when the chant of 'Nixon go home!' was replaced with 'Claudia, Claudia, bellissima!' and the gang of young men changed their feelings of hatred to feelings of lust.

The next day we went to a lovely old villa on the hills above Rome to do the still photography. David shooting, assistants hovering around, Claudia looking beautiful. The English actor David Warner was in town and he turned up to watch the show. He'd recently starred in a movie titled *Morgan: A Suitable Case for Treatment*, and we were delighted to meet him. He was a very nice bloke and stayed most of the day, and in the evening he insisted we accompany him to sample some of the best food and wine in all of Italy. We did. The food was spectacular, the wine delicious. When the time finally came, in the early hours of the morning for the evening to end, David made his farewell. That's just before we were stuck with the huge bill. That's showbiz!

A room with more than a view

I was devoting more and more time to painting, and I knew just where I wanted to paint. I first laid eyes on 'the Cabin' when I was fourteen. I'd walked around the rocks from Balmoral and came across this magic little building tucked under a big fig tree at the end of Chinamans Beach. It had an old loquat tree near the front gate and the whole garden was overgrown. Glowing ultramarine morning glories covered the old wooden fence and brilliantly coloured rainbow lorikeets swooped and dived around, screeching their joy of being there. And I wanted to be there. It was love at first sight, and I knew that one day, somehow I would have a relationship with that house. It took about fifty years to make it happen, but it was destined to be.

When I'd made a commitment to try and find my way as a painter, I knew I needed to paint. Sounds simple, but that's really it. Not talking about painting. Not theorising about painting. Not dreaming or pontificating about painting. Just painting

and drawing. Mostly making mistakes. Mostly failing. Mostly angrily destroying work. But working. Covering the canvas or the paper. I don't think there are any shortcuts. You need some natural talent, but you can't rely on that. You have to love it, to be obsessed by it and do it. Over and over again.

Long before getting the Cabin, I had my eye on another building, an old derelict shack behind the trees at the end of Chinamans Beach. Around the time I joined Jim's agency, I finally crept inside that old place one cold Monday morning. A couple of rooms and a veranda. No back wall, just chicken wire. Broken furniture, broken glass, lots of bottles and old papers scattered everywhere. I saw the front room could be a studio with a bit of clearing up. It had a couple of windows that still had glass in them and a glimpse of the beach through the trees. Perfect.

I swept out the worst of the mess and set up an easel near the window and some space on the kitchen table for a drawing board. I had no idea who owned the building or when it had last been occupied. So like some artistic squatter, I moved in.

I'd walk down there every Monday morning after taking the kids to school. I needed to find the discipline of working completely on my own. It was strange to go from a bustling agency situation, where I was surrounded by people and business problems to solve, to a silent space with only the wind and the seagulls' calls to share my day.

I loved it, and although I often needed to visit North Sydney to do some freelance work, I spent as much time as possible painting. One day, when looking through some papers and rags I came across an old business card. *Captain Lowick*, it said, *marine insurance assessor*, and a couple of phone numbers.

One of the numbers was finally answered. A rather gruff voice. I explained who I was and what I was doing and enquired did he have any relationship with the little house I was painting in. He told me he owned it, it was called The Nook and that it had been condemned by Mosman Council and at some time was to be demolished. I asked if we might meet and he told me where he lived and a meeting was arranged. He lived in a big concrete set of apartments at Manly on the end of the point, facing the harbour. I stood in the foyer, rang the bell and was invited upstairs. I'm not sure what I expected, obviously an old man. Maybe with a wife and a little dog or cat, and a neat and tidy little flat.

Not quite. When he opened the door, I was confronted by a huge man, red beard, naked to the waist, wearing a tattered old sarong. Behind him, in the middle of the sparsely furnished room, was an old Kelvinator fridge that was the centre and support for hundreds of empty beer cans: he was making a huge beer-can pyramid. He smiled while ushering me into the room, and suggested it would be a good time for an ale! Well, it was 8.45am after all.

The only other object in the room apart from the beer pyramid was a very large telescope, trained across the harbour to the nudists on Reef Beach opposite. Too early for a glimpse but I'm sure on hot days for him a bit of a perve and a handful of ales would be the order of the day.

He was a lovely bloke. And happy for me to do whatever I wanted with The Nook.

We would often have a barbecue down at The Nook on the weekend. Lots of friends would turn up and lots of wine consumed.

One morning though when walking down the bush track to The Nook I heard the unmistakable sounds of demolition. All my

painting materials and drawings had been chucked out and were being burned. All I could salvage was one window pane on which I had drawn an image of myself so it looked through the trees as though someone might be in there. A sad day, but inevitable.

It's fair to say that, as idyllic as those days might have been, it was a difficult time in Judy's and my relationship. We were going in different directions. The pressure of meeting the household budget; the ups and downs of painting. The needs of a young family. The approaching marker of forty. No marriage is a constant process of endless happy days. There will be hills and valleys, some deeper than others.

* * *

I had a little office in Ridge Street, North Sydney. A room to do advertising work and, on a tiny enclosed back veranda, just enough space for a little studio. It was no more than a metre wide, so you had to be pretty dextrous to work there. I started to need a copywriter to work with, so I was joined by the very clever Stuart Gibb-Cumming.

Stuart had a girl who did his books one day a week and suggested she and I might meet and maybe I could give her some work. Well, I certainly did and from that day for the next thirty years, Kate Harding became my secretary and close friend through thick and thin. Through triumphs and failures; through anonymity and fame. She was the first employee, and the whole family remains thankful for her help.

I had been wanting to have an exhibition of my work. And in the back of my mind, I'd been thinking about opening my own gallery. But I needed to show that I could have an exhibition

in a big commercial gallery first. My choice was the then Holdsworth Gallery. They showed lots of great Australian artists – Boyd, Olsen, Nolan etc and I hoped that the legendary Gisella Scheinberg might give me a show. I met with her at the gallery. She said she would look at some of my work and maybe consider exhibiting it. I rather naively suggested she should come to my studio. She laughed and said that's not the way she did things and I could bring some pictures of the paintings.

I said, 'No, you have to see them – some are quite big.'

She must have been feeling particularly generous that day, as she finally agreed, and a few days later she arrived in a chauffeur-driven limo and viewed my stuff.

The exhibition she offered was with David Boyd in one room, Greg Irvine (a rather decorative artist from Melbourne) in the second room and me in the main room between them. It opened on 29 June 1980, my fortieth birthday. Late for a first exhibition, but I had been getting ready for many years.

The most expensive painting in the exhibition was a long view from the Cabin studio, priced at $1500. I'd worked on it for months and months. No one bought it.

There were about thirty works in all, and some drawings and a print or two. About half the works sold, mostly the paintings priced around $500, and I went home thrilled with the response. You never forget your first exhibition. Though it's usually almost entirely filled with friends and relatives and should not be viewed as a barometer of future shows, mine felt like a good start.

The next day Aaron Kaplan, who had started a very trendy magazine called *Billy Blue* with an old friend, Ross Renwick, made an offer for the Cabin painting. He suggested $1000. I needed the money and sold him the work. We were able to

buy it back a decade or so later for $30,000 and it will not be for sale again.

A year or so after that first exhibition I painted the picture called *Sunday*. It's all about the joy of being in the Cabin. The yellow table in the foreground with the pattern of the paint and the brushes with postcards from various travels. And outside, the sweet frangipani. There's the pattern of the little boats and the mosaic of people on the beach and the rhythm of the clouds. A highly decorative and sweet painting. Like a sundae. Art to eat with your eyes.

It was only a couple of months later that I opened 'The Art Directors Gallery' in the front room of the terrace house in Ridge Street, North Sydney where I had my office. I knew a number of art directors working in agencies who spent time on their own work and I hoped that some of them would exhibit with me. Adrian Lockhart, Gus Cohen, Bob Marchant, Franklin Johnson, Bill Bowers and Steve Malpass from Melbourne, and many others. We had many openings with people spilling out into Ridge Street.

For my first exhibition at the Holdsworth Gallery, I'd shown a simple blue-and-white drawing of Sydney Harbour. Once I opened The Art Directors Gallery and started exhibiting there, I decided to print it on a few white T-shirts. Kate had a friend Jan who worked down in Milsons Point. We made twelve, with numbers on them like a little edition. I didn't at that time imagine we'd sell that many. I wanted to give them to the press to promote the exhibition. They liked them.

Marion von Adlerstein in *Vogue* wrote: 'You can hang a DONE on your wall or a DONE on yourself. There's an integrity to everything he touches.' That's one of the nicest things anyone

has said, and to respond to her belief, all I can say is that thirty-five years later we are still selling that classic design.

Once those garments were gone, we printed a few more, and I hung one on a coat hanger outside the Ridge Street studio with a handwritten sign that said *Sydney Harbour T-shirts $20*. Kate had a few in a basket beside her desk and every now and then someone would come down the hall and buy one.

We needed to advertise. *Billy Blue* had just been launched, mainly aimed at the advertising, design and architecture crowd, and it featured a lot of fresh Australian writing by Peter Carey, Phillip Adams, Derek Hansen and Ross Renwick. And cover art by Martin Sharp, Bob Marchant, Adrian Lockhart and me.

I did quite a number of covers, and always traded the artwork for space in the magazine to promote the Art Directors Gallery and the T-shirts. By then we had a small range. The classic blue on white T-shirt and a white on blue version, and even sweatshirts. Not the fashion garments that were to come later when Judy became the designer, but simple, flat pieces.

Art to wear. And at a time when there wasn't anything beautiful you could buy to show the image of Sydney. They were in demand. That meant we needed a shop. It needed to be where the tourists were. Not in Ridge Street, North Sydney.

Somewhere in the city — maybe The Rocks?

ART and Design

I remember lying in bed one Sunday morning with the papers when I saw a small ad offering the lease of a little gallery at 123 George Street.

'That's it!' I said, and on Monday morning I was there.

In the early 1980s, not many people went down to The Rocks. Mostly old winos and sailors. But I felt that in time that would change. The little building was the middle one of three, with a shop selling Scottish gear on one side and a little café on the other. There was no awning, as there is now, and the place was pretty run down. A sign proclaimed *The Arabia Gallery* and the front half of the space was devoted to displaying African artefacts. The back half was the consulate for Cameroon. It was run by the Consul Louis Brocheaux, a small, precise Belgian man, rather Poirot-like, with a statuesque blonde in very high heels as his secretary / assistant. It turned out later that parts of his collection of Benin bronzes were very valuable, but I didn't have the eye or the education to know that at the time. We got on well. He said that there were already a number of people interested and

began to regale me with stories of his time in Cameroon. What adventures he must have had.

He rather surprised me when he asked if I had ever made love to a pygmy. Well no, I had to admit, a couple of shorter girls maybe in my youth, but never a pygmy. He closed his eyes and reminisced about a time that clearly meant a lot to him. All the time, the statuesque blonde listened to all of this with a devoted smile. Even given my lack of experience with pygmy women, he sold me the lease and in a few weeks we moved in.

It was in need of cleaning up and painting, so one Saturday afternoon I rounded up my team of willing labourers – Camilla, Oscar, and their friends Antony and Kellie Rowe, Francesca Belli and the Morrison boys, ranging in age from six to twelve. I promised to reward them with banana smoothies at the old Gumnut Café. No unionised labour, just the gang of kids from our neighbourhood.

The first things we sold were T-shirts and sweatshirts, even some hand-printed pareos, as I remember, with the space divided so we could hang a few little paintings and drawings on the back wall. Kate looked after the sales and I set up a studio upstairs. People liked the paintings and the prints, and we began to attract quite a few tourists. Bits and pieces were published in magazines and newspapers about the little shop. Everything was designed by us.

I had an office upstairs and was still doing the occasional advertising job to supplement our income and pay the bills. My cousins, Jennifer and Christine, had joined the staff and the downstairs shop had changed its name to The Sydney Harbour Shop and was starting to be filled with lots of touristy stuff.

When *The Most Beautiful Girl in the World* TV program came to Sydney, we were asked to supply garments for the contestants to

wear. The shoot was at the Darling Harbour Convention Centre and I was invited to be there. I'd taken a new limited edition print to give to the host, David Hasselhoff. Lots of girls were in bikinis we'd had made, gliding along wrapped in our tropical pareos. Sitting in front of me was a then well-known parliamentarian. He had been a popular and successful sportsman and loved the glow of power and fame. He asked what I had with me and I explained it was a limited edition print for the show's compere.

'Let me see,' he exclaimed. 'I'll sign it too!' thinking this would add considerably to its value and importance.

Before I could explain that it was a limited edition print and should only be signed discreetly along the base, he whipped out an industrial-sized black marker and wrote his name in huge letters across the middle of the drawing. I doubt that it added any value, and I bet it's in a bin somewhere.

Not long after that we were approached by *60 Minutes*, then the top-rating Sunday-night show, hosted by George Negus. There had been a few newspaper and magazine articles about my paintings and the little shop, but this was really the big time. George and his partner Kirsty came for a kind of pre-interview and before long I found myself with him in front of some paintings surrounded by the whole *60 Minutes* crew. It was a nice coincidence that only a few years earlier I had actually produced the first press ads for the show.

The exposure of *60 Minutes* certainly helped to expand our custom. I was able to rent a space directly behind the shop, in Nurses Walk, a great little laneway, still in the shape it was in from convict times when the first hospital of the colony was nearby. That meant the building on George Street could become all shop. With more space, we needed more stuff to sell. To that end, Judy

joined the business and began to design swimwear, resort-wear and homewares to join the ever-increasing numbers of tees and sweats. Some days you just couldn't get in the little shop. There would be a line of tourists, mostly Japanese, outside on George Street, and the shelves would have to be restocked several times a day.

We acquired a warehouse and extra family members. My aunt Nancy worked there sometimes, and Mum was a constant visitor. She really wanted to be either the store detective or the lady who stood by the door and informed the customers that her son did all of this.

I've loved Japanese haiku ever since I bought a little book called *The Four Seasons*, with works from various Japanese poets. Over the years I've made a number of artworks inspired by them. *Butterfly Dreams* and *Experimenting With the Moon* are a couple.

I would learn of their dreams in flowers. But ah, butterflies have no voice.

As a butterfly lives for such a brief period of time, even its dreams would be full of the thoughts of beautiful flowers. I've made two large paintings to this poem.

The other I've mentioned is *Experimenting, I hung the moon on various branches of the pine.* I take this to mean that not only as an artist would you choose to carefully position the moon within a painting, but simply as an observer when you gaze at the moon, you position yourself to get the best view. You become part of the work of art.

2015

This morning we went down as usual to have a swim and breakfast at the Cabin. It has the promise of a beautiful day. Cloudless sky. Warm early morning light. I like to sit for a while on a wooden support of the next-door slipway. Just to sit and look around quietly. The tide is going down, probably half tide, and the water is very clear. Out in the bay there are still hundreds of seagulls floating around, looking for the next breaking water to show them where their baitfish breakfast will be.

With big schools of baitfish there will be bigger fish, probably tailor lurking in wait and suddenly churning the water as they lunge for the little guys. And then behind the tailor, maybe a kingfish, and I guess out in the channel a bull shark or two, gliding silently up to the back reaches of Middle Harbour to mate. I won't be swimming too far out. The smoothest way in (I've still got a bit of gout in my foot) is to walk down Tom's slipway till it's covered in sand. I like to again just stand there for a bit.

Our neighbours today include internet entrepreneurs, liquor barons, racehorse owners and breeders, bankers, judges and lawyers. And a few people like us who've been here for years. There's also a few artists. In the early part of last century there were famous artist camps at Balmoral and Sirius Cove, where Streeton and Roberts produced some of Australia's most recognised and memorable paintings.

Nowadays, living close by are Jo Bertini who does wonderful paintings based on her many trips with camels out in the desert, the noted sculptor Anne Ferguson, Michelle

Belgiorno, whose work shows a love affair with Japanese art, and Rob Piggott, who occasionally makes a bright construction wood sculpture or simply paints or draws with his grandkids directly onto the peeling paint on some of his old walls.

Then around the headland is Paul Delprat. Paul runs the Julian Ashton Art School in The Rocks. It's an institution and has been there for years. Started by his great-grandfather, it continues to teach the classic skills of drawing and painting. Paul has had a long-running disagreement with the Mosman Council over a little piece of land that should be the right of way to his property. The disagreement has been going on for years and has often turned into farce. So much so that in a fit of anger and dismay, Paul decided to secede from the municipality. He has set up his own principality and appointed himself as the Prince of Wy, with his wife as consort and his daughters as princesses. Paul is often on the front page of our local newspaper, wearing his traditional robes and crown, and still feels aggrieved at the lack of council understanding. He's clever and funny and always has a story or a poem to offer any conversation. He's a fine painter: one of the best pictures I've seen of his is a small one illustrating the John Willis shark attack. The attack happened on the rocks just below Paul's house. I still swim there near those rocks at the sheltered little beach called Edwards Bay, but again, not too far out. When I was a boy, the postman lived in a little cottage tucked into the rocks at that spot. It looked idyllic. A faded blue tin roof, a few daisies around the little front door. Sheltered under an old loquat tree, with a couple of frangipanis at each end of the little veranda. The council knocked it down.

UP from something

In the early 80s, Olivia Newton-John and her then business partner Pat Farrar came to visit and told me about their desire to set up a shop called Koala Blue in Los Angeles. They had seen our little shop in The Rocks, and asked if I would do the logo for her proposed company and a few designs for them.

I was flattered. I liked them both and after a lunch with Olivia at the coffee shop in the old Regent Hotel, I agreed to do it. For free.

From then on it was a series of handwritten notes between them and me and I sent off the logo and the first designs. They loved them and I was happy to be part of something that was set up to promote Australian design. Not long after they had produced the first garments, they wrote to say they planned to use the logo and drawing on lots of different things.

OK, I said, but now it can't just be a gift. To get things going we are going to have to enter into a proper licensing arrangement where I would receive a small royalty on everything sold using my designs.

Instead of the usual little handwritten note, I was stunned to next receive a letter from their lawyers. On one of those lawyers' letterheads where all the partners' names are listed down the left-hand side. The letter indicated that they had no intention of entering into any ongoing business relationship.

In other words, fuck off. I was less than amused. I was very angry and disappointed, and feeling let down.

Well bugger it, I thought, I'll just accept that I've given them the designs and let them do what they want, and let that be a lesson in life and in business.

A few months later, after the original Koala Blue store on Melrose had opened, I received a call from the US.

'Ken Done?' the voice enquired.

'Yes, that's me.'

'Bart Jacobs's the name. I hear you did those designs for Koala Blue. I've got a shop in Malibu and I wondered if you'd do some for me?'

As I felt little loyalty to Koala Blue by then, I agreed, and sent off some new koala drawings to Bart. He was excitedly on the phone a few weeks later:

'Ken, Ken,' he explained, 'they're walking out the door. Do you do bunnies?'

Well, not really, but I sent him a few bunny drawings, a bit like koalas but with long ears. Again, a few weeks later, that same enthusiasm for the design and then he enquired if I did Scottie dogs? Scottie dogs, he exclaimed, were very big in California and he'd love some Scottie dog drawings.

'Mate,' I said, 'look, if we're going to work together, you'd better come to Australia and we'll see if we like each other and can work out some business arrangement.'

A week later he called. 'I'm here. At the Regent. Just up the road from your shop. Come and meet me.'

'How will I recognise you?' I asked.

'I'm tall,' he said.

Bart is tall. Very tall and very nice. Over the years we became great friends with him and all his family and for around seven years or so had a happy and profitable business association. Even though that is now concluded, we're still friends. That's how business should be. We went through bunnies and Scottie dogs to many, many designs for Thanksgiving and Christmas, Easter and Hanukkah. I did logos for lots of Californian and mid-western cities.

Once in LA, we arrived at the time of Passover and were invited to the family seder at their home in Brentwood. All new to us. I was seated next to an old uncle who served in New Guinea during the war. He regaled me with a tale of his exploits during this time and repeated the same story many, many times. Every time we sat together he would tell me the story, as if I'd never heard it.

When Bart decided to take his business in a new, slightly different direction he on-sold our licence to another operator. Not a bad bloke, and very keen to see if he could get me into the Disney area of licences.

So one day there I was in the studio headquarters of the animation department. We'd been directed down Mickey Avenue, past Cinderella Place and around via Dopey Drive to the correct building. They, Disney and our new licensee, were very keen to explore the possibility of me working with some of their classic characters, Mickey, Donald, Pluto etc. And they wanted me to try and create some new ones.

Tempting, but not really the direction I wanted to go in, and the commitment would leave absolutely no time to paint, which increasingly was my main endeavour. After the first exhibition at the Holdsworth Gallery, I was still doing some commercial design. The client from the US would call with the need for a few drawings and I'd quickly knock them off, send them downstairs to Kate and Kyoko and spend the rest of the day painting.

Every day I was flat out to fit it all in: the needs of the shops, the needs of the US and the licensees in Japan and the US and Australia and the painting. No wonder I had no time (or interest) to check the books.

Over the years, we were often credited with designs that were not mine. Especially in Australia, a garment or object that had bright colours was often mistakenly thought of as coming from me in some way. And the 'simpler' we made things, the easier they were to copy. In the US they take action if they feel the design is being knocked off. And when our licensee found numerous designs in the LA airport that were clearly copies of mine, the whole thing went to court. We won. The offending garments had to be disposed of and we eventually received the money we would have got had the designs in fact been ours.

Once I received a T-shirt that was clearly a knock-off of one of my 'Classic' Sydney designs. It was line for line correct and all the colours were spot on. The thing that gave it away was that written under the image were the words *Gulf of Thailand*. Now I know the Thais are very industrious but I didn't notice the Harbour Bridge or the Opera House last time we were in Bangkok. I like to think it was some poor woman with ten kids who printed it in her garage and just thought it was a nice picture. Who knows?

As for licensing, although the wording by the lawyers is very complex, a licence is really quite simple. You've got to want to do it, and you've got to like the people. That's it. Desire and trust. If any of those parts falter, you have to close it down. Naturally, both parties want it to be profitable. They usually offer say four or five per cent of the wholesale price of the object. You can sometimes bargain for more, but that's roughly it.

When I look back, I realise I didn't really know too much about the day-to-day accounting of those areas; nor did I care. It only came down to whether I wanted to do it. In 1999 we were approached by Mervyn's, an American company that had almost two hundred stores across California. They had seen our designs and were keen to use them to develop a brand coming from Australia. To that end, we licensed the Down Under brand, as I wanted to keep the Ken Done brand associated only with art and art-related products. They had planned to do quite a range of clothing for the whole family, as well as almost everything else from sporting outfits to beach toys. As the licensor, we retained the right to approve any design or product and for quite a while it worked very well. When the boys from Mervyn's arrived to sign the original contract, it was Australia Day and we picked them up from their hotel beside the harbour and tried to convince them that all the boats, fireworks and celebrations were for them. They were nice guys and good fun, and although the licence only lasted a few years, we did well out of it. And so did they.

Sheridan and Hale were great. Oroton were good at the start but after a while we had our doubts. They had opened a warehouse in the US and were very keen for us to renew our arrangement well before the due date. I guess in a purely business way they just wanted to be sure of their cash flow. We agreed

to sign almost a year early. But in the next year it became more obvious they were really only interested in their image and position of their brand in the marketplace and that they simply saw us as a source of revenue.

Things were also done in Japan that I was unhappy with. I remember one meeting in Sydney that ended in Judy's tears. She rightly felt passionate about our image. They led us to believe they felt otherwise. Lesson: don't make my wife cry. We no longer work with them.

Sheridan was another matter – people still want to know if we do bed linen. Great quality – lovely products. When the first duvet covers appeared they were an immediate success. Maybe it was because there just wasn't much colour in bed linen in those days or maybe it just struck a chord with a certain customer. I didn't just treat them as bedroom stuff, but like a big piece of design, a bit of art to sleep under. Very Matisse-influenced.

* * *

In 1986 I was approached by the boys from Mojo Advertising to be in a campaign promoting Alan Bond's beer – Swan Lager. It was planned to coincide with the America's Cup races off Fremantle. Three ads were to be filmed. One with Greg Norman, one with Ben Lexcen and one with me. The concept was based on the lines: 'They said you'd never make it, but you finally came through. For all of you who made it, this Swan's made for you.' It was suggested we should shoot in Los Angeles and that the concept would revolve around the work I had done in the launching of the Koala Blue store.

As flattering as this was, I convinced them that koalas just aren't masculine or sexy enough for a beer ad, and it would be better if we went to Paris, for instance, and revolved the ad around girls in bikinis. Much more 'beer-ish'. So there I was, in a big sheepskin coat, running up from the Metro to enter a fashion show. Me onstage, lots of beach girls, toasting the crowd with a Swan lager. No doubt this TV exposure was great for business, both for the brand and for me. People still remind me of it, and I'm proud to say it's available for viewing on YouTube.

The Shop becomes an Empire

Business was booming. About this time we began the licensing arrangements with Bart in America, Oroton, Hale and Sheridan in Australia, and an old traditional company called Fukuske in Japan. We rented part of a warehouse in Pyrmont.

I put on Colin Bush, who was about to retire from David Jones, as managing director. He then brought a young salesman to the business called Chris McVeigh, who took over as MD when Colin left. He did a great job for many years. We also hired an in-house accountant, Paul Lister, who is still with us now, as general manager.

We bought our own warehouse in Moore Park, took over the lease of the shop next door on George Street – the one that had sold the Scottish stuff – opened a shop in the QVB, put on more staff and yet more family members. Allan, Judy's brother, opened a branch of the business in Avalon, and when they moved to Surfers Paradise where we had a shop, he fortunately agreed to take over our operation there. The first Surfers shop had done well but I suspect that some of the profit got slightly displaced

between the clothes racks and the till. Couldn't prove it, but we were relieved when Allan and his wife Trish took over.

After a while we were able to buy our own building in Surfers on Orchid Avenue and for ages it was our most successful outlet. We also opened a couple more stores on the Gold Coast and then in Cairns. We were able to buy a great little building that was the original telegraph office in that city, and a building behind. It did very well for a few years, and now that we've closed all our shops, maybe one day it will become part of a big international hotel. Cairns is a bit of a boom and bust town, so it's just a matter of timing. Maybe the grandkids will appreciate it one day.

In all, by the late 80s, we had fifteen shops, around a hundred and fifty permanent staff, and we were wholesaling across the country. The bed linen we had designed for Sheridan became immensely popular and that led to me having to do store appearances. Not my favourite thing, although it is very flattering to meet people who like what you do.

I did one at David Jones. I was asked to be at the main store on Market Street at 10.45am, and they asked if I could wear a tropical suit. So I arrived on time, clad in my best white linen outfit. At the top of the main escalators, they had placed a big bamboo table, covered in enough art materials to do a major mural or the Sistine Chapel, and they had arranged large fake palm trees to flank the desk. The whole thing was dominated by a big banner above the desk, spelling out my name in multi-coloured letters. It was like a bad set from *Fantasy Island*.

I took my place and waited for the first customers to arrive. You see their heads first as the escalator rises to the first floor. You are right in front of them. You smile expectantly. They glance at

you and quickly move away, left or right. Here come some more, maybe these women will stop, you hope.

But no, left or right, to some other section of the store. At last a lady stops, stares, then finally approaches the desk.

'Are you Ken Done?' she hesitantly asks.

'Yes!' I reply.

The clue should have been the big bloody coloured sign above my head, but no matter, she was there. She said a few kind things about my work and began to move away.

'Wait,' I said, knowing I needed to do something to keep her there, to avoid more of the loneliness and disappointment of the escalator view. 'Would you like me to do a little drawing for you? Maybe a little Sydney Harbour sketch?'

'OK,' she replied.

Now you can probably guess that I've done lots of Sydney Harbour drawings and that I can do them quite fast. I was just about to whip one off when I realised the moving away predicament that faced me in the immediate future. To that end, when I finished the city and the bridge and the Opera House, I decided to add on North Sydney and then a bit more up to Chatswood and Hornsby. And then the other way, south to the airport, almost down to Bulli. I kept her there though and generated a bit of a crowd.

She might have chucked it in the bin when she got home, who knows, but it served its purpose. Sort of performance art. Very popular with your average black-clothed curator of modern art galleries today.

* * *

What was happening with the painting, you might well ask? I gave it everything I could, any time I could. I had the Cabin by then, and most days would find me in there, hard at it. Sometimes painting comes easy but most times it's the journey and adventure of not knowing how it's going to end. That's the pleasure. Starting with an idea and seeing where it takes you. Some days you want to explore the view across the harbour, or the pattern of people on the beach or some days a picture about Japanese poetry or some days a painting about Ray Charles or music or who knows. You set the problem yourself and no matter what, it never ends quite the way you imagined. Lots of times you have to destroy the work. As you get older you get better at editing. When you're young you show many things, eager to prove what a clever boy you are, but in time you understand to show less. Do what you like.

You may have noticed that I use the word painter more than artist. Artist is a very, very overused word. A student might say when they leave art school, I'm now an artist.

Well, no.

Ask again in fifty years. Ask after five hundred paintings. I reckon it takes most of a lifetime to use the word artist correctly.

2015

We have breakfast at the Cabin every morning. From the main house, the minute my eyes open, I can see and sense the day. From the bedroom window, I look down on the beach and the gardens stretching below. To the left, the big palm and across to the mulberry tree and the pond. I see the old olive tree where the ashes of my mum and dad are. A simple rock marks the place. The rock looks vaguely like two figures and the olive tree's branches interlock on one side. To the right, I see the magnolia tree, resplendent sometimes with its pink and white flowers. Along to the vegetable patch, up against the old stone wall and past the frangipani and the gazebo to the morning sun. Today, late summer, the first rays of light strike the treetops above Parriwi Road. Then down to the houses hugging the cliff before spilling onto the beach below. Our end of the beach is still in soft violet shadow and the warmth of the morning tells you of the hot day to come.

We walk down past the figs. Frangipani. Orange. Lemon. Mandarin and lime trees. I turn on the switch that starts the little waterfall, then down the last few steps to the front lawn that juts out into the harbour beneath the camphor laurel tree. The tide is rising. The water is clear, a pale emerald. We feed the waiting lorikeets, screeching with joy, casually displaying their amazing colours: orange, ultramarine, yellow, red, lime, dark violet and aquamarine. Next, bread for the waiting seagulls, then finally a walk along the beach and back to the Cabin. We know how lucky we are. There are not many people who can start their day like that. We never take it for granted. And never will.

Land of the Rising Done

By the late 80s, the business had expanded still more and we'd purchased a beautiful old warehouse in Thurlow Street Redfern. It had a huge airy attic that I turned into the studio, and we added a balcony from which you could look to the city and across to Moore Park. All the parts of the business were there: my studio, a gallery, the graphic and fashion design studios, all the administrative offices, warehousing and dispatch, and we were even printing our own t-shirts and silkscreens. In 1993, after graduating from university (Visual Communications, with first-class honours, I'm proud to say), Camilla came to Thurlow Street to fill in for someone who was on holidays and get her portfolio in order.

Camilla is a perfectionist and has a great eye, and during those years at uni she hardly asked me a question – for no other reason than she wanted to achieve things with her skills. And she did. It was a joy to see her receive her degree. Both the children have been exposed to the media from a very early age, and they learned not to take anything too seriously. Even when I was surprisingly named Father of the Year in 1989, and they suddenly found

themselves being interviewed on TV, they seemed to take it all in their stride.

Camilla has a great sense of humour and is the most loving and generous person I know. She and Oscar have a very close bond, and it's a joy to see them working together. They grew up with the business, and they drive it now. Oscar has developed an amazing ability to see opportunities for us, and has become very entrepreneurial. He was born about five years after Camilla, so there's never been any sibling rivalry. They are best friends and by far the best thing Judy and I have ever created.

When Oscar left school, he had no real interest in becoming part of the business. He worked for a very smart ad agency, and then travelled to the US and Europe. When he returned, he'd still not really decided on what to do, so he came to the warehouse and eventually got involved in the business. He learned fast: he's now the managing director. He's great. He's inventive and bright and, with Camilla, he's building the business into a much more diversified group than I ever did. They are both clever, good people. I think working together we have each found our place in the team and we see all the people who work with us as part of the extended family.

As I've said, our licensing in Japan began in the late 1980s. Tokyo is a fascinating city at any time and in the early 1980s had a real boom. A Japanese critic once commented that I showed Japanese people what they were not, and suggested the freedom and brightness of my work elicited a strong response from them. Young Japanese girls especially responded to the designs we showed in the first little shop and I've always been grateful for their enthusiasm about my work.

I travelled many times to Japan and made many store appearances. It was amazing to arrive at a big department store

and find, unlike at the David Jones signing experience, a huge crowd of people lined up politely along a wall, carrying armfuls of our designs and waiting for me to sign them. These sessions sometimes went on for hours and you really had to concentrate. I would have a Japanese assistant sit beside me to listen to the customer's name, write it in English and pass it to me. I then could personalise the signing and I would often add a drawing. If I began to draw cute koalas there would be screams of delight.

The work in Japan led to many things. Probably the most important were the covers I did for *Hanako* magazine. I visited the *Hanako* magazine people when they were still planning their product, and made contact with Miss Chie Matsukawa, who had showed great interest in my work. Then we were contacted by the new editor and he flew to Australia to brief me on the project. *Hanako* was a magazine created for young Japanese women from around twenty to thirty – these were the women who were changing Japanese society. He was a nice man and asked whether I would do the logo for the magazine and the cover.

I thought he meant the first cover. Little did I know that the magazine would run with my artwork on every cover for the next thirteen years. I'm sure there's not another publication in the world that has used one artist's work in this way. The publishing company, Magazine House, produces some of the most successful magazines in Japan. On rare occasions, say the Birthday issue, they might request a certain kind of image, but by and large they left the cover design up to me.

In a sense, I hardly did anything for it. We simply sent up, every few months, images of all the paintings I'd been working on and from those paintings the editor and art director in Tokyo would choose an image for their cover. That meant in

the crowded display of newsagents and booksellers in Japan, my work really stood out. It sold close to a million copies each week and spawned a sister magazine called *Hanako West*, which came out monthly.

As I had written the logo in my hand, in Japanese law it meant that I owned the visual expression of that word, so that even if they wanted to make other products using that word, they first had to strike a business arrangement with me. This is international art in modern times! When they decided to create Hanako chocolate or Hanako Travel or a Hanako decorated car, they would first have to have my approval.

It shows you something of the visual sophistication of the Japanese that they would respond to a mass-market magazine with art on the cover. The chairman of Magazine House, Mr Shimizu, even asked if I could make some drawings to a series of haiku poems that he had written.

After thirteen years, they decided to change the cover concept and now run with more fashion-related imagery as the magazine has moved further into that area. But even now, my name still appears under the logo and a fee is still paid for its use.

Here's a piece that was written about my appeal to the Japanese:

In 1993 Done was included in Yusaku Kamekura's final issue of *Creation: International graphic design, art and illustration.* The twentieth volume of this collection completes Kamekura's long-standing project to document and publish the best of the world's graphic art, design and illustration. Inclusion in this publication, acclaimed and distributed widely throughout Japan and Europe, marks a recognition of the maturity of Done's imagery and technique. Yoshihisa Kinameri described

Done's reception by the Japanese in the text accompanying the twenty-four images:

Particularly noteworthy is the impact Done has had on international corporate management ranks in modern Japan. In the pre-war era, Japanese entrepreneurs nearly worshipped the works of the French Impressionists – Renoir for example – which they eagerly collected and placed in local art museums. Today's Japanese business leaders display equal fervour for the works of Ken Done. Why?

The answer lies foremost in the overflowing colourfulness of Done's works which positively affirms the wonder of life itself. Whereas the majority of contemporary artists seem to pursue courses of self-destruction or self-assertion, Done's works – like those of the Impressionists – are socially 'wholesome'. This is strongly evident in his treatment of colours: Done's colours exude a certain 'stability', a sure-footed balance.

Members of Japan's management ranks like works which follow a proper path; they shun works that undermine social stability. Done uses colours of 'pre-established harmony'. They are colours of florid splendour, yet underlined by a clear measure of diligence. It is this diligence which Japanese pursue at every juncture – even in the realm of art.

Yoshihisa Kinameri, 'Ken Done', *Creation 20*, 1993, taken from
Ken Done Paintings, 1990–1994, Done Art and Design

Another amazing project was when I was asked to design a beer can for Suntory. I was hesitant at the start but when they said they would be using the first picked hops from Tasmania and that the beer would be called Beer Nouveau, I was won over. In the first

year, the brand sold around 800,000 units, in the second year, 1.3 million (it was a hotter summer). But because of the importance of the brand, it led to the launch being held at the new Australian Embassy in Tokyo, complete with the Qantas choir, seafood flown in from Australia and a huge ice sculpture, symbolising the beer. And more than that, it led to the chairman of Suntory visiting the Australian Embassy for the very first time. This was a pretty big deal. But to my memory it received not a line in the Australian press.

I've played a few games of golf in Japan. They have all been very memorable occasions. The courses are beautifully manicured and the game is just one part of a full day. You're picked up early at the hotel, then after an hour or so, breakfast at the club. Then the first nine holes, a lunch, then the following nine. Back to a sumptuous clubhouse for an afternoon steam bath and then some time called 'joyful chattering'. Getting slightly drunk could be another way of putting it. Then back to Tokyo for dinner and many more drinks. That's golf in Japan.

However it was my first Pro Am that was the most important. It was sponsored by Suntory and I flew up specially for the match. I expected maybe a few hundred spectators and a couple of photographers. It turned out that the Pro Am was televised and had about 10,000 people following the game. Lots of the world's best pro golfers were there and a number of Japanese stars. Among the amateurs were Japanese pop singers, movie stars and top businessmen. I was given a set of clubs with my name emblazoned down the side of the bag. Pretty classy stuff. My handicap in those days was around twelve, so I wasn't too bad and one of the things I was best at was driving. I could hit the ball a long, long way. I was in a group with Brian Jones, a pro from Australia who

lived in Japan and had done very well on the Asian circuit. My other companions were the managing director of Suntory, the ex-British ambassador and a leading businessman. Following us were the chairman of Suntory, the current British Ambassador, a famous pop star and one of the Ozaki brothers. There was a bit of a holdup at the ninth tee. Some fans even called my name and snapped some quick pictures. We waited to hit off in front of two large stands of spectators. As there was a slight break, it was decided we should do a group shot, all together, looking very smart, ambassadors, chairmen, stars, top pro golfers, big-time businessmen, and me. It was my turn to drive off, as I'd done quite well on the last hole. I teed up the ball. The crowd were silent. I took aim. Visualised the shot. Took the club back, swung down and through to a perfect follow-through. Unfortunately I'd managed to just make contact with the very top of the ball and it trickled along the ground for no more than a metre or so. I heard a sound from the crowd that I'd not heard before. It was the sound of impending death. The crowd knew that the correct thing for me to do was to kill myself, there and then. Attendants would silently arrive with a stretcher and my body would be whisked away to a small polite round of applause. These thoughts were going through my mind as I bent down to pick up my tee. Then suddenly I realised how great this experience was, because I had reached the pinnacle of embarrassment. Or maybe the correct description would be the ultimate depth of embarrassment. Whatever it was, I knew I'd never be embarrassed playing a bad golf shot again. I can now quite happily stand on the first tee at Elanora, hook the ball hard left, into the rocks, and have my drive ricochet back across the heads of my companions, into the bushes on the right as I casually walk up to my bag for another ball to

hit a 'provisional' shot. No, I'll never be embarrassed playing golf again. Well, maybe. You never know!

The other great experience in Japan was when I was asked to design the logo for a new town being built not far from Osaka. It was being built by the company that owned the Keihan Railway and consisted of four precincts, North, South, East and West Rose Town. The first building was an art gallery / community centre and the townhouses surrounding it were large by Japanese standards.

I took my mother and Judy to the grand opening, and in classic Japanese style, I stood with a line of dignitaries all armed with golden scissors as we cut the ribbon to announce the opening of the town. It was interesting that the first building should be an art gallery. This is the image they wanted to set for the town.

In 1991 I had my first major exhibition in Japan. It was organised by our friend Chie Matsukawa and the *Yomiuri Shimbun*. It travelled to five major cities across Japan – Tokyo, Osaka, Shimonoseki, Fukuoka and Nagasaki. They produced a lavish catalogue and we attended the opening ceremony in Tokyo. These openings are quite grand. Lots of flowers sent by wellwishers and yet again a ribbon cut with golden scissors by me and a group of dignitaries. It was estimated that almost 200,000 people would have seen the show after it had visited all the cities.

The second major show, in 1993, was in a beautiful and prestigious building in central Tokyo with a large atrium foyer design by Isamu Noguchi. He is one of the world's most acclaimed sculptors and had created an amazing space of large granite platforms with a gentle stream flowing down through them. The ceiling consisted of fourteen large panels, and I created fourteen large paintings exactly the same size to complement the

space. The building is the headquarters of the Sogetsu School of Ikebana and is owned by the famous Japanese film director Hiroshi Teshigahara. His son directs the school and had created a special arrangement of an old cherry tree and flowers to be shown with my works. The exhibition was opened by Lee Ufan, a most revered artist who has a number of works in our National Gallery and other major galleries throughout the world. His work is very minimal: simple brushstrokes mostly in grey. It is almost the opposite of mine, but he spoke glowingly of the colours in my paintings. These were large works based on walking down through our garden to the sea. It was a great honour to be given the space and a great honour to have the exhibition opened by such an artist.

Again, it didn't seem to rate a line in the Australian art press. However, some people must have been taking notice of what I'd been doing as I was very proud to receive the Order of Australia. I have no idea who nominated me but I can only thank them. I am immensely grateful for receiving this award and my only disappointment is that my father was not around to see it happen.

When we purchased the building in Thurlow Street I doubted we'd ever fill it, but it wasn't long before we did. Members of the family all worked there: Christine, Jennifer and another cousin Linda, and at stocktaking time my aunts and uncle would help.

We employed a few nice Greek ladies from the street and we spent many happy years there. Having the Greek ladies meant lots of treats, especially on religious days. Big plates of dolmades, galaktoboureko and biscuits. We really felt part of the Redfern environment. We turned the big top floor into a gallery, the Moore Park Gallery. We showed a number of Australian artists' work and on opening night James Morrison and Don Burrows played for free. What a joy. They are superstars, and although Don is now not as sprightly as he was, James continues to travel the world displaying his amazing talents and abilities on many instruments. Looking back on those days, I'm stunned to think that now his adult children regularly play with him – they're great. The last thirty years have gone too quickly.

We showed works by Bob Marchant and I bought the biggest work there both to help him out and because I liked it. The painting went on to win the Sulman Prize: a good result for us both.

Martin Sharp called me one day to ask if I'd like to look at the work of a bloke called Harold Thornton. I'd seen Harold around town and even before I saw his body of work I knew I liked him. Harold wore a bright little hat, a Technicolor coat, bright green trousers and big yellow shoes. The back of the coat carried the sign *World's Greatest Genius*. A big claim, I know, but it showed a certain confidence. Harold had spent quite a few years in Amsterdam and had once decorated the front and interior of a café / smokehouse there. He may have smoked a joint or two in his time, but the body of his work was great.

He showed me paintings of Darlinghurst and Kings Cross in the 40s and photos of the windows of the café, now in storage, in Holland. We agreed to pay the cost of bringing the windows and paintings to Sydney, around $20,000 I remember, and we arranged to show them all at our gallery. The opening night was a buzz. Harold holding court, his eyes twinkling, his white beard glowing against the brightness of his outfit. Surrounded by admirers and pretty young girls, he was having a great time. I don't really know where all that stuff is now but I hope it's safely packed away somewhere. I know the National Portrait Gallery has the painting he did of Bob Brown and all the people trying to save the Franklin River in Tasmania, but I have no knowledge of where the rest of it is.

Judy had an old friend who at that time worked closely with the brilliant pianist Roger Woodward. Roger asked if I would do the logo for a new festival he'd planned for Sydney. It was to

be called the Sydney Spring Music Festival and I was happy to help and there would be no charge. He kindly offered a private performance for us one afternoon. We arranged for a piano to be winched up into the gallery and quickly organised for family and lots of friends to attend. Roger is a kind and generous man and one of Australia's, if not the world's, great pianists.

Around this time we held an exhibition called *Paintings from the Cabin*. Elwyn Lynn, the art critic at *The Australian*, wrote this:

> Ken Done, as everyone knows, is hedonistic assurance itself. His present show, Paintings from the Cabin...shows he's extracted what he's needed from Hockney, Bonnard and Matisse. Done can set grounds awash with rich stains that Bonnard might applaud and divide canvases like *Model in Backyard*, 1985, into areas of rich Matissian patterns...he again and again provides dashing, spontaneous escapes, especially in linear depictions of yachts, jetties, sails, bathers, bridges, and fishermen. His world teems with joyous, really relentless activity.
>
> Elwyn Lynn, art critic, 'Calm amongst the frenzy',
> *The Australian*, April 3–4, 1993

Art does not drop out of the sky and hit you on your head. I've been influenced by and learned from many, many people. I guess the key ones would be Van Gogh, Matisse, Bonnard and Picasso. But they are just the well-known ones. In Australia, Nolan, Williams and Whiteley clearly have meant a lot to me, as has the American painter, Milton Avery. Every time you make a work, you can see or feel the influences of a lifetime of looking. Sometimes the pleasure can come from some little work done by

an unknown painter in a little country art show. Who knows? This morning, I looked closely at a couple of shells I picked up from the beach and then I gazed into the petals of a pale mauve and yellow freesia. What could be more beautiful than that?

As part of the festival, Roger wanted to gather some musicians and improvise an hour or so's music in front of a big painting of mine. I was thrilled and flattered. It took place in the Art Gallery of New South Wales. The painting hung against a long wall. There was an audience of two hundred or so people and Roger on piano. James Morrison was on trumpet and flugelhorn, with a trombonist and a drummer. They simply stood in front of the work and improvised.

The painting was called *Playing on a magenta reef* and is in a big private collection in Italy. Sadly, the performance was not recorded, and only a few photographs exist. I heard that a few older members of the Art Gallery Society were against the whole thing. Now you can attend many jazz or classical performances in the gallery, and so you should. An old friend, Pat Corrigan, regularly organises performances by James Morrison there. The last one was very special. James appeared with his quartet and, as a surprise guest, Don Burrows. Don was James's mentor all those years ago at the Conservatorium. They played together for years, all around the world. Sadly Don has not been in the best of health and lives in a retirement home in Frenchs Forest: he suffers from Alzheimer's. Judi, James's wife, had gone with a limo to pick him up, and it was hoped he might play.

He's a shy bloke, Don, but he was visibly moved by the reception he received when it was announced to the crowd that he was there. And when he went on stage, it was as if time had rolled back. He carefully assembled his clarinet and played as he

always had. The notes soared with joy, leaped and curled and then melded seamlessly with the thrilling trumpet sounds of James and the band.

How I envy the musician, to be able to play other people's compositions, to play in the company of other souls, to bask in the applause of an appreciative audience. How great. If I do a good painting, the dog barks twice.

LOSING A LOT OF MONEY

During those years I was so busy getting the products we were making and the paintings I was doing as good as they could be, I had little time to be concerned with money. So here's how I came to lose millions and millions of dollars. You have to go back to the early 50s, when my father took over his father's machine tool business, and had a small office in Bridge Street. Next door to Dad's office was a young accountant, Ron, just starting up his practice. Ron was dedicated and honest. He began to do the accounts for Dad and when I made my first dollar Ron became my accountant too. His business grew a little and he took on a young graduate who was also dedicated and honest. Let's call him Walter. When I began my business, Walter became my accountant, and he had a young assistant. Let's call him George.

We went to George's wedding. We gave him presents at Christmas. We welcomed him as part of the extended family. We trusted him, and though we were shocked and upset by Walter's sudden death from a brain tumour, at least we knew George

would take over our accounts. During those years my focus was entirely on trying to design and create the best things possible. We were entering into multiple licence arrangements and I was travelling a lot to respond to the various needs of our licensees in the US and Japan. We were opening new shops. We were putting on new people and we were moving into new areas of clothing and homewares. Judy was running the fashion side. Camilla and Oscar were taking over design and management. We had fifteen shops, around a hundred and fifty employees. We won the Fashion Industries of Australia Grand Award. We were expanding in Japan and I was spending every hour possible designing for the business and trying to paint. I was surrounded by a great, dedicated, creative team. I was never interested in the money, but I knew that it would come if the product and the pricing and the distribution were right. I needed an accountant I could trust, and I thought that was George.

I had set out very early for him my attitude to money: any profits after the salaries and the running costs of the business were to be invested in blue-chip shares, with a small percentage available for more speculative investments – and once or twice a year I wanted one sheet of paper showing where things were. I did not want any sleepless nights thinking about money. On reflection, I think that if I'd actually seen the money, say in the bathtub like Donald Duck's Uncle Scrooge, I might have paid more attention, but no. George dutifully showed me the paper and everything looked fine. We owned a number of blue-chip shares and he was working with an investment advisory team that included a representative from the financial planning arm of the Commonwealth Bank. I was secure in the thought that with advisers of that calibre, I need not worry.

My first inkling that something was amiss came when I was contacted by the chairman of a stock exchange, who said it was imperative that he knew by 4.30 that afternoon if I was going to take up my options in a particular company. I said, 'You must have the wrong bloke, as I know nothing about that organisation.'

'Well,' he said, 'you own shares in that company and they need an answer.'

Alarm bells were ringing. I called an old friend who'd been the chairman of Coopers and Lybrand, and had moved to PWC. He directed us to a very bright youngish accountant there, Glen. From our first meeting, we liked and trusted him. He's dedicated *and* honest. Totally.

When we began to unravel the extent of our losses, we were shattered to find the number of businesses George had invested our money in. Businesses and people we would never consider being associated with, including a loan of almost $900,000 to a guy we thought was a friend. Never once did this 'friend' explain to us that *we* were his supposedly private benefactor, who apparently just wanted to help Australian talent. This was another bloke we'd embraced into the family and who had come to our home a number of times, and to our family Christmases. He really wanted to be a pop star. He used our money to record an album at Abbey Road in London with a full orchestra backing him. I'm not sure how many CDs he had pressed but I imagine ninety-nine per cent of them are still at the bottom of his wardrobe.

Oscar and I went with Glen for our first meeting with our lawyers. First time for us in that situation. Little did we know there would be four years of meetings and lots of heartache and lots of expensive bills. We liked our lawyers though and learned a

little bit about that world. As our barrister and his opponent both lived in Mosman, I suggested two courses of action. 1) I could do some offensive drawings and send them to the CBA to show them our displeasure or 2) the barristers could meet in the cheese shop in the Fourth Village in Mosman and see if they couldn't sort it out there. These suggestions showed only my total lack of understanding of how the law really works, and a short case is not really a good outcome for the lawyers. However it did lead to mediation conducted by the highly respected Tony Fitzgerald. This was in very flash offices overlooking the harbour. Nice big paintings, stylish boardroom, lots of serious people for the CBA, stunning view, total waste of time. Great sandwiches though and I can only assume that from Mr Fitzgerald's fee he would surely have made them himself. Over a year later we reluctantly settled the case which meant we were left hugely out of pocket. The CBA are bigger than us, they have the power and all the money, however the door is not entirely slammed shut. The bank has been asked to explain the actions of some of their investment advisors, and as far as I'm concerned they still owe us lots of money. I'm also still considering the offensive drawings option.

George has disappeared. We don't wish to see him again.

2015

Looking out the window I see the Thursday race has just
started. Twenty or thirty big gleaming white yachts are sailing
down the harbour. Filling my vision. All leaning over at the
same angle, just the leading ones preparing for their first tack
on the way to the heads. They'll return in an hour or two, and
if the wind stays in the same direction it will be a glorious sight
with all the coloured spinnakers set for the run to the line. A
couple of boys on windsurfers with sails as clear as butterfly
wings dodge in and out among the yachts. The boys are leaning
back on the boards, almost touching the water as they seek to
achieve maximum speed.

The back marker yachts are still tacking back and forth
in the last rays of the sun down at The Spit, but soon
they'll be racing off to catch the fleet. I can hear clearly
the sound of the sails against the wind as they tack just
below. Windsurfer sails have changed quite a bit since I
had one years ago. They used to be heavy and striped, now
they are light and clear as insect wings and look like flying
cicadas. The boards are coloured. The one I can see has a
luminescent pink edging to the sail and a bright turquoise
board. The boy wears a black wetsuit. I used to make lots
of paintings of them. While I'm waiting for the yachts to
return I can see there are a couple of surfboats training. Fit
young men are in one, fit young women in the other. The
sweep trails his long oar out the back and I hear him calling
the rhythm to his crew.

Lifesavers give great service to the beach-going public
and it's part of our heritage that they should be there. Going

to the beach when I lived in Maclean was a trip in a bus with
Mum, then a climb down the path, past the bright succulents
that grow in the sand and onto the beach. It's a great little
beach, Yamba. Then later when I'd go to the big beach at
Manly, the treat was to hire a surf-o-plane and rush to the
waves to swim out a bit and wait for just the right moment.
The moment when you could catch a just-breaking wave and
ride in on your stomach, all the way up to the beach. Rest
triumphant for a bit and run out again. Surf-o-planes were
the forerunner of surfboards. In the 50s surfboards were
only used by big boys who kept them in the surf club. Heavy
long things – nothing like the lightweight ones the kids use
today.

The Middle Harbour yacht race returns. The wind has
dropped. No spinnakers. Still very nice to watch them glide
by. We've got a couple of kayaks and often paddle around
the bays and beaches nearby. It's great on a smooth sea, early
morning, sun sparkling as we head over to Grotto Point.
We sit for a while under the little lighthouse and look out
to see the swell between the heads. Sometimes we continue
around, past Washaway Beach to Crater Cove. There is a
wonderful little collection of hand-built stone huts, some
hugging the cliffs and some half hidden in the bush. They
have been there for years and have just about the best views
of the harbour. There are large rocks in the water just below,
with sweeping brown kelp washing back and forth with
the tide. You very rarely see anyone. The handful of people
who squat there are very private indeed. There is a solitary
flagpole and a few flowering bushes. High above you can
glimpse people at the lookout at Balgowlah. You can climb
down through the bushes to the huts – that is if you can
find the track. Once or twice we went around the point to

Reef Beach. You have to be careful as there is a dangerous bombora just before the headland: it can be treacherous in a big sea. I love to look down through the water on these trips. Bream, rock cod, the pattern of the light on the rocks. There are a couple of special spots I know where there are patches of the most intense emerald-green grassy weed that sways back and forth. And we used to see large ultramarine grouper in the shallows close to the rocks near Buddha Beach. We haven't seen the fish for quite a while. Probably shot by some bloody spearfisherman. The grouper is a protected species.

You'll never see Buddha Beach marked on any map. Nor will you find Tony's Rock or the Japanese Tree Beach. They are all only known by those names to us. Buddha Beach because if you look very closely, you'll find a carving of him in a rock above a little sandy inlet only accessible at low tide. Tony's Rock's easy, cause some bloke obviously called Tony wrote it there in white paint. Now faded, fortunately. And the Japanese Tree is so called because many years ago, before it was felled in a big storm, there was an old gnarled tree with its roots around a big rock on the waterfront below Parriwi Road. It's slowly rotting now and is wedged between some rocks. It's not far from the 'Sea Frame'. This is a beaten-up concrete rectangle that sits in the sand, near the Japanese tree. It's about two by one metres. And it's constantly changing, depending on the tide. Some days it's all sand. Other times, bits of seaweed and little fish. Sometimes shells and bits of driftwood. It's better by far than most paintings. Nature as Artist. Unbeatable.

There are a couple of council rangers who walk the beach each day. One we've become quite friendly with, a gentle soul called John. He arrives in his ranger's uniform and clumpy

big ranger boots. Years ago I convinced him to walk along the beach barefoot. So now, under the trees, I can see him take off his boots, carefully fold his socks, roll up his trousers and make his beach patrol. I guess it might be against some regulation but I'm sure it's much nicer for him to feel the sand between his toes.

FISH and FAME

I'm standing on the end of the slipway, about to swim. The water is crystal clear. You can easily see lots of little fish swimming around...and then I spy a big whiting, slowly gliding past. It's almost exactly the colour of the sand, so you have to put your 'fish eyes' on to see it. And there, the shape of a small stingray hiding under the sand. If I had been down earlier at the top of the tide, I'd have seen half a dozen big bream feeding on the rocks in front of our lawn. They are always there at that time and I used to try and catch them. Not any more. I'm happy to just be able to observe them nibbling on the weeds and other stuff around the oyster-covered rocks.

My father never liked fishing. He told me once he just didn't like to see fish gasping for air when they were pulled out of the sea. I think it's because it reminded him of my mum, desperately trying to breathe during her asthma attacks in their early married life. Later, our much-loved and respected family GP, Dr Stephen List, got Mum's asthma under control. Talking of Dr List. On one trip to the US, I was stunned to hear the sound of 'Take Me

to the River' and 'Don't Worry, Be Happy' coming from the mouth of a mounted plastic fish at the LA airport. You know the ones I mean now, but then that particular phenomenon had not yet reached Australia. I bought one and brought it home to the delight of the family, and Mum couldn't wait to take it up to show Dr List. He loved it and when I next saw him he asked would I trust him to take it home? Well, I replied, I trust you with my mother – I think I can trust you with a plastic fish! We still laugh at it.

Which reminds me again of Roger Woodward at Thurlow Street. The performance was breathtaking. Marred only by a bloke fainting in the front row. Before anyone could react, Roger had flown from the piano and was about to give mouth to mouth. Not really necessary as it was a simple faint, but you never know. To hear Roger and then to find his face hovering over him was a bonus that the bloke had never expected.

* * *

In the small warehouse we rented in Pyrmont, I was able to set up a small, long, thin studio area. I divided my time between painting in the Cabin and working there. But then when we moved to Thurlow Street, I could really paint in earnest. The studio was huge, the length of a tennis court, with views across to the Moore Park Golf Course in kind of a long loft area, with windows on both sides looking down into the space below.

On one side I could look into the design area, where Camilla and Kyoko worked, with Kate's little office next door. On the other side I could look down into Judy's fashion area, with the big long tables covered in newly designed fabric and garments.

The problem with a big studio though is you start to do big paintings. Bigger than is necessary really, unless they end up on gallery walls. Certainly bigger than most people choose to hang in their homes. That's not to say we haven't sold big pictures, it's just you tend to sell more little ones.

In that storeroom we were already building a collection of quite diverse works. Paintings about poetry. Paintings about landscapes. Paintings about colour and decoration. Some of them are not bad.

Out the back we had the visual merchandising department. Business was growing rapidly and it took all of my efforts to balance the designs, the products and the overseas licence demands. Fortunately Camilla, who is a great designer, took quite a load of that from my shoulders, and of course Judy was in control of the fashion and the swimwear.

In those days we never had a five-year plan. More like a five-minute plan and a fifty-year plan. The fifty-year plan was that we would all live happily ever after. The five-minute plan was that we would respond instantly to any opportunity. The business and the product range were growing.

It's a very complicated process to take part of a painting and finally see it end up on fabric. From the very start, all of the artwork has been professionally photographed and catalogued, as many pieces have been the source for fabric and designs. We all learned on the job. In the beginning, all the colour separations were done by hand and the process was essentially screen printing. Now of course everything is digital, and you can achieve incredible reproductions on all kinds of fabrics. But our desire to make in Australia wherever possible hasn't changed; nor has our commitment to make each product, whether it be a scarf or a swimsuit, the best possible.

We had proper fashion parades with a catwalk, models and music. These were attended by various buyers from interstate with their local counterparts and of course family and friends. Little did we know during one particular showing for which we used a stunning brunette model, Yvette Duncan, that she would in time fall in love with Oscar and become our much-loved daughter-in-law and the mother of our adored grandchildren.

Our swimwear was great, even if I do say so myself. People loved the prints and often commented on the fit and style. Around this time we received the 1993 Fashion Industries of Australia Grand Award. Us. Our little company. We were thrilled.

I was in Los Angeles at the time of the presentation, so they set up a satellite link and I sat alone in a TV studio in LA and said a few words of praise for Judy and the team and then celebrated by myself in my hotel room with a dark almond-flavoured chocolate. I think back in Sydney they drank champagne. Well deserved, too. That's quite an accolade considering we were not a fashion house and we'd only been around for a decade or so. We'll be forever grateful for the vision of the then chairman, Peter Norton.

ART ON WHEELS

In 1989 I was asked by BMW to do an 'Art Car'. These were a collection of real cars, decorated by very famous artists, the first being Alexander Calder in 1975. There had been five others since that time, Frank Stella, Roy Lichtenstein, Andy Warhol, Ernst Fuchs, and Robert Rauschenberg. The Aboriginal painter Michael Nelson Jagamara and I were to become respectively the seventh and eighth. It coincided with a large trip I had planned with my father, so we were able to start our journey in Munich. We were met very early by Uli Larb, a nice German man who had been an executive at BMW headquarters in Melbourne over the previous few years; I'd heard that he was one of the people who had originally proposed my name. We loaded our luggage into the latest BMW saloon and he suggested as we had an hour or two before our meeting with the BMW curator he could take us on a drive up to the mountains overlooking the city. Off we set, on to the autobahn, and instantly got up to sphincter-tightening speed towards the mountains.

I sat in the front. Glancing now and then at the speedometer, looking at numbers I'd not seen before. Uli chatted away, relaxed

and in control. After a while, we flicked off the motorway and embarked on a series of stomach-turning corners up through the pine forest to eventually find grassy meadows with cows and flowers in bright green grass and the ultimate joy of coming to a halt. I hope Uli didn't notice that my face was quite a similar colour to the grass. A coffee or two, a marvel at the crisp air and the stunning view down the valley and back in the machine for an even more buttock-clenching hurtle down the mountain.

Before we knew it, we were back in the lovely old part of the city and shown upstairs into the curator's apartment. It was Saturday morning, and it's Munich. So we had to eat white sausages with sweet mustard and pretzels and drink wheat beer. It's a tradition, and a delicious one. The brief was also delicious. Simple. They would give me the M3 racing car in which Frank Gardner had won the touring championship in 1985. It would be sprayed white and what I painted on it was entirely up to me.

He took us to the very impressive BMW headquarters and I was able to see the Andy Warhol car they had on display. Also very impressive. Looked like he might have done it one afternoon between lunch and dinner. Strong, confident, bright. He was a great artist who really understood his times.

After lunch, we were able to visit some of Dad's clients in Switzerland. Despite my well-established mechanical incompetence, I still was able to marvel at the sight of big great grinding equipment. Robots glided along tracks to select the right cutting tools, then deposited them back to the big machine. It was loud. Then they started to grind. Wonderful peelings of steel bundled up below the cutting. All in hermetically sealed rooms. Super efficient. Super precise. My dad's business. I was never able to help in that, although I did do rather a nice logo for the

company. Mechanical Precision Equipment Company. Started by my grandad just after the war, revived and expanded by my dad and, after a bit of a try, ended by Oscar and me a couple of years after Dad passed away.

We stopped a bit in London. I'd been asked to appear on a breakfast TV show. We were staying at a nice hotel beside Grosvenor Square, near the US Embassy, and a car had been arranged by the BBC to pick up me and the other guests. First me, then Ronnie Wood of the Rolling Stones, then Patrick Macnee, 'Steed' of *The Avengers* fame. Bit of a blur, live TV is. All seemed to go well though. Ronnie draws really well and showed some nice pictures of the Stones, Patrick Macnee chatted about the new *Avengers* episodes and I can't remember what I said, or even why I should have been there. They seemed to like it though. It must have been about T-shirts and koalas.

Then by Concorde to New York. Great experience for both of us. I'd been on the Concorde before from Washington to London, but this was Dad's first time. Unbelievable that he should have learned to fly on tiger moths, graduated to Lancasters and Wellingtons during the war and then at twice the speed of sound we would cross the Atlantic in a few hours only. We landed at Kennedy, then took a helicopter to the city. What a sight: flying into Manhattan at night. We were only there for the next day, because a meeting had been arranged with the head of Bloomingdales – Marvin Traub – a doyen of the department store directors. He had given me a fifteen-minute meeting, more than I deserved really as all I'd done was a range of sweatshirts and things produced by our American licensee. They'd been pretty popular though, and he was generous in his praise. Big office, as you'd expect. Great view over the city. Top of New York. Just for a day.

* * *

When Dad and I flew home I couldn't wait to start work on the Art Car. We worked at a spray painters shop near Mascot. I had painted a tiny model car as a guide. The concept was fairly simple. The car should look a bit like a parrot or a parrotfish, and look like it's accelerating even when standing still…look like it was ready to go really fast. The hot colours should be at the front near where the power was, gradually changing to cool across the passenger area. And the wheels should be hot colours. Strangely enough, up till that time, no other artist had painted the wheels. Strange, because that's what makes the car move.

It was only when South African painter Esther Mahlangu did her car many years later that the wheels were once again incorporated in the overall design. Esther is a Matabele woman who practises that bright, clear, geometric form of design. Colour outline in precise black lines. She and her husband came on a trip to Australia and we were given the delightful task of entertaining them here. Esther of course wears traditional garb, part of which is the large number of metal rings and beaded collars around her neck. Her husband, a taxi driver, also wears mainly traditional clothes. On the day of their visit, he had chosen to dress in a large lion skin.

It was a clear, crisp morning, and we'd planned a barbecue beside the harbour. Before lunch, I thought I'd show them both how to play boules. We set up the metal balls on the front lawn and commenced the game. Now our front lawn is right on the harbour and frequently tourist boats sail past. You often hear them comment about me and the studio and lots of tourists (especially Japanese ones) in those days would snap a shot or two. One

wonders what they would have made of finding a black woman with her elongated neck and a man in a lion skin on the Sydney foreshore. Or the bloke in the old paint-splattered shorts, holding the beers, for that matter.

BMW decided to show the two Australian cars at the Powerhouse Museum. The then director was Terence Measham, who was bright and enthusiastic about his job. He'd had his people create a great set for the cars near the museum entrance. I'd agreed to produce a large painting to complement my car and a limited edition print illustrating its creation. We arrived early and met Michael Nelson Jagamara for the first time. He's quite a reserved and gentle man and had created the big mosaic mural outside Parliament House in Canberra. It was great to finally meet him.

However Michael and his minders and a couple of mates had been there for an hour or so and had sampled quite a few glasses of the beer and champagne that were to be served when the guests arrived. Michael was relaxed and happy and well, just a little pissed. By the time all the guests had arrived and we were gathering beside the stage to do the official stuff, Michael's minder took me aside to suggest that Michael was not really in a state to stand (let alone speak) and that maybe I could talk on his behalf.

I asked Michael directly.

'Mate,' he said. 'You talk, you tell 'em, OK?'

I was honoured and delighted to be given the task, so in my speech I paid respect to Aboriginal art and culture, described Michael's talent and thanked the appropriate sponsors. I'd lost sight of Michael and his mob in the crowd, so when I came to ask if he wanted to come to the dinner that had been organised, he waved a no thanks, and with some assistance drifted into the

night. A few days later, in one of the local papers, I was accused of being the only artist who spoke, and why should the other artist not be given the opportunity to talk? Move on.

Later that year, about a hundred kilometres from Alice Springs, Michael Nelson Jagamara taught me a great lesson. We were there with a film crew and the musician James Morrison, making a film for BMW about mobility.

There was a break in the filming while the director planned the next shot. James, Michael and I sat on the sandy and rocky ground. To fill the time, I thought it would be fun if we played a variation of boules. I chucked a rock out to be the target and explained to Michael that the object was to try and throw other rocks to land as close as possible. We played for thirty minutes or so before the director called us for the next set-up. James and I started to walk towards the position when Michael called us back.

'We gotta pick up them rocks we been chucking and put 'em back where they live,' he said.

He was right. That's an understanding and love of country and land that most whitefellas will never feel.

In 1993 Terence Measham called and asked me if I'd be interested in decorating the Powerhouse's planned restaurant. It was in a space that had previously been used as a members' meeting room and the brief was that I could create something that would bring colour and style into what was a pretty dark and drab area. Although it was offered as a commission, I wanted nothing for it and I asked that if they accepted my concepts, they should pay Terry Waters, a sign writer I'd worked with before, and simply pay for the materials. It turned out that the paint was donated by Jim Cobb from Chroma Acrylics and we were ably assisted by Terry's son Ben and my son Oscar – what a team!

I had to present the drawings to the board and the then chair, Rowena Danziger. Everybody was happy and left me to do pretty much what I wanted. The concept was a large yellow sun up at the top of the space with the yellow rays spilling down the walls to reach shapes, based on frangipanis, morning glories and leaves.

The palette was yellow, ultramarine and white. I also designed the plates, bowls, and salt and pepper shakers and a series of cut-out vases of flowers, certainly influenced by Matisse, and the end result seemed to delight everyone.

On the opening night, a few plates were smashed in Greek style and lots of champagne consumed. Everybody seemed to love it and it was very well reviewed. I was shocked, therefore, a couple of years later, when I received a call from the then chairman who, without preamble, said they had decided to have the space repainted and close the restaurant. And what did I think about that? All I could say was it's entirely your decision and it seems it's already been made.

'How modern of you,' he replied.

Modern! I thought, what do you think this is, a kind of installation? Inside, I was very disappointed and dismayed, but I knew there was nothing I could do. Maybe they just weren't selling enough coffee, tea and cakes. Anyway, it wasn't the Sistine Chapel. That's life. Move on.

2015

Most days I go to the studio first on my way down for a swim.
You need to see fresh what you've been working on and
sometimes you know immediately what has to go or what has to
be worked on. I'm often waylaid by work.

I've had many studios. They are an artist's kitchen, a
shed, a workshop, an operating theatre, a room of pleasure
and pain. I always clean up at the end of a painting session.
I want to be able to get straight into things. Clean brushes,
clean water. Mostly when I'm painting I start about 8.30
or 9am, stop for lunch. Maybe a nap, and work through
until the late afternoon. Then sometimes after dinner for an
hour or two, when you've been thinking about things and
need to rush down to change something or add something.
Sometimes you step back and think, Well that's pretty damn
good. This 'I'm a clever boy' moment is always put into
perspective when I'm just about to close the door. On my
bookshelf sits an old toy gnome my daughter bought me.
He's reclining, and emits a number of rumbling farts as you
pass by. I should turn his battery off. But then again, he
always makes me smile.

I just called the office – a painting has just been sold.
Brilliant! It's always nice when someone buys a picture.
This was one I was particularly pleased with. One of a series
of four about the boats and beach and flowers. Subjects
I've explored in many ways over the last few years, but
this one was very loose and simple. Almost childlike, the
childlike you can find only after fifty years or so work. I'm
tempted to rush down to the studio to paint but I've got to

stay with this writing. In the studio is that big unfinished Cleopatra for the Bell Shakespeare Company, and I know I should really work on her. You have to go where your mind drives you.

ON

I've had well over fifty exhibitions of my work in Australia and overseas. That means more than fifty opening nights. It's always a slightly nerve-wracking time. There needs to be a few minutes where you can quietly walk around the exhibition before anyone arrives. Only then can you see the pattern of the works. The paintings are never hung chronologically, so you see a different kind of relationship between them. Never before have you seen them in that space or in that lighting. Nothing you can do will make them better or worse.

There they are: you have nailed your talent to the wall for all to see. I must admit, the overwhelming majority, in fact all people, say nice things. Often they will say nice things you don't want to hear, like, 'Oh, the one I like has been sold.'

The room fills, drinks are offered. Lots of chat, small, quick conversations. A speech from someone who says something nice. A reply where you try to thank all the right people, and then people continue talking to one another. Not necessarily looking at the work. Then someone will say, 'Oh, I love that bit in the top corner.'

Bugger me, you think, that's the one part I don't like, don't look at that. But of course that's the reality of art. The viewer decides what he or she likes and that's that. The nicest thing is when you visit a home where some of your paintings live. It's like seeing part of your family, where they live with other people. They are not yours any more. Their life is with someone else. You just hope they will be treasured.

I had exhibitions in Los Angeles and San Francisco during 2000 and 2001. Australian friends Kimberly and Kevin Kalkhoven were there, and Kevin purchased another painting to go with his increasing collection of my works. He's a fascinating bloke. Super successful with racing car teams and interested in many projects. Originally from Adelaide, he designed something to do with computers or machines. Far too complex for me to understand. We met last year on *The World*; they have an apartment on that most luxurious of boats.

In San Francisco, the exhibition was in the foyer of a big building at Number 1 Bush Street. In LA it was in a gallery in an area called Bergamot Station, a former railway station now redeveloped as a collection of galleries. It was full-on Hollywood. A searchlight glowed in the sky and lots of people came by limo. Jane Seymour arrived and I was given the job of squiring her around, as she also paints.

On that trip we were invited to a special event to pay tribute to American sportswomen. It was a lunch and we were asked to arrive early for pre-lunch drinks with some of the stars. I spent most of the time talking to Geena Davis, who had been in *Thelma and Louise* but had also represented the USA in archery. When we got to our table I was delighted to see that I'd been seated next to her and on the other side was a place for Dustin Hoffman. I was

really looking forward to meeting him and chatting about all the great pictures I'd seen him in and how much I admired his talent. He arrived just before the parade, leaned across and said, 'Hallow.' It was the only thing he uttered in my direction throughout the whole lunch, but I'll treasure it, Dusty.

On the catwalk beside the tables a parade of famous US sportswomen were presented, the last one being Mary Lou Retton, who had won gold in the gymnastics. Mary Lou simply tumbled and spun down the catwalk and somersaulted to a stop. A perfect ten.

After the lunch I found myself talking with her as another bloke sidled up.

'Oh!' she exclaimed. 'Have you ever met Princeyboy?'

She was clearly on close terms with Prince Albert of Monaco. Much closer than me. Thinking about that meeting, I remember that I did meet Prince Albert in Fremantle during the America's Cup defence. We were both at a launching of a little yellow duck on the Swan River for a children's charity. Nice bloke, but no point in bringing it up during the Princeyboy meeting in LA.

In the evening we had been invited to the St Jude's Gala at the Beverly Hilton. We were all staying at the Peninsula, opposite. When we arrived at the front entrance in our stretch limo, I was able to point out Michael Douglas standing outside waiting for his car. The foyer in that hotel is not large, but it is very stylish. A huge arrangement of flowers dominates the space, with reception to the right. The family and the luggage were being unloaded while I strode to the reception counter and slapped down my credit card. I went back out to the limo to see what I could carry and have a secret look at Michael Douglas. As we stood there, the man from reception came out to me.

'Is there some kind of problem?' I grandly enquired.

'No, Mr Done,' said the receptionist, 'it's just that we don't take Cabcharge.'

The reception at the Beverly Hilton was pure Hollywood. Judy and Camilla went to the hairdresser in the late afternoon and, once we were all dolled up we were delivered by limo, even though our hotel was just across the road. As we walked up the red carpet, there was a phalanx of photographers lining the ropes, and a lot of general public people too. When we walked up, of course not a flash appeared until we were almost at the door. Some bloke from Brisbane recognised me and called out encouragingly, 'What the hell are you doing here, mate?' It led to a number of flashes from the paparazzi we'd just passed but any shot would have been of our bums.

It was a big room with lots of table hopping. Marc Anthony and his band performed. Great food and entertainment by Ray Romano. Very, very funny. After the ball there was a special VIP room that we had access to. All the athletes, lots of stars. Our friend Michelle from our gallery in Sydney was with us and with her great presence and confidence was chatting to Matt le Blanc. Judy and I went to bed. The kids went to Trader Vic's.

* * *

In 1996 I had an exhibition in Paris, in a gallery that was just around the corner from the famous Bristol Hotel. It happened because a French doctor, Yves L'Henoret, came to the gallery one day and admired my work. He insisted on visiting the studio one afternoon. He is a big man with a kind face and soft eyes. Although he'd been qualified to be a doctor, he told me he just

didn't really want to continue down that path. I don't know enough about Yves's early married life, but when we met him he was living with Francoise, a soulful young French girl who had spent time with the Aborigines in Arnhem Land and the north-west of the Kimberley, studying their language.

Leno and I shared a great love of certain French painters: Matisse, Bonnard, Derain, etc. He had a friend back in Paris, Francois Mitaine, who had curated a big contemporary exhibition, FIAC, for the French Government, and had his own little gallery on the left bank. His gallery was unavailable at the time so we showed at the Galerie Scot on the Rue de Miromesnil. We even had some big posters and signs on the Boulevard Saint-Germain and one right opposite Les Deux Magots. They were only there a week or so but it was great to see them. The after party was held at Monsieur Mitaine's apartment, not far from the Seine where Matisse used to live. The place was packed. Francois had hung a very large spotted and striped yellow beach painting of mine on one wall and beside it a very, very tiny Bonnard beach painting. I think the Bonnard won. But it was an honour to share the wall.

* * *

There have also been exhibitions in London, both at the Rebecca Hossack Gallery in the Bloomsbury area. I'd first met Rebecca in Paris, where I'd gone in 1999 for the announcement of my involvement in the Sydney Olympic Games.

John Spender was our ambassador in Paris; he'd kindly organised a lunch at the embassy and there was a small exhibition of my work in the foyer. Rebecca asked if I would like to show

with her in London. So about a year later the exhibition was ready for the opening. It's a fairly small gallery in Charlotte Street and the place was packed.

Rebecca had organised a barbecue outside and the guests spilled out onto the pavement, blocking the cars. The show was kindly opened by then Australian High Commissioner in England, Michael L'Estrange. Kathy Lette and Geoffrey Robertson made an appearance, as did the revered food critic and my old colleague Fay Maschler. What she made of the barbecue, who knows.

There were quite a few family and friends there. It was the night of my sixtieth birthday. There was a cake. And lots of paintings sold. Whacko.

Rebecca had asked if I'd like to give a bit of a talk. Sure, I replied. I'm a bit of a chatterbox sometimes and I'm happy to talk about painting. Well no, she said, of course you have to speak at the opening, but this would be a talk at Oxford University!

So Judy, Camilla, Oscar and I arrived at that hallowed university town a few days later. It's so crowded in the centre of Oxford that you have to leave your car at the outskirts and take a bus in. It was high summer, early in July. We'd been invited to spend the night in one of the old colleges. Through the gatehouse, past the porter's lodge and up to our rooms. They overlooked the inner quadrangle and I could only imagine with envy the pleasure and privilege of being a student there. There was a kind of cocktail party first then we were led into the old dining room. I was seated at the top table between a couple of distinguished dons. There's quite a bit of traditional ceremony and protocol to start the evening, then you nervously eat your dinner, with a bit of trepidation about what you will say. Thankfully it all

seemed to go all right, with laughter in all the right places. It was an unforgettable experience for me – and quite a long way from Maclean Primary.

When we returned to our rooms it was well past midnight. Out on the lawns of the quadrangle groups of students in dinner suits and evening dresses were stretched out, laughing and joking about their summer ball. And having a nightcap or two. We looked down from our little window, high in the old stone building. It was like a scene from *Brideshead Revisited*. My darling Camilla gave me a copy of that book to mark my time at Oxford. Ken Done at Oxford. For one night only.

Janet McKenzie, a distinguished Australian art historian and author, had written a book about me and my work, and a few days later it was launched at Australia House. The high commissioner spoke and I was very pleased to have Mel Gooding there – he had written a great book on Patrick Heron. I'd met Patrick briefly when he was a guest of the Art Gallery of New South Wales. He's a great colourist and it's interesting to see the effect that Sydney's light had on his paintings. We met at the little studio set up for him inside the art gallery. I rushed up to the bookshop to get a copy of an earlier book of my work, published by Craftsman House, to show him. Because you can't just say, 'I'm an artist!' It's better if you present proof.

After my second exhibition in Rebecca's gallery in Conway Street in 2007, we'd been asked to attend Jeffrey Archer's summer garden party. Jeffrey had bought a number of paintings from my gallery in Sydney a few years previously and kept most of them in his stylish apartment across the river from the Houses of Parliament. He is a great storyteller and has raised huge sums for charity. He is also a great mate of Billy Connolly, who often

visited him when he spent a little time writing in a more confined space than that beautiful home.

The home he shares with his wife, Mary, is in Grantchester, just outside Cambridge, and was once owned by Rupert Brooke. There is a tiny ivy-covered cottage set in the grounds away from the main house and this is where Jeffrey mostly writes. The garden party was very stylish. A big marquee. A band. A men's choir of Cambridge students. Delicious food and piles of strawberries and cream, and sitting at the next table, Margaret Thatcher. There were lots of politicians, writers, sportsmen and film people. But Thatcher commanded centre stage. Outside, discreetly under the trees, was a line of dark green portaloos. Very stylish, with piped classical music. I think there was one for the exclusive use of the Baroness herself.

Years before I had flown up to Brisbane to attend a dinner at art dealer Philip Bacon's house. Jeffrey Archer had been a client of his for many years. The retired judge and now playwright Ian Callinan was there. Philip's house is filled with treasures. It was a night of champagne, great Australian reds, fine food and lots of chatter. It was the first time Jeffrey and I had met, because even though he'd purchased things from us, I hadn't been in the gallery at the time. The first work he bought was from the very early *Postcard from Sydney* series. He rang the gallery we had above the warehouse in Redfern. It was closed at the time but fortunately the managing director Chris McVeigh was downstairs and took the call. Jeffrey insisted he should come round and see the works. He was a very early client, and is now a friend.

Lets Talk about "PAINTING

Painting basically falls into two categories. One is where you sit in front of something and look at it. The other is when you look inside your head. A few years ago I was visited by a distinguished English painter. I showed him my studio and he enquired about the light. How was it, and what was the path of the sun? 'Well,' I said, 'it doesn't matter: the light is in my head.'

Sometimes I sit and look at something or somebody and try to make a picture about that, but I'm not interested in producing photographically correct images. That's the role of photographers. And now, when everybody is a photographer, with millions and millions of images being recorded on millions and millions of mobile phones, I think painting has a different role.

The feeling of paint, put on by hand, or brush, or palette knife or a bit of stick – the tool doesn't matter – it's a *painting*. Good or bad, it's all up to you. I love the honesty and love that you find it in the untrained painter, the works that you sometimes find at the local fete or on some jumble stall. Often they are more fun

than many of the very serious and glum images you find in some contemporary galleries. Because I'm studied at some schools, I often find myself in a classroom, surrounded by kids' versions of my Sydney Harbour paintings or Barrier Reef works. Almost without exception they are better than mine. Fresher, more innovative, more adventurous.

But I'm very pleased to receive many, many images from teachers around the country and lots of birthday greetings. And now, because of the internet, we get regular requests from classrooms and kids overseas. I think art should be accessible. And the language used should encourage as many participants as possible. That's not to suggest that professionals should not explore the outer limits of language and understanding. But now and then that kind of 'artspeak' is used to cover up the shallowness of the work.

It's natural to like people who like your work. And not to like people who don't. I think the artist himself or herself knows inside just how much more they need to learn. And how many times they fail.

In 1992 I made a diptych. It's a double self-portrait about the act of painting itself. The first picture is preparing. I've got my Walkman headphones on, the bird above my head symbolises the music, my hands are ready, the colours are laid out on the palette and the brushes ready for work on an old chest.

The other painting shows me arranging the colours of a painting but now my hands are more like sausages, not doing precisely what I want them to do. But below on the palette is the mixed up paint, showing that sometimes the most beautiful things that come out of working are beside the point. Incidentally, that part of the painting was used recently by Judy as a design, and printed on a sweatshirt. Art to wear.

* * *

In the 1990s, I was contacted by a couple of students from the University of New England at Armidale. One of them was Amanda Bishop, who has become one of our funniest actors and for years did a devastating take-off of Julia Gillard. They came to the studio and said they wanted to be in the *Guinness Book of Records* with the world's largest painting and any profit raised could go to charity, specifically the UNICEF-based Robert Nestdale Memorial Fund. The students originally wanted to create a blow-up version of one of my paintings.

As flattering as this was, I convinced them it would be better to have as many people as possible paint metre-square pieces of canvas we could then join together to create one large work. I specified the colours to be used and said that people should simply paint something they loved. A flower. A fish. A bird. The sun. Things they could do easily. Then when we assembled them all, it would become a giant smiling face. I arrived a few days before the final judging and agreed to produce a number of the panels. The work itself was laid out on the university's football ground and, as students were playing in the afternoon, could only be there for that morning.

The students worked tirelessly, as did one farmer, who'd agreed to sew all the squares together. This meant designing a small sit-on mower-like contraption he could ride up and down and sew the pieces together. The Friday night before the final measuring had been cold and frosty and we found that the canvases had shrunk, and another row was necessary to break the record. We couldn't convince any television station to cover the event, but fortunately the mother of one of the students had a light plane, and we were

able to get a photograph of the completed work from the air. It's amazing to have been involved in two *Guinness Book of Records* attempts: World's Largest Painting and World's Longest Painting.

The second happened like this. An English lady married to a bloke in Dubai wanted to do something to get into the *Guinness Book of Records*. She wanted to organise a number of international artists to come to Dubai, and, with the help of schoolkids, who would be bussed in, to make an artwork that would be at least ten kilometres long! And she almost made it. It took a couple of years to set everything up. To choose the artists, to organise all the flights and accommodation, to get the canvas and all the art materials, to set up the canvas on a new road in the desert about ten kilometres outside of the city and to generate enough interest to raise money for Médecins sans Frontières. Probably the most famous artist invited was Robert Rauschenberg from the USA. He came with a burly, bearded assistant and a suitcase full of tricks. There were artists from many countries and we were all put up at a number of flash hotels along the beachfront. Most arrived a week or so before the event, and we were honoured to be invited by the Australian Consul to have drinks on the top of the Burj Al Arab. It's an amazing hotel. Its decoration is somewhere between Cecil B DeMille and King Farouk. We swept up to the foyer in a limo, flying the Australian flag, and the doorman greeted me as Mr Ambassador. 'I'm not, it's the lady next to me,' I explained.

We were ushered up to the cocktail lounge, past more gilt than in Liberace's lounge room. The bar is just below that helipad featured in one of the Bond movies. The air was warm and still and the moon shone over a sea studded with some of the most amazing developments Dubai has created.

The next day, we all met at a stunning resort out in the desert, called Al Maha. It was an opportunity to meet all the artists and be part of an astounding barbecue and feast under the stars. Judy and I had been lucky enough to stay at that resort a few years before. It's very luxurious. You have your own pool overlooking the endless sand dunes. The pool is chilled against the desert heat and in the early morning you can witness falcons being flown by young sheiks. I told them, 'We feed the magpies at home in the morning,' but they didn't seem too impressed.

Anyway back to the painting. After the sumptuous feast, with dancers and musicians winding in and out of tables, the artists were directed to a private room to discuss how much of the canvas they could cover. Remember, to set the record, the canvas needed to be almost ten kilometres long and one metre wide and at least sixty per cent of the surface must be painted. In other words, you couldn't just paint a long line and get away with it. And the whole thing had to be completed in one day to be in the *Guinness Book of Records*. We had been taken out to see the set-up earlier in the day. The area where the international artists would work had a food section, toilets and a first-aid station. The canvas was already set out and disappeared into the distance. It was held down over sheets of hardboard with bricks every couple of metres. The logistics were incredible to get it all to this stage. It was planned that the artists would kind of start in the middle and work from 8am to midday, then busloads of schoolkids would arrive to do their bit. Rauschenberg and I committed to do at least ten metres and the artist from England (cream linen suit, red and white spotted cravat, panama hat) said he'd like to do a small snow scene! That only left about nine and three-quarter kilometres to do.

When we arrived back at our hotel the evening before the big long day, we closed the curtains against the lights of the beachfront and prepared for a very exciting morning.

We woke early. The room was dark. There was a strange moaning sound. We'd not heard anything like it before. I opened up the curtains. It was the wind. Strong wind. Wind that made the palm trees bend and shake. Wind that was picking up sand from the beach and flinging it at the windows. This was not good. A couple of years planning was at risk but so many things were in place that we simply had to proceed. We arrived at the canvas. We took our places. The wind had abated enough to start. The English artist worked next to me on his little snow scene. An artist from Oman worked carefully with bits of gold leaf. Robert Rauschenberg and his assistant were a few artists down to my left. I began working fast and big. Paint everywhere. Lots of action, lots of onlookers and then, sadly, lots of wind and sand. In the distance the canvas started to bend and buckle. Some bricks blew loose and the wind picked up the hardboard and tossed it across the sand. It was becoming dangerous.

Sandstorms formed and the organisers were frantic working out what to do. All that planning. All that work. After a hasty conference, the record attempt had to be abandoned and we were all bussed to a hotel for lunch while part of the canvas was cut into lengths that would fit onto trestle tables, hastily erected on a basketball court at a private girls' school. The artists all worked on their respective panels for the afternoon and the plan was to auction off various parts of the work at a later date. So, no *Guinness Book of Records*, no afternoon off for the kids to do their stuff and no entry under the world's longest painting. Nice try though.

There's a PS to the story or maybe I should say a Poo S. A dinner had been arranged in the grounds of the home of the woman who had initiated the whole exercise. We all gathered in the evening in her beautiful garden and of course by that time the wind had settled into a warm desert breeze. After a few drinks, the disappointment of the day softened a bit and we were able to enjoy the company of the other artists and meet a few of the local dignitaries and their wives and girlfriends. There was one gorgeous almond-eyed beauty with long dark hair. Dressed in a clinging sheath, she was stunning. Although I'm a happily married man, I couldn't help but stare, and my gaze was acknowledged with a number of discreet smiles. She clearly was a princess of the desert and the dream of many men. Lucky sultan, I thought.

After a few drinks, I needed to go to the loo. A servant directed me to the bathroom. I locked the door. Now there are many things that work brilliantly in Dubai, but in that neighbourhood, the toilet system clearly wasn't one of them. Nestling in the bowl was a log that must have brought tears to its owner's eyes. I desperately tried to flush the monster away. No luck. Just the sounds of a cistern that had given up. Well, I wasn't going to touch it, so after a quick leak, I was on my way out. As I was washing my hands, there was a gentle knock at the door. 'Just a minute,' I called. I dried my hands and opened the door. It was her. The Sultan's prize. She smiled. I wanted to scream, 'It's not mine, it's not mine!' but too late. She entered the bathroom and closed the door behind her. I shot out to join a group as far away in the garden as possible. She eventually came out and began to mingle. She never looked at me again.

* * *

My journey with art has certainly taken me down some unexpected roads. For me, art is something that stays with me. Gives me pleasure over time. I've seen some great installations; I've seen some great performances. I tire sometimes when I walk into a large gallery space and see a number of badly tuned TVs, a pair of fireman's boots and a half-eaten sandwich with pretentious wall text explaining to me that it's ART. Well. Maybe not.

I've also worked in most mediums – pencil, crayon, oil pastels, watercolour, inks, gouache, linocut, etching, acrylic, oil and water-based oil. Although the last seems a contradiction in its name, it has all the qualities of traditional oils without the harmful or smelly chemicals. I have no doubt Van Gogh or Matisse would have used the modern materials. This is painting I'm discussing. A branch of art.

Now, according to some, art can be found in installations, performance or even a light bulb flashing on and off. I guess as there are no art rules, anything at a certain level can be art. It is in the eye of the beholder or the eye of the curator.

But I like painting. I like pictures. From the edible details of early Dutch still lifes to the violent strokes of painterly abstraction. From naive pictures at country shows to sophisticated scratches on barely covered canvas at big-time contemporary galleries. There are lots to like.

We have collected primitive pieces from the South Pacific, small works by famous French masters and some big name Australian icons. On the bookshelves of the studio are expensive vases and worthless junk. But they are worth something to me. It doesn't matter: it's just that you should like it. That's how you should look at art. You may not understand at the start every nuance of the painting, but you should like it. It's like a

relationship. You're not going to get everything on the first date. Its pleasures will be revealed over time.

Think of the paintings in your own home. Some you still glance at, some you just pass by. Chuck out the ones you just pass by. Get new ones. The world is inundated with visual things. Our lives are filled with TV pictures, outdoor posters, magazines etc. Swift moving, complicated images. We are bombarded by so many visuals these days. For me, that means art should be more like poetry, more to be looked at over time. You can't compete with the shocking images we see each night in our living rooms of horrific things happening in the world. Young painters who set out simply to shock have a hard time. We as a society are almost unshockable.

Ups and Downs

Over the years, there's been quite a lot said about my work by various critics. Mostly positive, I'm pleased to say, but some unpleasant, bitter or ill-informed. On 26 January 2015, Australia Day, a painting of mine was on the special commemorative front cover of the *Sydney Morning Herald*. A work was also on the *Canberra Times* cover and another painting on the front cover of the Melbourne *Age*. It was the first time any single artist's works have been used that way. I was proud of that.

But critics do vary. Years ago, someone was moved enough to write to the Letters to the Editor section of a local eastern suburbs newspaper. He wrote that in his opinion *Ken Done does not have a scintilla of ability.* I thought that was a tiny bit harsh.

At the other extreme, a lady recently wrote that I was better than Rembrandt, Van Gogh, Renoir and Leonardo Da Vinci all put together. As much as I'm flattered by her thoughts, that has clearly gone too far. I'm prepared to admit the truth probably lies somewhere between.

Once at the opening of an exhibition in the city, Barry

Humphries, one of our brightest ever stars, said to me, 'They'll never forgive you for being successful!'

I hope he's wrong, and who are 'they' anyway?

Once I was at Canberra Airport late on a Friday afternoon. It's always busy there with lots of politicians and business people rushing to catch flights. As I walked to my gate a well-dressed man called me over.

'You're Ken Done, aren't you?' he asked.

'Yes,' I replied.

'Well,' he said, 'I just want to tell you that I know nobody else in the world likes what you do but I think it's great!'

I could only offer, 'Thanks,' and continue to my plane. I thought: Nobody else in the world! Bugger me that would be a fairly large number. What about Judy and the kids and Mum? Nobody else in the world! I guess I knew what he meant as I did seem to be upsetting some of the old art establishment, whose idea of a painter was restricted firmly to the starving artist cliche.

Art critics – you never know when they'll pounce.

* * *

A few years ago I went for an annual check-up. No problems. Everything fine. Chatting and joking with our GP, I stood up to leave and shake hands when he looked up and exclaimed 'What's this?' I sat back down. Bugger. Almost out of there. 'This could be a bit of a problem,' he explained. 'Your PSA rating has gone up quite a bit since last time. I want you to go and see a specialist. Soon.'

Suddenly a little knot of fear starts to tie itself up inside and before I know it I've met Associate Professor Stricker at St

Vincent's and he's done a biopsy and says he'll call when he knows the results. Over the next few days, even though I went about everything normally, there was that little knot of fear, tightening just below the surface. On a Monday night I'm sitting having dinner with Judy and Camilla after playing golf, and the phone rings. It's Professor Stricker. He says I have cancer and he wants to see me on Thursday. I sit down.

The girls can see there's something wrong. My head is spinning. I'm not really afraid, as my dad had prostate cancer and I know he didn't die from it, but I'm still a bit stunned hearing those words. Immediately I know I want to do something about it. Fix it. Solve it. Whatever it takes. Well, what it takes in my case is the removal of my prostate by robotic surgery by the best team in Sydney. The machine is called the Da Vinci and strangely enough we'd been to a number of charity balls and meetings to raise funds for it. I'd heard great things about the machine's ability in the hands and direction of a great surgeon. I'm just glad it was called the Da Vinci, not the Van Gogh. I need my ears. Although the professor had explained in simple terms what the alternatives could be, in my case, he (and my GP Dr List) recommended surgery rather than radiation or simply waiting to see what happens. The staff and the nurses at St Vincent's couldn't be nicer or more helpful. I don't remember much about the process, naturally, and you're a bit sore for a few days, and walking around with a catheter is not the most romantic thing.

I was operated on a Friday. Home on Sunday. And on Wednesday I started a large set of paintings about the attack on Sydney Harbour by Japanese midget submarines. I did nothing else for several months. Having your prostate removed does change your life in several ways. There's a sadness about the loss of sexual performance, but let's face it, at seventy you can't

expect to perform as you could at seventeen. I was sharing those thoughts with Billy Connolly recently, as he has also had the same operation. We agreed that a degree of performance could be achieved with say the images a couple of Tahitian beauties, the Luton Girls' Choir, a hypnotist and at least twenty-four hours' notice. Not quite spontaneous lust. OK.

It's easy to make jokes about prostate cancer but it leaves you with not only a loss of performance but also some feelings of depression that you have to find ways to put into perspective. Of course, the most important thing is that you are still around. And I can only advise any man who has any symptoms to do something about it as soon as possible. I'm still here and I'm pretty healthy. I hope to have many more years to share the joy of our children and grandchildren. Who could ask for more?

I worked on the pictures solidly for several months, and they have been very well received by both the public and the critics.

In an article by Michael Fitzgerald in *The Sydney Magazine* (June 2012) he stated:

Done has received among the best reviews of his career for the exhibition, and it has prompted some in the art world to reconsider his work as a whole. It could forever change how we see the man, his art and the harbour he has painted for more than fifty years. And Glenn Barkley, a curator for the Museum of Contemporary Art said that he believes that a Done painting could sit 'very comfortably' alongside a Whiteley in any public gallery: Whiteley was another great painter of the harbour, and I think it's quite interesting to consider them together.

It's an important part of Australia's history and I hope one day the works will be seen in Japan. There is a beautiful big gallery in Nagoya and they are keen to show my paintings about the attack on Sydney Harbour by Japanese submarines. I'm disappointed that some bureaucrat seems to be hesitant about the show. There is quite a bit of controversy about Australia purchasing submarines at the moment so they may be employing the John Cleese 'don't mention the war' tactic.

* * *

Recently I had a big exhibition of reef paintings at the Tweed Regional Gallery, which were as beautiful as I could make them. As in any big exhibition, there is always a book near the door where people can write their impressions. Of course you want to read them but you can't just rush over straight away. You have to be cool and wait until the gallery is almost empty. Then you quickly scan the pages. Ninety-nine per cent of all the words are kind, and you egotistically think, Well they clearly know what they are talking about.

But the ones you really remember are the less than positive ones. At that exhibition there was a beauty from a ten-year-old girl from Murwillumbah. She wrote: *Really, Ken, I can do better paintings and I'm still in primary school. Next time try harder!*

Well, Miss Murwillumbah, I guess next time can be seen optimistically as there will be a next time and 'try harder' – good advice. I'm always trying harder! The gallery wants to have another exhibition in a few years. I'll agree only if they call it *Ken Done Trying Harder.*

2015

It's Valentine's Day. I'm going down for a swim. There are
four or five very large cruisers moored at the end of the
beach and one really big super yacht. The cruisers are filled
with families, barbecues on the back and little kids jumping
overboard. Further out, the biggest boat of all only has two
people on it. A young couple. A diving board automatically
appears out of the back transom. The guy casually dives off
it and his girlfriend walks down the stairs in a filmy white
outfit to watch him swim. It's a bit too far away to see who
they are.

A boat like that, assuming it's not his, could cost many
thousands of dollars a day to hire. Maybe she's an actress?
From this distance she looks a bit like Miranda Kerr. Or
maybe he's a successful movie star or rocker. Maybe he's a
banker or a broker or maybe the local coke dealer blowing
a little of his profit on a day on the harbour. Who knows?
Maybe they are just a nice young rich couple and I'm only
showing the vivid imagination of an aging old man. They
sit together solemnly while being served afternoon tea by
the uniformed waitress.

A little closer to the shore, a couple in a rented
rowboat seem much happier, and further down the beach
out in the water a rather mismatched couple attempt to
consummate the day. I say mismatched as she is quite
large and he is quite tiny. She throws her arms around his
neck and he has to brace himself. He shows strength and
patience as she fiddles with the bottom of her one-piece
and attempts once again the difficult task of trying to

make love underwater. I give him a tiny round of applause as I walk past.

A bit further down the sands, a woman speaking what sounds to be Russian is about to enter the water. She is very pale and has covered herself in lots of cream against our harsh sun. She clearly loves being in Australia though, as she is wearing a bikini made out of our flag. The Union Jack part has slipped so far up her bumcrack it's almost disappeared and only the stars of the Southern Cross can be seen. This may be a clue to our future emblem.

Closer now to the end of the beach, a group of Chinese Australians are playing beach cricket and when a ball is belted into the sea a young guy makes a great 'diving in the water catching the ball in one hand that you stick out as your head goes under' catch. This is a move perfected by young Aussie boys that is clearly being taught to all newcomers to this land.

Tomorrow, I'm going to finish Cleopatra's picture. The gallery girls called this afternoon to say they had sold another picture to an American collector. It's a sort of reef painting, quite abstract, that evolved from a trip to Rowley Shoals a couple of years ago. It's always nice to sell a big work and know it will be hung in a beautiful apartment in New York. When a painting goes, it embarks on a life of its own. Out in the world – who knows if I'll ever see it again? It's a tiny bit sad sometimes, like kids leaving home.

I love seeing where my works end up. Over the years we've donated many works to hospitals. I want them to be paintings that can give pleasure to people waiting in there – art to lose yourself in. Even for a little while.

Paintings should be on dentists' ceilings. And in doctors' waiting rooms. (I love the old Tommy Cooper gag from the 60s about the age of magazines and papers in the doctor's waiting room. He said: 'I went to the doctor's the other day. Shame about the *Titanic*!')

INCUrABLE WANDERLUST

Judy and I have always travelled. I used to love to look at a battered old atlas we had when I was a little boy, and dream of seeing other lands. I could not have imagined that I would have the good luck to see so much of the world. The inside passage from Alaska, down the Canadian coast to Vancouver and on to the Rockies. Samoa, Tonga, Fiji, Sulawesi, Turkey, Korea, Portugal and Northern Spain and recently the Northwest Passage from Greenland to Nome, Alaska, and to the Seychelles, Mauritius and Madagascar. We returned to Tahiti and then on to Chile on the way to Easter Island, and the Galapagos. Then Brazil, Panama, Guatemala, Cuba and the Azores, and finally to London to meet up with our friends for a trip to Turkey.

INDIA

I went to India with Oscar in 2005. Judy and I had been many years before, when it was Bombay not Mumbai. It was hot,

steamy, humid and desperately poor. Now it's hot, steamy, humid and very rich in lots of areas. You are still confronted with poverty and suffering in the slums but there are lots of very wealthy neighbourhoods.

I had been asked to do a store appearance at a modern shopping mall, twenty kilometres or so out of town. We inched our way through roads filled with cars, motorbikes, scooters, trucks, vans, pushbikes, bullock carts and men carrying impossibly high loads of stuff on their heads. Everyone was vaguely heading in the same direction and finally we arrived at our destination. Although I'd said I wasn't going to do any kind of painting demonstration, I saw the minute we entered the department store that they thought otherwise. Before us were seated lots of kids with adults crowding around the sides, and in front, a long table of art materials. And an easel. There was clearly no turning back so I made some simple paintings of Sydney Harbour and the kids in the audience followed. They had been given pads and crayons to produce their own versions of my work. Because I am an Australian Goodwill Ambassador to UNICEF, I'd suggested the kids should come from an orphanage. They were bright and happy. Children there are sometimes just left on a train by their desperate parents. At least these ones had found shelter and care.

Afterwards I was talking to a small group of boys – about cricket. I knew that would strike a chord. They eagerly told me that they'd divide the boys into two groups. One group plays for India, the other for Australia. One little eleven-year-old boy asked me if I'd like to meet Ricky Ponting. I was stunned. I didn't know he was there, even though India played Australia quite a lot. 'Well, sure,' I said, eager to meet an Australian sporting legend. The crowd parted and a small lad approached and held out his

hand. In a broad Indian accent he announced, "Ello, I'm Ricking Ponting. Captain of Australia!'

G R eece

You might recall that when we left London to return to Australia, we stayed a few weeks in the Greek Islands. Since then, we've made a number of visits there. I spent my seventieth birthday in Hydra. Judy and I had been there many years earlier for one night only. One night because we missed the last ferry. We'd been with our friends Dick and Lalé Williamson, who were then living in Athens. We had been walking along the little narrow path on the cliffs until we could look down past the olive groves to a little headland and a scattering of little white buildings. Perched on the rocks at the end of the beach were a little white villa and its adjoining chapel. The sea was Greek blue. The beach gleamed, and through the clear water around the rocks you could glimpse divers seeking sea urchins. A couple of speedboats were moored off a bathing platform and the whole thing was postcard perfect.

A couple of decades later, in 2010, we were able to rent that villa with our kids and grandkids and we spent a wonderful holiday on the beach. It's such a beautiful little sleepy island, Hydra. The Australian writer George Johnston and his writer wife Charmian Clift spent many months there in the 50s. Lots of designers and architects have homes there. They are inside the shells of old faded houses, their stylish interiors hidden behind paint-peeled doors.

Our friends from Sydney, George and Michelle Harris and their daughter Sophia, were in Athens with George's mum, and they had arranged to celebrate my birthday with us. They arrived

at the villa in the afternoon, with enough time to swim in the sparkling sea before we met later for dinner. When the musicians gathered around our table to sing 'Happy Birthday', all the crowd joined in. It was the final of the soccer World Cup, and, as the match progressed, the shouting got louder and when the Spanish finally won, the place erupted with cheers. We drank more fiery liqueur. Our granddaughter was there, and slept peacefully through the whole performance. Head down in the high chair.

As I write this in February 2015 we are planning where we'll spend my seventy-fifth. There is something magic about the Greek islands. The light and the sun. The soft afternoon breezes. Looking out to sea, you can easily imagine a boat full of oarsmen with sail set for Crete passing by. I did quite a few little pictures in Hydra on that trip. Mostly little white churches clinging on to rocks, or the feeling of early morning light as it touches the old olive trees and slowly works its way down the beach, where a few fishermen are folding their nets after a night's catch.

Morocco

This was our first big trip with our friends Bob and Millie Wise. After Casablanca, where we'd hired a four-wheel drive and a guide, our first stop was Fez. What a beautiful city. A jumble of sand-coloured buildings, ancient palms, mosques and minarets. Bob and Millie had been there before and booked us into a famous old tiled hotel with a lovely terrace outside our room. Grape vines heavy with fruit hung outside our bedroom door and a little fountain tinkled away in a small pool on the terrace outside the suite. Sadly, the toilet also tinkled away and sent a small stream of very smelly liquid across our bedroom floor. We moved rooms.

All Moroccan towns have an old market area. A souk. The one in Fez is very special. Once you are inside, you have simply gone back in time. Carpet sellers, brassware, stalls of multi-coloured spices, women in burkas. Old men with wiry beards. Donkeys pushing their way through the crowd. The sounds of people hammering. Making shoes. Making pots. You can look down through little openings to see in the gloom families cooking or mending or sewing. It's hot and humid. Men with coffee in big containers strapped to their backs offer a sweet moment. The passageways get narrower and narrower. We lose Bob. Well, Bob likes a good haggle and maybe he's just doing some deal with a local in the music business, who knows? Millie is sure he'll find his way back.

We went to see the famous outdoor vats where they dye carpets. The place stinks so you are given bunches of mint to hold under your nose. You look down on a patchwork of colours from saffron yellow, lemon, all the reds and magenta and Bengal rose through to dark purple and black. The whole area is set inside a warren of tiny paths that wind in and out of the market itself. The limbs of the carpet dyers are stained with decades of colour. Walking carpet men.

We eventually found Bob and a little restaurant near the tiny mosque we had seen from our balcony and stop for lunch. Moroccan food is good. We had pigeon pastilla, tagines of every kind, couscous, goat stew, mint tea and rose petals on everything. Back to the hotel. Avoid the smelly river. And prepare for the next drive. This will take us up over the edge of the Atlas Mountains on our way to Marrakesh. We take turns driving. Again, don't look down. Moroccan lorry drivers have a very cavalier attitude to left and right and you often have to make a last-minute change

in your direction to avoid a head-on smash. The lorries are mostly decorated in swirling Arabic designs and can be quite attractive, except when bearing down upon you. Sheep and goats amble beside the road, with wizened old shepherds trying to keep them in check. Women in black stare out from the shadows of their little homes and, like kids everywhere, children run beside our van, laughing and hoping for some kind of handout.

Eventually, late in the afternoon after driving through the searing heat of the day, we see Marrakesh in the distance. It looks great. Even greater when we pull up at our accommodation. Bob has booked us in at the famous Mamounia Hotel. It's a stunning old place. Famous for years. There are green and white columns outside. A bearded doorman stands outside in starched white uniform. Inside, away from the bustle of the street, the corridors are cool and clean. Lots of tiles, lots of Arabic decoration, lots of flowers, lots of style. Our suite looks out over the pool and across the precisely placed palms to the rose garden and then beyond – through the haze to the snow-capped Atlas Mountains themselves. Churchill used to stay at the Mamounia. He's supposed to have stated that it was the most beautiful garden and view that he'd ever seen. Or maybe he was just hoping for an upgrade. It is stunning and the cerulean-blue swimming pool was an oasis of pleasure for the weary van drivers. Our room was richly decorated in the swirling arabesques that so entranced Matisse on his visit to Morocco. On the little bedside tables were plates of nuts and dates and, on the centre table, a huge bunch of perfect roses. There is a small casino in the hotel. On wandering down through the corridors to reach it, you expect to see Hercule Poirot or Sydney Greenstreet. Or Peter Lorre or even Humphrey Bogart and Lauren Bacall themselves.

HONG KONG

We went home from Morocco via Hong Kong. One morning while wandering through the narrow streets, we came across a little temple in the old part of the city. It was smoky and dark with a few worshippers lighting joss sticks and candles and leaving offerings in front of the altar. I was struck by a little yellow-seated figure, just to one side. I asked the priest about the statue. He said it was just something that people directed their problems to and prayed to. I was gazing at its painted expression when the priest surprised me by saying I could buy it if I really wanted it. Now, I'm not a religious man, but I was rather taken with a religion that would let you take a god home, as it were. He sits now on my bookshelf. I've painted him a bit. He holds the dreams and hopes of so many in the understanding eyes.

Burma/Myanmar

Since Morocco, we've gone on further adventures with Bob and Millie. The next time was to Burma, before it became Myanmar. When we went the army was very much in control. Soldiers with guns everywhere and lots of angry-looking guys checking us out. We had planned to go first up to Rangoon then by boat down the mighty Irrawaddy River to Mandalay. Rangoon is hot, humid, teeming with people and motorbikes. We'd booked at the old Strand Hotel, built by the Sarkies brothers, who built Raffles in Singapore. The Strand looks like a smaller version. It has very white columns and an imposing liveried doorman. On our first morning, Bob had asked for a newspaper to be delivered. It arrived during breakfast. Ironed and carefully folded in a small

wicker basket, borne by a butler in a crisp white jacket. We were bemused to find that when Bob opened the paper to read it we could see him through it. So many articles had been carefully cut from the paper that it looked like a kind of decorative paper screen. It was so flimsy that it was hard to hold. It's impossible to imagine that so many stories could offend the government of the day. But they've got the power. They had the guns.

We were able to drive past the compound that Aung San Suu Kyi was being held in and we marvelled at her courage. Now she's free, and things have changed dramatically in that country, but at that time the situation was still very tense. By the late afternoon we'd almost reached the river and our boat. Travelling through the last few riverside villages, we saw lines of boys in saffron robes with begging bowls carried in front of them. The villagers came out to place food for the young monks in the bowls as they silently walked along the smooth dirt path.

The boat to Mandalay held about fifty or so tourists and once on board up the rickety gangplank, we went upstairs to have a drink in the sunset as we drifted along. The watercourse is quite wide in parts, narrow in others. There are mud flats on the river's edge, with quite a few small reed houses built there so farmers can use the soil until the river changes shape again. Bullocks pull old carts with solid wooden wheels along the banks and kids frolic in the water as the sun goes down. It's not necessary to be able to sing all the words of 'On the Road to Mandalay' but you can't help but hum a few bars as you sail along.

We eventually reached Mandalay. The dawn really did come up like thunder, and then the rain poured down – the kind of monsoon rain you only experience in those areas – and soon the streets were awash and flooded as the drains blocked up. But just

as soon it was over and we...you know I can't really remember what we did. Not much, probably. Just enjoyed the town. I do remember we were held up at the airport for ages because some general was arriving and we and all the other people had to pack into a stifling departure area while the general and his entourage were given the royal treatment. A bit annoying really as his plane landed and pulled up a couple of hundred metres down from the main airport building, and as far as I could see we posed no threat to him from our position. I don't know why we couldn't have stood outside instead of in the chicken coop we were herded into. But as I said before. They've got the guns.

RUSSIAN Far East

A few years ago we flew to Vladivostok to join a small Russian ship for an expedition north towards the Bering Sea. The Russian Far East had been closed to tourists for many years, so we jumped at the opportunity to visit such a remote and secret land. I'd always wanted to go to Vladivostok. Such an exotic name. I knew it was where the Russian fleet was moored and lots of submarine and Cold War radar sites were there. We cruised past high cliffs, shrouded in mists, and beside rocks covered with seals and sea lions. There were huge bird colonies with nests precariously clinging to the cliff faces. Each day we'd go by Zodiac to explore the landscape and the little coves. Sometimes we could go ashore on deserted rocky beaches, accompanied by a man with a rifle on bear patrol. We saw lots of bears actually, big brown ones, a couple with cubs, strolling majestically along the shoreline or climbing up the grassy slopes to their cave. At one point we were able to get within a few metres of one mother and her cub.

We were in the Zodiac, and she and her charge were fossicking around a couple of old abandoned rowing boats. The young bear would constantly sniff the air but the mother was surprisingly unconcerned.

On one shore excursion I fell badly and twisted my ankle. Judy and I were walking around an abandoned military base and suddenly the grass I stepped on gave way and I tumbled over. It bloody hurt. There was not much anyone could do, though, so back on board the ship's doctor just bandaged it up and told me to rest for a day or so. I did, but it meant when the others went on excursion, I had to sit alone on the deck. Well, not entirely alone. The captain had brought his son along for the trip. A boy of about eleven or twelve. The crew had given him a small pair of overalls that had to be rolled up to allow him to walk around. He was a nice kid. He didn't speak any English and I spoke no Russian. He would take great delight in mimicking my clumsy twisted-ankle gait and loved to wobble round the deck imitating me.

We had a few expert guides on board. One, a Russian bloke who lived in the area, convinced the captain we should venture further up the coast than had been planned. He wanted to do this because he knew there was a huge herd of reindeer twenty or so kilometres away and they were on their annual migration to the sea shore to sample the salt there. The ship was in radio contact with some herders travelling with the pack and we glided into a very remote bay one morning with every hope of seeing them. I was able to hobble along this time. A number of Zodiacs were sent ashore and we gathered on the top of a low hill overlooking the beach. A clear sky. Cold. Grey water lapping at the rocky shoreline. Gulls swooping and diving overhead. And a little clump of tourists, clad in bright coats and ski jackets, waiting

patiently. Just after lunch a walkie-talkie message came through. The huge herd was only a few kilometres away and running fast in our direction. We strained forward to see the first one. One, two, then a hundred, then a thousand. All shades from white through browns to jet black. I didn't know reindeer could come in so many different colours. They galloped towards the beach to take turns in licking the salt, then went back up the slope to the grassy area and began to be herded into huge lines, making spirals and circles as the men in traditional outfits tried to keep them together. To our astonishment, a young man suddenly leaped into the crush of animals and, with a huge knife, slit the throat of one of the beasts. We were shocked but later found out the animal had been limping (glad no one thought of my limping as such a problem!) and would not have been able to keep up with the herd on the return journey. And besides that, they needed some lunch!

It's such a remote part of the world. We visited the little island where Vitus Bering is buried. On a windy, grassy hill looking out to the sea that bears his name, his remains rest in peace. On this island were a couple of little huts, used only in high summer. I peeped inside. A stove. A bed. A tiny kitchen. Some tins of food. Some fishing gear. To get to those huts we crossed streams full of salmon. Twisting and turning, as they broke the surface you could almost catch them with your hands.

There is a Russian outpost called Petropavlovsk a few hours' sailing away, and we spent the afternoon there. It is a pretty grim-looking community. Lots of old concrete buildings. Lots of things in need of repair. To find a shop you have to go into one of the accommodation blocks, where the local shop is tucked away. Although the town was grey and grim, the people were not. They performed a number of traditional dances for us in a little

museum. They want to preserve the language and customs of the original inhabitants of the land. It's a bit Siberian, a bit Eskimo. There was once a thriving fishing fleet there. It's not there now and nobody seemed to be able to tell us why. The long winters there must be so dark and cold.

When we returned to Vladivostok and the boat trip ended, Judy and I had booked a kind of add-on excursion. It was billed as a fishing trip down a remote river, then a couple of days in a Russian hunting lodge. It sounded good and even though I was still limping, we were eager to go. There were maybe a dozen or so people from the boat with us. We arrived at a kind of tented camp beside the river. It was very clean and new, with proper sit-on loos. Nice lunch, then we set off down the river. The river flowed through fields of grass and wildflowers. Overhanging trees offered patches of shade and we trailed lines, hoping for salmon. We caught a few. They didn't seem to give much of a fight and mostly we threw them back. It was a lazy, hazy afternoon. The air was thick with midges and mosquitos. Russian mosquitos could give Aussie ones a decent challenge. They are big and vicious. You need one hand on the fishing rod and one hand to keep the buggers at bay. Late in the day we pulled up under some trees at a little landing. This was where we were to meet our host for the evening at the hunting lodge. Already we were imagining a kind of Ralph Lauren wooden building with bear skins on the floor and deer antlers on the walls. An old stone fireplace and some stylish worn leather chairs to sink into with a vodka or late in the evening maybe an old smooth brandy.

It turned out not to be quite like that.

Our Russian host was a big man, with a great collection of both gold and silver teeth in his mouth. He had a shaggy beard

and was wearing very old and very large leather shorts. Whenever he bent over, he displayed a bumcrack that would be the envy of any Aussie tradie. But he had a great smile and told us to follow him through the woods, so we did.

Even by this time I still needed an old ski pole to help me walk, but not to worry because we were on our way to a hunting lodge. After a few hundred yards we entered a clearing. There was an old army truck parked among the weeds, a rusty aluminium garage to one side, a tin shed behind the woodpile and through the birch trees you could just see an old house. I limped towards the truck, expecting that was the vehicle that would transport us to the hunting lodge, when I was stopped by Mr Goldteeth Bumcrack. He pointed to the aluminium garage: 'Ladies sleep in there,' then to the tin shed: 'Men sleep in there.' Oh no, that is not what we had imagined. So I found myself about to share a shed with blokes I hardly knew and Judy was taken away for a bit of secret women's business or something.

I chose the bed nearest the door. We were then summoned by Mr Bumcrack to join him in his private sauna. He had constructed his sauna down by the river. It was a rickety old building but it really worked. Hot as blazes inside, and he took great delight in pouring buckets of water on the glowing coals to fill the room with steam. The only benefits of this hellish torture was that the room filled up with so much steam you didn't have to glimpse the entire bum or any appendage of our host. He delighted in showing us how to strike ourselves with the birch bushes he'd made into whips and I think he was a bit disappointed when we wimped out of that part of the performance.

He then issued instructions about what the evening might entail: as far as I could work it out, we were to be at his place in

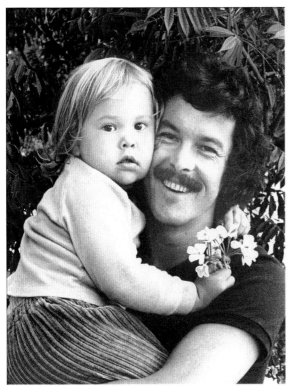

Camilla and me, 1973.

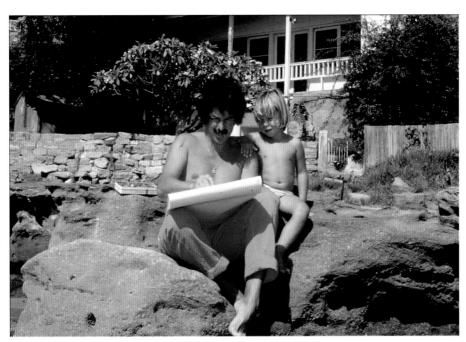

Me and Oscar, 1981.

'Beer Nouveau' beer cans for Suntory, 1991. The clincher for me was that it was brewed using the first-picked hops from Tasmania.

Hanako magazine covers. For more than thirteen years my artwork appeared every week on the cover of this most successful Tokyo magazine. They still use my logo.

A collection of handblown glassware for Kosta Boda, from brandy balloons to liqueur glasses, with stems inspired by palm trees.

Our Reef print homewares – art to eat off!

Our gallery in The Rocks, Sydney.

Princess Diana and young Prince William on
a beach in the Virgin Islands (she is wearing
our pareo). *Trinity Mirror / Mirrorpix / Alamy*

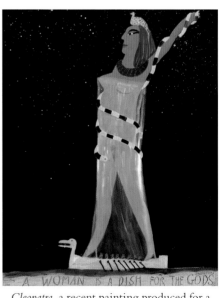

Cleopatra, a recent painting produced for a
Bell Shakespeare Company fundraiser.

Designs for a new Australian flag.

The Powerhouse
Garden Restaurant
(sadly painted over!).
Penelope Clay

With some kids in Africa, during our first UNICEF trip to Zimbabwe. I've had the privilege of being a Goodwill Ambassador for more than 30 years. It continually reminds us of what has been achieved and what is still to be done. *UNICEF*

Me and one of my heroes, Ray Charles.

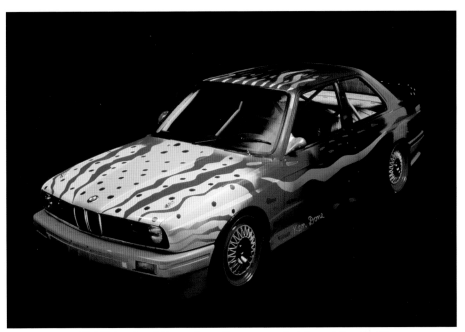

BMW Art Car. Like an Australian parrot – bright and fast. *BMW*

One of the graphics for the Sydney Olympics, 2000. Best Olympic Games ever.

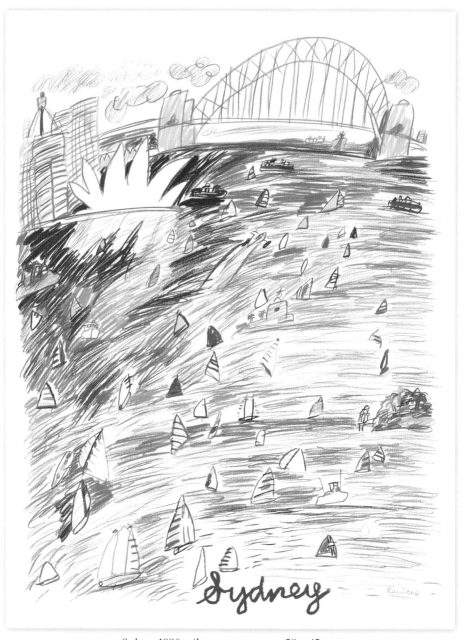

Sydney, 1980, oil crayon on paper, 58 x 45cm.
My first *Billy Blue* cover, and one of my first Sydney Harbour drawings.

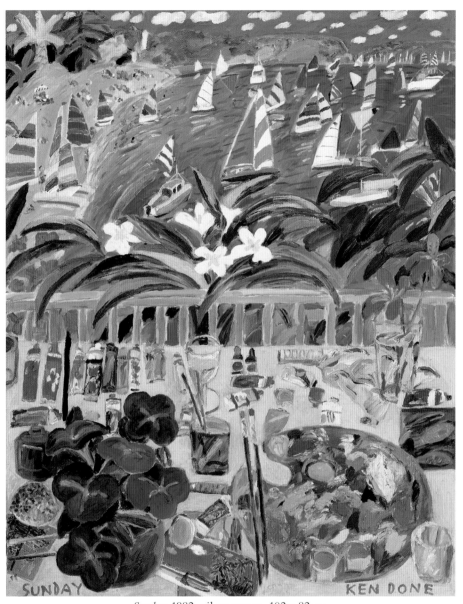

Sunday, 1982, oil on canvas, 102 x 82cm.
A hot Sunday and a painting like a sundae – rich and decorative, and a landscape
you could eat. This is the joy of being in the Cabin at Chinamans Beach.

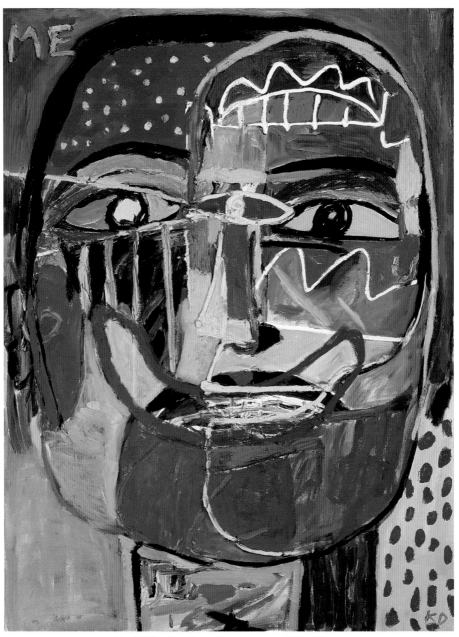

Me, 1992, oil and acrylic on canvas, 102 x 76cm.
Archibald Prize Finalist, 1992. Collection of the National Portrait Gallery, Canberra.

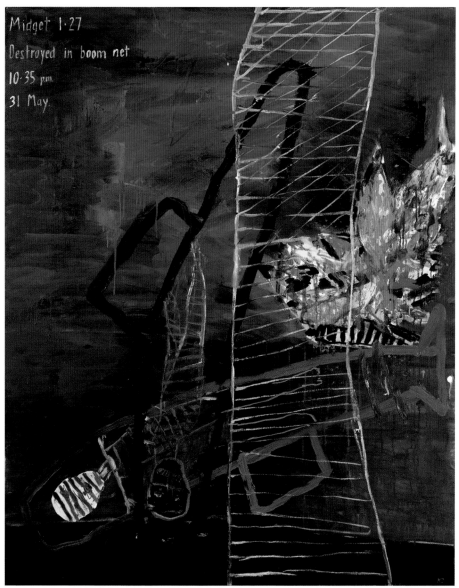

Caught in the net, 2011, oil and acrylic on canvas, 152 x 122cm.
One of a series about the attack on Sydney Harbour by Japanese midget submarines in 1942.

Walking on Lake Eyre, 2002, oil and gouache on paper, 46 x 66cm.
Hot and shimmering.

Chinamans Beach January II, 2002, oil and acrylic on clayboard, 61 x 81cm.
Looking down from the garden to the beach – an endless source of inspiration.

Opera House, black sea, night sky, 2009, acrylic on canvas, 60 x 70cm.
Sydney at night, and the stunning beauty of the Opera House.

Grandogs by the beach, 2007, oil and acrylic on canvas, 41 x 50.5cm.
A little painting of two of the world's best dogs – Bexley and Indi.

Turquoise coral head I, 2011, oil, acrylic and oil crayon on linen, 152 x 122cm.
Another painting about the joy of being underwater on a coral reef somewhere.

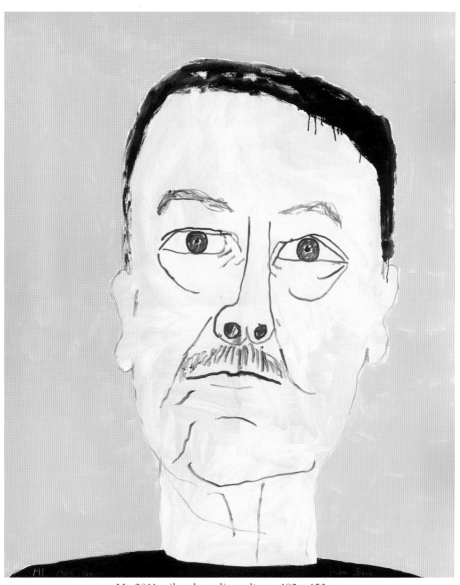

Me, 2011, oil and acrylic on linen, 182 x 153cm.
Archibald Prize Finalist, 2011.

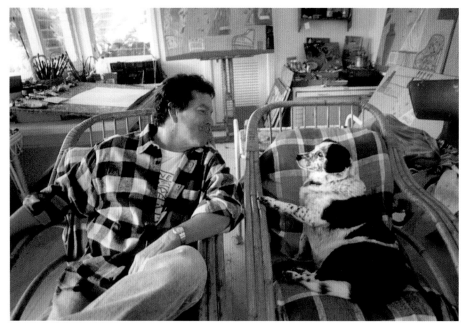

In the Cabin studio with our beloved dog, Spot.

Family diving holiday, 2012.

half an hour, when we would be given traditional Russian food and lots of vodka and we'd all get totally pissed. He grinned and laughed throughout all the details, as to him it was just the kind of night to offer any guests. Especially ones from Australia.

His house was not a Ralph Lauren hunting lodge, but it was cosy and clean and his wife had prepared quite a spread around their kitchen table. Soup, sausage, meats, vegetables, black bread and shots of our host's homemade vodka. He sat grinning at one end and I sat at the other. In his broken English he began a series of toasts to our respective countries, our respective sportsmen, our respective monuments and governments. Anything he could think of that meant we'd have to throw down another glass of firewater. I did my best to keep up the Aussie end, but I was exhausted and my bloody ankle was throbbing.

He wasn't happy about me going but I just had to get to bed. I hopped through the darkness. Through the mosquitos. Through the long grass and back to the tin shed. I collapsed, the vodka making my head spin. My ankle throbbing with pain. It seemed like I'd only just fallen asleep, although it was probably an hour or so, when I was suddenly woken with some strange movements near my bed. Rubbing the sleep from my eyes, I looked over my blanket to see the amazing bumcrack of Mr Bumcrack right in front of my eyes. Mr B seemed to be wanting to get under my bed. I was quite stunned. Thank god he wasn't trying to get into my bed. It quickly became clear that Mr B's old dog had chosen to sleep under my bed and Mr B was just trying to extricate the shaggy old beast and get him home to his place in their house. I squeezed my eyes shut and just pretended the whole thing would go away. Fortunately it did.

The next day we were taken to see a mineral water bottling plant and had a flop in a mud pool beside a river. The bottling

plant was supposed to be one of the tourist highlights of the area, but the mud bath was much more fun. In an area about the size of a couple of tennis courts, lots of large to very large to extra super large Russian ladies in tiny bikinis slopped around in mud pools. It was a surprisingly pleasant experience, although the little towels we were given to clean ourselves off afterwards would never be the same again.

On our return to Vladivostok we headed off to a picnic under one of several big volcanoes that dominate the landscape. No road. In a huge old army troop carrier we bumped and crashed along a dry riverbed, climbing up to the slopes of the volcano. Our guide set up a little barbecue and we gathered wild blueberries before lunch. The looming volcano was snow covered at the top and groups of climbers could be seen all roped together, attempting to scale its slopes.

We left the Russian Far East on an Aeroflot flight from Vladivostok. I'd travelled on Aeroflot many years before so I had some idea of what to expect, but this flight was worse than I imagined. Our seats were right at the back of the plane, hard up against the bulkhead. There was hardly any room to even squeeze into them, let alone any space for my increasingly painful foot. We'd booked a wheelchair to meet the plane at Seoul in Korea, where we were to be transferred to a Thai Airlines flight to Sydney. I eventually hobbled off the Russian plane and into the welcome arms and wheelchair of the Thai attendant. The airport at Seoul is modern and spotless. It was a joy to be there. As we waited at the front of the line to be boarded onto our next flight, the Thai attendant in a very broad Thai accent told me they would look after me perfectly and that champagne and care would be willingly offered. I was assured they would do anything

to make me happy and comfortable. I could only murmur my thanks.

Quite a few people were gathered around the gate but wheelchairs go first. I was just being wheeled away by another lovely cabin attendant when my new Thai friend called out to me, loudly, in the broadest Australian accent: 'How they hanging, mate?'

This got the assembled passengers' attention and all I could reply was, 'Well, it's my ankle, not my nuts. But thanks for enquiring.' I think he'd been taught the expression and accent by some travelling Aussies and he saw it as a term of endearment. I appreciated his concern.

Beijing to ST PETERSBURG

We did another trip from Beijing to St Petersburg in 2008. Previously Judy and I had travelled north from Beijing through Siberia across the endless taiga forests to Moscow. This time we took the Silk Road through western China. It was great to have Camilla with us and we were thrilled to be in China again, and with the prospect of seeing so many new parts of the country. After leaving Beijing we headed south to Xian to stay a day or two and see the terracotta army. On this train trip we stayed each night at different hotels – the best in each town. Xian has a wonderful old wall surrounding the old city itself and it's heavily decorated with banners, signs and big statues to various Chinese gods and idols. Like any Chinese city, it's bustling with cars, bikes and people. Below the wall at the roadside stood groups of tradesmen looking for work, all with signs indicating their respective trades. China seems to grow before your eyes: the

skyline of all the big cities are dominated by cranes building yet more office blocks or hotels or apartments.

Although most people have seen photos of the terracotta warriors, you are not prepared for the scale of the place. It's astounding. Huge covered pavilions hold hundreds of figures in various states of repair, and across the way is a mountain yet to be excavated – it is believed thousands more warriors are hidden inside.

Then on across the plains of western China.

From the station at Dunhuang we set off to meet up with camels to carry us to the Lake of the Crescent Moon. It must have been such a relief and comfort to the Silk Road travellers of the past. The modern-day tourist can just gaze with amazement at the azure water in the midst of all that sand. If you are prepared to climb on steep ladders placed on the side of the giant sand dunes, you can sit on a rough mat and slide down to the bottom. It's great fun, if a bit hard to steer – you just have to lean forwards and hope for the best.

Then westwards to Almaty, over the border to Kazakhstan. The train pulled up at a siding and we were loaded onto buses to get to the border. In the middle of the desert stood two big iron gates. Closed. A little fence went left and right for a few yards. We could easily have driven the bus around it, but just in case of land mines, we had to wait. Finally, like something out of a Disney cartoon, a little car bristling with dangerous-looking soldiers appeared in a swirl of sand. The driver braked; they all jumped out. They put down their guns and opened the gates. Welcome to Kazakhstan.

In one of the towns there is a large outdoor museum dedicated to the invention of astronomy and the understanding of the moon

and the stars, and down near the railway station there is a huge statue to the man who invented algebra. I couldn't help but go across and kick it to somehow make up for the hours of worry and helplessness the subject had given me at Mosman High. In fact, I can remember a report card that showed 29 out of 100 for maths. No wonder I was ripped off by our accountant! I received a report card once that had these comments. From the English teacher: *Ken is one of the most inventive students we've ever had.* A couple of lines lower another teacher, more embarrassingly, had written: *Ken is a wonderful student. If I ever had a son, I'd like him to be like Ken.* In between, another teacher had written, *This boy is a fool.* I guess I was beginning to understand you can't please everybody. It's an important lesson for young painters.

After Kazakhstan we drove from Ashgabat in Turkmenistan to Khiva, Uzbekistan. We spent a day in Khiva with some of the most beautiful and simple buildings we've seen. It's a 2500-year-old walled city and it is so easy to imagine what it must have been like to be living in those days.

Then onwards and upwards through the Russian countryside to Volgograd – once Tsaritsyn and, later, Stalingrad. Right in the middle of town, down by the river, they have kept a couple of buildings exactly as they were when that terrible siege ended. What destruction and what courage and perseverance the people of that city must have gone through. For privileged Western people of my generation, it's impossible to really understand. The city is dominated by a huge statue of Mother Russia, proudly standing guard, and at the war memorial they conduct a flag ceremony every day – it's incredibly moving.

Then on to Moscow. The city had become even more modern and inside our hotel you could have been in New York. We

met up with our old friends, Ric and Kerry Hedley, who had been visiting their family in London and were to travel to St Petersburg with us. As I mentioned earlier, Ric had been a mate since art school days, so we were keen to see as many galleries as possible. Unlike the Moscow I first visited in the early 70s, everything was open. In the past I was only shown traditional Russian revolutionary pictures and big heroic panoramas of battles and sieges. Now it's possible to visit the homes of the great Russian collectors of what we now call Modern Art – Shchukin and Morozov. Their eyes well ahead of everybody else. And the money to keep Matisse, Monet and Picasso in paint. Lots of it. It's amazing to see the clear bright freshness of a Matisse in a dark room furnished with old Russian drapes and heavy furniture.

We had private drinks and songs in St Basil's church: 'Kalinka Kalinka', and the 'kalinka' of lots of little vodka shots. Then a walk across Red Square, past the Lenin mausoleum to the big GUM department store. There is very little in Moscow's shops that you can't find in New York. We saw the ballet, the churches filled with glowing icons and the impossible traffic jams. Now and then you have to pull over and make way for an official car. Flags and stars. Get out of my way. I heard somewhere that for some money, almost any rich bloke can get his own star and flag for the car. There are lots and lots of rich people in Moscow, and it seems that, as ever, money will smooth the path. Or traffic jam.

We went to the big station we'd arrived at a few years previously on our trans-Siberian trip but this time we were heading in another direction and we set off for St Petersburg. Light snow fell and we were soon travelling through the outskirts of town. Big old wooden houses. Little villages. Lakes. Forests. Domed church spires and then over a big river and into

St Petersburg. This time we stayed at the Grand Europe Hotel. One of Europe's finest. It has the most amazing breakfast room. The buffet is huge. Tables laden with all kinds of food and drink. There's a big table of caviar and a harpist player on a raised stage. Tucked away there is a special bar with the best caviar only. And we were told that you can eat and drink the best vodka in a little private curtained room with your special companion.

It's a beautiful hotel and I hope we stay there again. Just around the corner are the ballet theatre and some lovely little churches. It's on Nevsky Prospekt and is close by a famous old delicatessen that looks like it's been there forever.

We went to the house where Rasputin is said to have been assassinated and drifted down the river to where Catherine the Great had lived. We visited the Hermitage again. You can never give it enough time. The highlight though was when our mate Ric tripped and fell into a glass case containing some of Catherine's most beautiful gowns. He wouldn't have looked much good in them anyway. The case was not damaged. Nor, thankfully, was Ric.

INDIA and Bhutan

Judy and I visited India again, travelling by private train from Mumbai all the way up to Darjeeling, with an extra bus trip to Bhutan. The train was navy blue and white with gold trimming and a liveried attendant who stood on a small red carpet to usher you on board and give you an icy cold drink in a reception area before escorting you to your cabin. Not exactly slumming it. Outside on the platform, hundreds of people sat or slept. Or stared. It did make us feel uncomfortable. It's amazing, India.

Such contrasts. Often beside the railway line there were whole cardboard villages. Thousands of people crammed into little flimsy shelters. Yet in the morning, lines of little kids in clean school uniforms picked their way through the mounds of rubbish on their way to class. We visited the Taj Mahal. Everything people say is true: it is very beautiful, reflected in the pools on a hot dusty Indian orange evening.

Then a few days later we were at the Ganges, where they burn the bodies. Not so beautiful. Through teeming crowds, around sleepy cows and down through the narrowest of alleyways we reached the mighty river. Then we were ushered onto one of the many rowboats going up and down the river until we got level with the funeral pyres. It was very hot and humid and not for the fainthearted. Men and boys dive into the swirling brown river where the bodies are washed, seeking anything that might have fallen from the dead. The large fires smoulder above and the sound of chanting fills the air. You are given a small paper boat with a little flower and a candle in it to lean over and gently float away as an offering to the gods and the hope of a better life. I watched my little craft sail away until the huge oar of a passing boatman sank it. Bugger. Maybe I should believe in some kind of god.

We visited the famous palace on the lake in Udaipur, then on through the brown countryside on our way north. In the late afternoon you could see all the farmers slowly wending their way home to their little villages, through the meticulously attended little plots of vegetables and small gardens.

Finally we arrived at Darjeeling. You reach this hill town up some very steep and narrow roads. All the vehicles are old Jeeps or four-wheel drives. There are tea plantations on all the hills around. Endless rows of green stretching up to the clouds. We

took a famous little steam train up to a hill station. Then back down again to the town. Darjeeling is quite a big town. I was able to buy a beautiful old yellow amber teapot that I've painted quite a few times. We tasted many teas. We started to understand the subtleties of the various leaves and brews.

We had arranged to go and see one of the most remarkable sights in the area. It was a couple of hours away and we needed to be there before dawn, so at 3.30am we groggily left in a bus to drive to our destination. We were headed for an observation platform high above the town.

This was where we could see the first rays of the morning sun touch the mighty Himalayas and the majesty of Everest itself. We arrived just before dawn. You are seated in comfortable chairs, facing east, waiting for the sun. The sky begins to lighten and then the first rays appear. They lit up gloriously the top of the bus we had arrived in…and that was it. Clouds and mist swept around our viewing area and looking across towards Everest we had a clear view for about five yards. On the wall was a glorious photo taken in April 1968 of the magnificence of the view. Crystal clear. Everest shining majestically and proud. We stared at the fog. Not even sure if we could safely make it back to the bus. Must have been great in 1968.

After Darjeeling it was onwards and upwards towards Bhutan. By bus. Up very, very narrow and windy roads. Don't even think of looking down. Parts of the roads were very unstable and the area had seen many avalanches. We eased our way past boulders and mountain-fed streams that threatened to halt our progress. Many, many hours later, we arrived at Thimphu. This is the capital, and one of the two major cities in Bhutan, and it sits below a mountain where a huge Buddha is being constructed.

The Bhutanese are a happy and contented race, or so it seems to the outsider. Our hotel was very modern and stylish. Lots of beautiful decoration on the heavy beams of its construction and lots of multi-coloured flags and banners everywhere. A dance troupe performed with men in reindeer heads jumping up and down over a burning flame. They do a lot to keep their traditions alive. Everyone who works for the government has to wear national dress. Long skirts for the girls and women and a kind of kilt and long socks for the men and boys. Very stylish really. The women seem to glide along and the men look vaguely like a Ralph Lauren fashion parade.

Bhutan, as you may know, has a National Happiness Index. They do not allow mining or forestry. They do not want the Chinese to take over in the way that they have in Nepal. The new young king has just married a very beautiful Bhutanese woman. It may be hard to preserve the lifestyle and traditions they so respect, but I hope they do. We visited the monastery where two rivers meet, and a number of hillside towns where the houses are decorated with massive penis drawings on their walls – pretty impressive appendages with great attention to detail. It's said that they're to ward off evil spirits, but somehow I don't quite see it happening in our street in Mosman, no matter what evil spirits threaten to invade.

It's a stunningly beautiful landscape: towering tree-covered mountains leading up to the snowline and far below, the rapids of gushing mountain streams. Bhutan makes most of its revenue from hydroelectric power, which it sells to Northern India. I hope it remains so.

We visited the local art school, where students learn over a five-year course to make paintings of the Buddha. In a wooden

three-storey building with not too much light, the young people work away slowly on the various stages and designs for religious icons. They were kind enough to ask me to work a bit with them and seemed most interested in the freedom and the line I used. It was a great treat for them when I encouraged the young painters to draw loosely and use colours they may not have considered before.

Of course somewhere in the classrooms there must be somebody who teaches penis painting. Probably not for tourists.

Beijing to MOSCOW via Siberia

We love trains and I was thrilled to be able to see the classic old Chinese engine that was to take us on the first part of the long trip in the mid 90s. The little gardens on the station had pressed metal pandas as surrounds and the station mistress was festooned with medals and braid. We left late in the afternoon. Little lace curtains, a little dining carriage with quite firm old seats, nice food and Chinese wine, and later lulled to sleep by the *clickety-clack* of the train as we lay in our bunk beds. Our attendant had closed the lace curtains and switched off the lights so we were asleep straight away.

In the morning we opened the curtains to find we were in the middle of the Gobi Desert, rattling along past endless sand hills. Occasionally in the distance, we'd see lorries on big highways travelling north and lines of plodding camels moving slowly south.

We stopped on the border and spent the morning in the market. Lots of plastic shoes, lots of Mongolian fashions, lots of knock-off western fashion. Lots of bags and bowls and bric-

a-brac. Tinned food of all kinds, mounds of vegetables and big hunks of meat lying on slabs with an attendant army of flies.

We had arranged a trip into the countryside as the train was stopping for a few hours. Mongolia looks a lot like a big golf course. Rolling grass-covered hills unfold into the distance. Lots of sheep. Lots of goats. Lots of horses.

We had been invited to lunch in a ger. Not a yurt, as they are sometimes mistakenly called. It was a group of half a dozen tents with smiling children rushing down to our bus to welcome us. The inside of the tent was warm and inviting. There was a central fire, lots of coloured rugs and a rather unexpected sideboard standing near the door. We were offered tea, yoghurt, biscuits and cheese. The cheese had been brought in by a young lad who had taken us to see where it had been kept. Under a rock. Out in the grass. A well-matured sheep's cheese that was delicious.

There are no trees on the plains of Mongolia, so it's the boys' job to set up a line to which they tether their horses. The boys didn't use saddles – they swung themselves up and galloped across the hills. Just to impress us. And we were very impressed.

We visited the capital, Ulan Bator. What a place. Genghis Khan could feed his army there. At the local McDonald's.

Then it was on to the Russian train as the gauge changes at the border and onwards across eight time zones through the taiga and frozen wastes of Siberia. On this train you stayed on board for the entire trip. Some people would think that might be boring. Far from it. We stopped often on the way across. We ate in one of two dining cars on the train. One like an old Russian pre-Revolution room and the other based on a kind of Swiss chalet design. I think it's one of travel's great pleasures to be dining on a train, watching the landscape pass by. A few drinks and all you

have to do is wobble back through the carriages to your cabin. Slightly disconcerting was the fact that after using the toilet at the end of the carriage you had to put the used paper in a little basket beside the seat. Not so romantic. At the opposite end of the carriage, a rather large blonde Russian lady sat in a small room with a samovar constantly steaming away. Very late one night, I wandered down to get a cup of tea and found that the tea lady was also steaming away with one of the conductors. Well, it's a long trip and maybe they were just old friends.

The taiga, the forest, goes on for days. It's quite hypnotic. Occasionally a small clearing held an old wooden dacha and now and then we'd stop at a small station in the middle of nowhere. The train had an entire carriage of shower cubicles and hair dryers. Each morning you passed your fellow passengers wearing their white towelling robes, bouncing along to the showers or bouncing back. It's a bit tricky to shower for too long in a moving train but it was a worthy and necessary addition to the accommodations.

One cold windy night, I woke to find the train stopped. I wiped the condensation from the window and was amazed to find that the entire station was painted the brightest ultramarine you could imagine. A bit ghostly and strange in the darkness. Only a few lights illuminated the scene and as there appeared to be no one around I wasn't even sure why we were there.

We stopped beside the town of Irkutsk at Lake Baikal, the largest freshwater lake in the world. The train slowly travelled around the edge of the water for many miles before we arrived at the town itself. The lake is so big it's like looking out to sea. Mountains can be seen in the far distance and in winter people camp and fish on the lake's solid icy surface. We visited the little

museum with its fading photos and skeletons of the Lake Baikal seal. It's not really understood how these animals found their way into the lake, as seals are normally found in the open sea.

Our train had been shunted to a siding so the other goods trains and the regular trans-Siberian express could rumble by. As we were going to be stationed there for some hours, a few people decided to have a swim in the lake. Even though it was summer, the water was near to freezing; and after an adventurous plunge in, I rather quickly emerged with balls the size and colour of blueberries.

Meanwhile, Judy had collected a bunch of beautiful wildflowers that grew beside the railway line and we set off on a journey that would take us through Krasnoyarsk, Novosibirsk, Yekaterinburg, Kazan and on to Moscow.

We arrived at the main Moscow station, the huge Russian engine sending clouds of steam into the station's roof. The proud driver and engineer took their bows. We had two engines, the first with a giant red star on the front of its massive boiler. And at each carriage, our attendants stood spic and span in their neat uniforms and medals. We'd shared a long journey. We'd become friends. Further down the platform I glimpsed our tea lady giving a discreet and tearful goodbye to our conductor. Maybe the end of a beautiful friendship or maybe just a break at home before they went the other way again.

After a few days in Moscow we flew to St Petersburg: surely one of the world's most beautiful cities. Pink and yellow buildings with wonderful decoration sit beside little canals. Beautiful icon-rich churches and that beautiful broad Nevsky Prospekt sweeping through its centre. We stayed at a fairly basic hotel, unlike the stunning Grand Hotel Europe we were to visit a couple of decades

later. We had seen many photos of the Hermitage, a beautiful pale yellow and white building; to look at it across the river, it is quite stunning. So is what's inside. You could spend many happy years strolling past its treasures. I admit to being brought to tears standing in front of some Matisse masterpieces I had only loved in reproductions. Especially the painting called *The Pink Studio* – I think it's Matisse at his best. Glorious colours and patterns – it shows the delights that can be found in a painter's studio. There are rooms and rooms of some of the world's greatest artworks. It shows the vision and understanding of those early Russian collectors of French paintings and the overwhelming luxury of the ruling class before the Revolution.

Then on to the Summer Palace. Gold, gold, gold and amber, amber, amber, rooms of almost unbelievable luxury and decadence. Lines of slack-jawed tourists marvelling at it all. Fantastic gardens and fountains, stables fit for a king or queen, let alone horses. And this was just a summer retreat. No wonder there was a revolution.

THE AMAZON

We've visited the mighty Amazon twice. Our first trip was on the same boat on which we'd done a circumnavigation of Spitsbergen, on the opposite side of the world. We boarded the *Polar Pioneer* in Iquitos. The boat was on its way from the Antarctic back to the Arctic, a trip it had done many times, but the tour company decided to do a once-only trip up the Amazon and back down again.

The river is brown and swift flowing and I was thrilled to stand on the top deck and watch the ropes be untied as we began our journey of almost two thousand kilometres down to the sea.

To Leticia, Manaus, Santarem and eventually Belem. Slowly drifting down the mightiest river in the world, winding through the dense steaming jungle, we would take the small Zodiacs up little side streams to visit tiny villages that had not had visits by anyone for ages. Wisps of smoke came from the cooking fires inside the huts and little kids jumped and dived on the river's edge as we approached. It seemed a very primitive lifestyle. Except that is for the TV aerial poking up through the trees to catch the next episode of some Brazilian soap opera.

We were surprised to see the kids swimming but the locals assured us we were safe from piranhas unless there was blood in the water. That might have been so but it was with a little trepidation that we swam the next day in a murky lagoon. Now and then we saw sloths in the branches of the trees moving very, very slowly and now and then we would catch a glimpse of a pink dolphin moving very, very fast. Some days the river is so wide you cannot see the other bank and it's just like looking out to sea. We stopped at Manaus, a totally jungle-locked town. No roads in – only the river and the occasional aircraft. It was one of the richest cities in the world during the booming rubber years and has one of the most remote and stylish opera houses anywhere. There was a charity performance on the night we were there and we had all been invited. It was black tie and evening gowns. The best I could do was a bow tie I had fashioned out of painted paper and Judy looked great in a pareo and scarf. The opera was about the beginnings of Manaus and the excesses of the rubber barons, evident in many of the crumbling grand buildings in the city.

After Santarem you reach a wide section where the Amazon River joins the Rio Negro. Two mighty rivers. One light brown,

the other almost black. Looking down from the ships bow, it's like the patterns and colours of a creamy cappuccino.

We finally reached the end of the trip. There is an island in the mouth of the Amazon that's bigger than Switzerland. Just south of that island is the port of Belem. Belem is a bustling city. It's also very hot and sticky. We stayed overnight in a room not much bigger than the bed squeezed into it. It was impossible to sleep in the heat, and with the noise of the city outside. One of our party, an old bloke from Brisbane, was mugged not far from the hotel, his money and camera taken by a couple of cowardly young thugs. We were all pleased to leave Belem. Then south to the waterfall of waterfalls. The Iguaçu Falls. Numerous cascades tumbling over huge cliffs surrounded by jungle. We stayed at an old pink hotel beside the falls. You don't see the falls when you arrive by road through the jungle, but a short walk down from the hotel and there it is. Far too big to even take in from one viewpoint. Clouds of mist rise in the air and huge flocks of parrots screech by. It is quite a walk through the paths to reach the precipice. You hear the roar long before you see it. You can stand perilously close to the edge and your eyes became hypnotised by the gushing torrent as it falls to the river below. Later we went down to the river and donned ponchos to motor by launch close to the base of the biggest falls of all. You come back to shore completely drenched: I don't know why we bothered with clothes at all.

Thinking about the Amazon again I do remember we went to a rather rundown zoo along the way. Some little river town. They had a number of water pens containing huge river carp bigger than a man that a number of guys were trying to move from one pen to another. The huge fish flopped and twisted around and it took four or five strong guys to complete the operation.

A bit further along into the zoo we were shown a dirty old pond where they said a huge alligator lived. We could not see him at all. The keeper assured us he was in there and they had a method to get his attention. This consisted of getting a chicken from an adjoining coop, attaching a string to the chicken's leg and tossing it over the fence near to the pond. I could see by the look on the chicken's face this was not the first time she had experienced this death-defying feat. And I noticed one other thing about this bird. She had thighs Colonel Sanders could only dream about. Those huge thighs had developed from the daily alligator toss, where the chicken had to brace herself before the lunge of the alligator and leap into the air to avoid the snapping jaws. She was then whipped back by the handler to the safety of her little house. We were shown the whole performance. The throw, the thighs bracing. The lunge. The leap. And our brave chicken lives to leap another day!

China

Not such a happy ending in China for the birds. We were in Harbin after the joint exhibition of Mosman artists in Mudanjiang. The city is famous for two things: the amazing ice festival in winter; and the world's biggest tiger sanctuary, outside the city. (There were lots of Chinese tourists visiting the tigers the day we were there but of course there are always lots of Chinese tourists in China.) It too is a bit rundown but very large. You travel mostly by bus around the park where the tigers run free, but now and then you are able to get out in fenced areas and walk.

During the bus tour we'd seen a tiger swim across a lake and take an unsuspecting duck. Tigers have such beautiful and striking faces, it was riveting to see its head just above water as it glided up to the

bird. The tiger's jaws opened. *Snap!* Not a happy ending for Donald.

In one area we went along a raised wooden walkway with a high wire fence on either side. I saw in the distance something strange. It was a group of middle-aged very well-dressed Chinese ladies doing something I could not quite work out. Only when we got closer could we see they were buying live chickens from a vendor and throwing them over the fence to the waiting tigers below. Close up you could see the momentary pleasure of the chicken as it was plucked from its bamboo cage quickly turn to disappointment as it flew through the air only to become a tiger's lunch. The tigers didn't fight for the food: they simply lay beside one another in a row and as each one received his bird he would pad off to the bushes to devour the fresh food. It was a bizarre experience, with the women apparently taking the same kind of delight people feel when feeding bread to ducks. Just a bit different. You can also travel in a glass-sided bus where the tigers are fed through a slit in the top of the glass and the people inside get a very close up view of the big cats' teeth in action.

Near the exit there were a number of buildings where lots of important research is being conducted, particularly into the beautiful Siberian tigers, whose habitat is shrinking. In a cage outside they had a couple of ligers, from a breeding program where they had mated a lion with a tiger. A rather sad-looking creature I thought. Not quite sure of itself. Not quite sure if it should chuff or roar.

The NORTHWEST Passage and The Inside PASSAGE

In 2014 we were on the only boat to successfully sail through the Northwest Passage from Greenland to Alaska. It's amazing to look

out across a completely frozen sea for days on end and it's only with the help of a Canadian icebreaker that we were able to complete this hazardous journey. There are many lonely monuments to the ill-fated journey that Franklin attempted in 1845; strangely no trace of any of his ships was found until 2014, when one vessel was discovered under the frozen sea near O'Reilly Island.

We've also travelled down the Inside Passage of Alaska and Canada, where you visit tiny fishing villages, mainly accessible in the summer months and then only by seaplane. I did no drawings or paintings on either of these voyages, but my head is still filled with the visual memories of our adventures.

* * *

We've been on safari in Africa, sea kayaks around Spitsbergen, close to the Arctic Circle, early-morning hot-air balloons in Turkey and numerous diving trips to exotic islands in the Pacific. By the time this book is published, we will have done a trip to Patagonia and the Antarctic, where I've agreed to make some paintings with the profits going to breast cancer research. Wherever possible, we've travelled with our children, and now our grandchildren too. I count myself very fortunate to have had the experience and the joys of seeing so much of this beautiful world.

The dying of the light

Once on the Channel 9 *Today Show*, I rather facetiously suggested that I'd like to paint an aircraft carrier. Lots of bright colours, with the jet fighters painted like colourful parrots. Stupid, I know, but we should be seen as a kind nation that would not attack anyone. So much money is spent on weapons. I know it's silly to imagine there will be an end to that. Our first line of defence should be the bindi-eyes that lurk in the grass behind the beaches.

I always make a drawing or a painting on Anzac Day. When my dad was alive it was my pleasure to drive in and pick him and a couple of his old mates up after the march. It was the only time they got together during the year. They had been Dad's crew during the years he spent away. Like lots of Australian blokes, he didn't talk much about the war. There were just a few slightly faded black and white photos in an old album. My generation was too young for Korea and I missed the ballot for Vietnam: we really have not known war.

After my father passed away in 1991 I would go around to Mum's place and watch the march with her. The last Anzac Day

she was here, 2008 (and I will say, suffering from a little loss of memory), I had been listening to the radio as I drove around the headland to her place. I said to her when I arrived that I'd just heard the announcer saying how great it was that things had changed and that now we were good friends with the Germans, the Turks and the Japanese.

Mum agreed wholeheartedly. 'But,' she said, 'not the Japanese!'

'Mum,' I exclaimed, 'you remember when Dad was alive and you both were involved with Rotary and you had that nice boy Toshi staying with you?' I said. 'You loved that boy so much he stayed for a few months and you and Dad visited him and his family. On their little farm, about two hours north of Tokyo, remember?'

'Was he Japanese?' asked Mum. 'Well, OK, not him but everybody else!'

My parents loved to travel. They went to China in the early 70s and Japan and the US and Europe many times. I apologise to Mum for sharing the Toshi story here, but it always makes me smile.

* * *

My mum was still in fairly good health at that time but had a full-time carer. Marina had nursed Mum once in hospital and then agreed to look after her at home. I'm not really sure how the whole thing came about, and even though Mum had a number of nurses as she got frailer, none came close to the care and understanding that Marina did. She became part of the family and travelled with Mum to Fiji a number of times. Later Marissa became part of the family too and would visit regularly to give

Mum a massage. Many years after Mum passed away, she is still visiting Judy and me each Monday night for aromatherapy and massage. What a treat. She and Mum and Marina all became very close and I'll always be grateful for the laughter they shared.

Mum also had a gardener called Ken. I think she liked his name. Some days I would go around to Mum's and Ken and I would carefully guide her down her steep front steps to my car. I had a wheelchair in the boot and we'd drive down to the end of the Balmoral Esplanade. Once there, we'd manoeuvre Mum into the chair and start on our regular route along to the Bathers' Pavilion. First around the wooden walkway at the pool, then over to the little wharf. We would always stop and chat to an old Italian fisherman who was a regular there, then on past the beach to the café. I'd introduced Mum to affogatos and with an extra shot of Frangelico she and Ken and I would spend a happy hour or so there.

When Mum got really sick with lung cancer, I went with her to the leading cancer surgeon in Sydney. He suggested that we do nothing. He thought treatment would be too much for Mum's body to take and it would be better not to do anything. When Mum and I left his rooms we were a bit confused. Even though he may have been right, Mum felt we should do something, try something. I felt that way too. It wasn't in Mum's nature to just sit back and wait: she wanted action.

We called my brother-in-law, Julian, who was a doctor then, and is a professor now – a kind and clever man. He recommended we get another opinion from another young surgeon he knew. This surgeon offered the possibility of hope if we had part of my mother's lung removed. He performed the operation himself. After the operation, Mum was sent to the crumbling old hospital out past Long Bay, Prince Henry. It was soon to be pulled down,

but we were grateful they had a bed and the nurses were great.

Mum's body was really knocked around though and on one of my regular visits I found her slumped in a wheelchair, hooked up to lots of machines and clutching a note for me. She looked imploringly at me and showed me what she had written.

She wanted to die. She wanted me to help.

I just couldn't. I knew she could find the strength and will to carry on. And she did.

We all had many years of her in our lives to come. Marina went on to work with the famous brain surgeon Charlie Teo, and it's a lot to do with her that Mum lived happily on.

We never talked of the letter again. I knew she was happy to be recovered and tried to get the best out of every day. She was a tough woman, my mum, and I hardly ever, ever saw her cry. But that outer toughness sheltered a deep and unshakable love for her family. She had a great sense of humour, and I feel her presence often. It's true: a boy's best friend is his mother, forever.

The last time I spoke to her was just before Judy and I and some friends went up to play golf for a couple of days. She was upstairs in my old bedroom, which we'd turned into a kind of sitting room. It overlooked the harbour and she was surrounded by family photos, crime novels, flowers and chocolates, with her little dog, Gemma, sleeping on the end of the day bed. It was a soft sweet morning, almost spring. I said goodbye and kissed her and was on my way back down the stairs when she called me back.

'You know,' she said, 'I don't want to go downstairs again, Kenneth.' I thought she just meant that she was a bit tired of the stairs, and that when I returned we would resume our trips down the steep steps and into the wheelchair and along the Balmoral Esplanade. It was not to be.

I was woken in the early hours of the morning at the resort we were staying at. We managed to get the early plane from Coffs Harbour to Sydney. I remember gazing out the window at the clouds and thinking about all our times together. All the jokes. All the care. And all the love. When we arrived at Royal North Shore Hospital, Oscar and Camilla were already there, and we sat numbly beside her bed. When everybody left, I stayed and quietly sang the nursery rhymes she had sung to me as a little boy. I can't be sure that she heard them but I hope she did.

She passed gently away later that night.

She lives within me and her grandchildren and her great-grandchildren.

At Mum's funeral, conducted by my cousin Carol, all her nieces and nephews spoke of the joy of the times they spent with Mum and Dad at Balmoral, and the many trips they were taken on. Mum really kept her side of the family together.

* * *

Towards the end, Mum's memory and perception was fading. I was saddened sometimes when we'd sit together having coffee on her top veranda and she'd ask quietly, 'Do I really live here? Is this my house?'

I would constantly assure her of those things, but her uncertainty made me so sad. Although my dad died too early, he was only seventy-seven, he was bright and clear right up till the end. He'd taken Mum shopping and she was unpacking things in the kitchen. Dad called out from the lounge where he'd gone to have a little rest and he died.

I so miss him and I'd love for him to know how great the kids are, and what a joy it has been for us to watch them grow, and how wonderful and clever his great-grandchildren are. How sad it is to know that you won't be around forever. My youngest grandchild calls me 'Fundad'; now his sisters do too. Of course, when he can pronounce words more clearly he may change it, but I hope not. Fundad's nice. Although sometimes I'm sure I'm Baddad or Saddad or Maddad. What a joy they are for us all and our best travels are those that include them. We've been to some amazing places and seen some wonderful things as a family. I'm writing these words in a beautiful lodge high in the wilds of Patagonia, looking across the plains to the snow-capped mountains of the Andes. It's a long way from my longing for a holiday in a tent at Yamba.

2015

I'd been invited to enter an exhibition called Naked and the Nude up the north coast. I had an idea in my head. I thought I might be able to use some of the drawings I'd done for the Cleopatra picture. I set up a reasonably big unprimed canvas, five feet by seven feet in the old measurements, and mixed up a big bowl of a kind of rich orange-y raw umber.

On a painting like this you have to work fast. Or I do. I started the nude about midday and finished at half past. It's a bit influenced by a drawing I once saw by the English artist Roger Hilton, free and stretched around. Sensual shapes. A nude. A woman.

I looked at it for a while, slightly changed the shape of the leg, then mixed up a real lolly pink for the background shapes. I finished at about one. One hour's work, sixty years in the making.

Who knows if it will be accepted, but it will be photographed and may end up in this book. It's one of the great pleasures of owning your own gallery. You can show what you want, when you want. That is unless when I poke my head into the studio tomorrow morning I think that it's just a load of crap.

(I decided it was. I painted over it.)

UNICEF

One of our longest associations has been with the children's charity, UNICEF, which does incredible work around the world. We are proud to be Australian Goodwill Ambassadors, and there is a worldwide cohort of us, including Audrey Hepburn, Roger Moore, etc etc.

We've had the opportunity to visit refugee camps in Zimbabwe and East Timor and it's there that you realise the real heroes are the people on the front lines who do everything they can to help the lives of the poorest children of the world. For instance, we were in East Timor not long after the Indonesian Army had trashed the main towns and many of the villages. They had destroyed the flimsy bamboo pipes that brought water to the villages. So UNICEF was digging wells and repairing schools and installing toilets. Each village had an elder, usually a woman, given the job, with a small payment, to teach the locals to use the toilets rather than just a hole in the ground or behind the nearest tree. These toilets had originally been designed for Africa and

could be simply constructed and erected by local villagers. You've just got to convince people to use them.

UNICEF also brings people together in unexpected ways. Here's my Roger Moore story.

Although we've never owned a boat, we were often on the harbour. A very old friend, Denis Power, who I met through Ric when I was about sixteen, had a charter boat we often used. It was a lovely old Hatteras, complete with classic rods and reels on the cabin ceiling – a beautiful craft called *Polaris*. We were on it many, many times before Denis passed away, far too early.

I used to charter the boat to show people around the harbour, so when we had the task of entertaining Roger Moore for UNICEF we arranged to spend the day doing just that, cruising around. It was grey and drizzling in the morning, not what we had hoped for but we had to go on as planned, and we picked up Roger, his then girlfriend and some folks from UNICEF at the little steps beside the Opera House. We set off towards the eastern shore. The girls all huddled downstairs inside, where Denis was driving the boat.

I suggested that Roger and I might venture up to the little covered deck at the highest point of the boat. So up we went: me and James Bond. I was trying to think of something kind of masculine to say. I couldn't for the life of me think of the last Bond film Roger had made. My mind was a blank.

Roger stood triumphantly braced against the rail, facing the wind and drizzle. What a man! I had to think of something. Then I remembered that I'd read a small piece in the local newspaper that he'd recently been in Malaysia, making a film with the well-known Belgian martial arts actor, Jean-Claude Van Damme. That's it! I thought. Drawing myself up to also face the wind and rain, I asked: 'So what is Jean-Claude Van Damme like, Roger?'

He turned, gave me the full-face James Bond stare, and in a rather plummy English accent described him with a single word that left me in no doubt Mr Van Damme would be left off his Christmas list. We had a nice day though and he's done a lot for UNICEF.

* * *

Another UNICEF association was with filmmaker Michael Cordell, whom we met in 1993 when Judy and I took Camilla (Oscar was in year 11 and unfortunately couldn't come), Kate Harding, and a film crew to Vietnam to make a documentary for UNICEF. There was a crew of half a dozen from Australia. There was a representative from UNICEF and interpreter ex-doctor from Hanoi. He had been with the Viet Cong and was to spend many days with us.

We all met in Hanoi. We were accommodated in a government guesthouse next to the famous Metropole Hotel. The documentary was to run for an hour so we had lots to do and shoot. As I remember, we started with a sequence of me being driven on a tricycle through the late-afternoon rush hour. This is where you take your life in your hands or in fact leave it in the hands of the man pedalling the bike. Cars and vans go everywhere, lots of unexpected ways around roundabouts even into traffic travelling in the opposite direction.

It was great though. The smells and sounds of a totally new city and one that had been hidden from Western eyes for a long time. Food sellers everywhere and people buying small bottles of petrol from roadside one-man petrol stations. So many bikes. So many scooters. Scooters piled with people and produce. No helmets in

those days. Just a grinning acceptance that somehow you'd get to where you were going unscathed. We visited the famous water puppet show where actors manipulate their puppets on long sticks and create astounding water tableaus. When we emerged from the show, we found ourselves in our own water tableau. During the hour or so we'd been inside the little concrete theatre, the heavens had opened and poured down buckets of monsoonal rain. The drains were blocked, the streets flooded. What an amazing experience. We made it to an upstairs restaurant for the first of a number of great Vietnamese meals we were to experience on that trip. There was hardly any refrigeration so everything was fresh and the beer was great.

The next day we set off north towards the Chinese border. We were on our way to visit the ethnic people of that area. They are the Hmong minority and because of a lack of iodine in their diet there is a lot of goitre and cretinism. The journey took us over some pretty dicey roads, through jungle, across lakes and eventually to the village. The people still keep their cattle under their house and live above. It's a shock when you see so many people with huge lumps disfiguring their throats. Climbing up the rickety wooden stairs in the tiny house we were visiting was like going back to another time. A baby swung gently in a hammock and her mother offered us sweet tea. Her elderly mother had a very swollen neck and it was amazing to think that her disease is easily preventable. Late in the evening, the men returned to the village and we all sat around a makeshift stage where a little play was to be performed. The story was boy meets girl, boy loses girl, boy uses the right salt, gets girl in the end and they all live happily ever after. The players are the doctors and nurses so in the morning when a clinic opens they are the ones who show the

villagers how to use the iodised salt. They had set up a degree of trust via the evening performance and it helped with their clinic.

We visited tiny mountain schools run by young Australian teachers: little mixed classes where kids come for half a day. We saw wells being dug to bring fresh water to a small community, meaning kids wouldn't have to trudge miles each day simply to lug water home. It meant they could go to school. Even for just half a day...

During the trip I made a number of drawings on location. Some of these were filmed for the documentary. It's quite a challenge to work at the white-hot speed you need while being photographed. One drawing I did on the roof of the hotel overlooking the river as the clouds swirled and the monsoon rains threatened. It was stiflingly hot and humid. I wanted to show the river and all the neon signs glowing in the evening light. The thunder roared and the rain pelted down. I quickly poured ink on the top of the drawing and let it run down the paper. It's a risk. You can lose everything. Or it can work, if you're lucky. That day I was.

On our trip south we had planned to stop at Hué. Quite a bit of planning had to go into our getting off the train. We were scheduled to arrive at about 3.30am and we had lots of luggage and camera equipment to unload. We were told we couldn't stop for long and we had to get in place like a line of commandos to complete the landing in time. When the train finally shuddered to a halt it was pandemonium. We were nowhere near the platform so we just jumped down beside the tracks in the dark. Someone rushed along with a light and we tried to get all our gear together as quickly as possible. Whistles were blowing and people were crowding around trying to help. Yelling and calling in Vietnamese. Lights flashing on and off, it was a nightmare.

'Quick, quick,' I yelled, 'stand clear of the train – I think it's going to move!'

'No, no, no move,' a Vietnamese man said, pointing to someone standing beside him 'He's the driver.' The driver had left his cab and wandered down to see what all the fuss was about. No move. No problems, mate.

After breakfast we set off to visit the Marble Mountain that had been Viet Cong headquarters. We started to climb with a group of chattering kids to show us the way. Most of the kids carried bottles of water to try and sell to us. We climbed higher. Gradually the kids dropped away until only one little lad was still with us – he came all the way to the top. It's an amazing view from the top of the marble mountain and easy to understand the importance as a shelling platform during the war. We bought drinks from our intrepid climbing boy and gazed down to China Beach. Inside there was a huge cavernous space where they had set up an operating theatre and temporary hospital.

As part of the documentary we did a sequence underground in the tunnels of Cu Chi. This meant squeezing into a tunnel with barely enough room to move. In front of me was the cameraman and behind him, his assistant. If you ever see this documentary, you can tell, easily, by the look on my face that it was an overwhelmingly claustrophobic situation to be in and I couldn't wait to breathe the clear and clean air of the jungle above us.

AN OLD PORT or TWO

The second exhibition I had in China was in Hangzhou. It had been arranged by a Chinese woman who'd lived in Australia for many years and she felt that there could be some ways our talents could do something there. She wasn't quite sure what and at that time neither were we.

The exhibition was in the large foyer of a very luxurious six-star hotel, the Dragon. Camilla, Oscar and I flew over for the opening and to explore ways we might do some business in China. The hotel was rated six stars because of the high level of technology available there. Just about all of it was wasted on me. For instance, you entered the lift, something registered your room card and lit the way to your room with little lights on the floor. Then the door would automatically open and the lights come on in the room. At the same time the TV set would begin to glow and a voice would welcome you back and enquire how your day had been and was there anything you required from room service or the butler? On the desk was a confusing array of plugs and dials. Perfect if you understood what any of them meant.

Downstairs they had erected large false walls to display the artworks, and after we had supervised the hanging and lighting, we were taken to the local university to meet some art professors. The art school part of the university was most impressive, set in beautiful manicured grounds. We were shown all the different disciplines – painting, drawing, sculpture and enamelling. This enamelling process was one they specialised in. Huge works on metal lined the walls and I marvelled at the colours and textures they could achieve.

Our Chinese partner, who had helped to organise the exhibition in Hangzhou, introduced us to companies interested in importing products from Australia. There have been many highs and lows in the operation since. In our business, when we say we will do something, we mean it. We'll look you in the eye and shake hands. That means we will give you one hundred per cent of our abilities and you can trust us. Simple. We are coming to understand that maybe it's not that simple in China.

In 2013 Oscar and I went to there to meet the president of one of the companies we had begun working with. This company is huge and mainly builds roads and bridges. In fact, they had built the longest sea bridge in China. It's forty-three kilometres, and it was this they wanted us to see first. Actually, first we were shown around the nerve centre, where a huge model of the bridge is and rows of people in front of screens control the traffic flow. Turns out, if you own the road and the long bridge, you can stop the traffic. And they did. And you can organise a police escort to smooth our way and they did.

It was the first time I'd experienced a police escort. The car and motorcycles led the way with sirens blaring. Also the bus we were in had a blaring siren and I must admit it was quite a relief

when we arrived at our hotel. The hotel was super modern. I had been given a suite about the size of our house. The company we were working for had built it and I think owned it. Their office building was next door and about the same size as the hotel, about twenty storeys high and in a totally rebuilt area of the city. Pine trees lined wide highways. A huge new stadium and tennis complex were opposite and numerous stylish apartment blocks led up towards the pine-covered hillside.

We were waiting in front of the client's building to be there precisely at the correct time when the president himself strode down the steps to usher us inside. The foyer was dominated by a huge screen and a giant map of the world. The screen flashed our names to welcome us to his company and on the big map there were lights to show all the countries they operated in. And there in Sydney: a tiny light symbolising us. We were very proud.

Oscar did a number of presentations on the proposed packaging for dairy products and other food-related products we could source. I just had to sit there looking old and slightly important. When it came to finally signing our contracts it was a very formal occasion. Downstairs in their own version of the Great Hall a number of big armchairs were arranged down the sides of the walls. Two larger and grander armchairs were waiting for the president and me. A photographer and members of his staff sat on one side, Oscar and our associates on the other. We exchanged gifts and speeches, all through an interpreter. Because I knew the president liked to do a bit of painting, I spoke in slightly artistic terms, suggesting these were only the first strokes on a large canvas we were embarking on together. I waited for the interpreter to explain. From the look on the president's face I think he must have been a little perplexed and thinking what have we got ourselves in for?

No matter: then we adjourned upstairs to the president's private dining room. We'd had a number of banquets before but this was the biggie. Each meal had started with a sea cucumber, a much-revered delicacy in China. Very expensive and very hard to eat with chopsticks. This was followed by some wonderful and delicious dishes and a few that we just had to let pass us by. There were lots of toasts and lots of wine. It's important to remember at a Chinese banquet that there will be lots of toasts and it's good manners to toss down all the liquor in your glass. You quickly realised that you have to either pretend you don't drink or if you do, try to take only small sips.

Anyway, our final grand banquet had finished and a number of the senior staff had returned to work. Or maybe a quick nap under their desks. So it was really just the president and me. We were on to the brandy. Not normally something I would be drinking at about 3.30 in the afternoon.

The president told me that when he comes to Australia he would like to buy some antiques. I explained it wasn't my area, but I'd be happy to introduce him to some experts in Australia. He said he'd also like to buy some port. Great I thought, my cousin's husband Peter Schultz's got a great collection of vintage ports, including some very rare 1947 Para Port.

'Yes, I can help there!' I exclaimed. 'What kind of port are you interested in?'

'Port with ships,' he said.

It took just a second or two to realise that he wanted Port Botany or Port Kembla or even Port Hedland.

'We-ell,' I said, 'I'll see what I can do!'

I'm not sure what will happen with our business in China. Oscar and Camilla have always worked together and balance their

skills well. We have a number of opportunities, and I guess it's an example of our combined abilities and experience that we've got this far.

I do know what happens after dinner in China. A foot massage. An institution in that country and the perfect end to a big banquet. We were taken upstairs and seated on big aircraft-style seats: Camilla, Oscar, me and a couple of our business associates. Then the masseuses arrive, carrying big wooden bowls of steaming water. First you soak your feet in the tub, then they commence an hour-long massage of your feet. Mostly they seem to do it all automatically while looking up at a TV set showing some Chinese soap opera. That's how it normally happens. But not when Oscar is there. Oscar is six foot four and has very big feet. Much bigger than the average Chinese. We offer extra but they just seem to giggle away and see the giant feet as a bit of a challenge.

After the business was done, we headed to Beijing by train. At three hundred kilometres per hour. Rock steady, clean and super fast. Flashing past farmers tilling their fields in traditional ways. Carrying water on their shoulders. Planting crops by hand. Living in little huts. While we fly towards cities with skylines that symbolise the growth and energy of this giant country.

* * *

On the way home from one China trip I detoured via Darwin. I'd been invited by Charles Darwin University's then vice-chancellor Barney Glover, as I'd offered them a painting for their collection. It came about when I met him in Canberra at a reception for Prince Charles and Camilla. That was a garden

party in the grounds of Government House. We'd been there a couple of times before when Quentin Bryce was the governor-general, invited by Stephen Brady when he was the Australian ambassador to the Scandinavian countries. He had kindly opened an exhibition of mine in Stockholm.

At the Prince Charles reception a hundred or so people were served drinks and food in a big marquee on the lawns outside the house. Small tables were set up where you could rest your drinks. Barney Glover and his partner shared the space with us and after a bit of a chat he asked if I'd consider donating a painting to the Darwin University collection. I was delighted and arranged to send him some images to choose from.

Prince Charles arrived at the reception and gave a very nice speech, as did the governor-general. She did such a great job and was much loved and admired by all Australians. After the speeches, the prince began to circulate among the dignitaries. Just then former prime minister John Howard approached me with Janette and I quickly made space for them.

I'd met him a couple of times before – once when I was named Father of the Year and when he was given the same accolade several years later. We were chatting away when an equerry approached him to say Prince Charles was leaving soon and wanted to see the ex-prime minister before he left. John said goodbye and started to walk away. Suddenly he turned back and asked if Judy and I had ever met the prince.

'No,' we said.

'Well, come with me,' he offered, and we quickly found ourselves in a line-up to be introduced to the prince.

He looked exactly like he should. Prince of Wales check suit. Oxblood shined shoes. A paisley tie. Nice smile. A secretary

beside him whispered in his ear as he approached each person, giving some detail as to who he was to meet. When we shook hands I said I was probably the only person there wearing one of his own ties.

'Oh,' he pleasantly replied, 'I've got lots of them.'

For one instant I thought he must have meant that he had been collecting my designs but I quickly understood that he was simply referring to the number of ties that people or organisations must design for him as gifts. No wonder he moved on to Judy.

The Men

As I've said, I envy the great musicians. Sometimes when I'm seeing James Morrison and Don Burrows play, I like to watch each musician with their eyes closed, listening to each other. It must be such a buzz to play together like that.

And for a singer to have everything contained within himself: it must be thrilling. I first met Darren Percival when he worked with James and the Big Band. This was long before he was so successful on *The Voice*. He would come over now and then to the studio, as he loves to paint. There's a song of his that he wrote called 'Falling around the sun'. It's so gentle and sensitive, it brings me to tears.

As is the song Norma Marshall wrote called 'Introduce Me to Your Friend', especially when sung by the lovely Emma Pask.

Painting is such a solitary task, alone in the studio; only you can decide when you've hit the equivalent of a 'bum note'. Painters live so much inside their heads. No wonder so many of them go nuts. To be a good painter you have to have very strong self-belief. And make all the decisions yourself. But that belief can

so easily be destroyed by the sudden realisation that what you've just done is a load of crap. So you just have to pick yourself up and start again.

I've been a Ray Charles fan forever, since my days at art school and earlier. But this story really starts with James Morrison. He and I first met in San Francisco. We had both been invited to attend the Neiman Marcus Fortnight. That great store had a promotion every couple of years, displaying the best of a given country. James was there to play and show his great talents.

There were about fifty Aussies, including Ray Hughes and his then wife. We were staying at different hotels around the city and one night after James had performed he and I decided to go out. Just a couple of young blokes from Down Under out on the town. With James being a muso, I figured he'd know all the dens and dives of that city. No. We just decided to go to the pictures. And get a choc-top each. We were in the Haight-Ashbury district and went to see *Raising Arizona*. I was informed later that it was very good. We didn't see much more than the opening titles as we had fallen asleep on each other's shoulders. Two blokes. Heads together. San Francisco. Nobody would have given us a glance.

Where was I? Ray Charles.

When James was performing with the incredible Philip Morris Big Band in Sydney, Ray was to perform. The band had the most wonderful line up, including the great bass player Ray Brown. James invited me to the afternoon sound check at the Entertainment Centre. I wanted to see or maybe meet my hero Ray Charles. Not to be, as Ray is far too grand to even do a sound check, so I had to be content with the joy of hearing him play in the evening.

Jump ahead a few years and we are all at the Ray Charles concert at the Opera House. It was great. We had the best seats. After the performance there was a special cocktail party up in the foyer overlooking the harbour. Lots of people were packed into that stunning space. Down the end a small stage had been set up and one of the promoters appeared and announced that Mr Charles would be making an appearance and that twelve people could have their photo taken with him.

To the embarrassment of my family, I knocked over old ladies to get there. I was at the head of the queue. I had no camera but knew a bloke nearby who did, so I implored him to take the shot when Ray arrived. As I was known to the promoter, he placed me beside the little curtain where the great man was to appear and before I knew it, I had taken Ray's arm and was guiding him onto the stage. My head was spinning.

I said to him, 'For me, it's like hearing Picasso sing.'

This is stupid on so many levels, including the fact that a blind person is not best placed to understand the works of Picasso. Ray looked in my direction. The bloke with the camera took a couple of shots and the next person was ushered up. I have the picture in my studio. Ray is leaning into me.

I look as if I'm saying, 'Ray, you just need a bit more soul in your delivery,' and Ray's expression is quite similar to Prince Charles's: Who is this person and what the hell's he talking about?

* * *

One morning, driving to work and listing to the radio, I heard an interview with Tony Bennett. He was to appear that night for a once-only concert at the Opera House and the performance

had been booked out for months. During the interview Tony was talking about the size of the audience he plays to and was reminiscing about how he really enjoyed the intimacy of the small jazz clubs where the audience was close by. 'You know,' he said, 'I'm going to ask that some chairs be put on stage tonight so I can recreate a little of that feeling.'

I called the Opera House box office instantly. They told me the performance had been sold out for months and there were no tickets available. I explained what I'd just heard. Told them to let me know if the chairs onstage happened and that I needed eight tickets. It did happen, so just before 8pm, a small group of us were led up onstage. About sixteen people and a seeing-eye dog.

The family made me sit on the chair closest to the front so I could take the stares and disbelief of the front-row fans who had bought tickets months in advance and couldn't understand why we were on stage. There were only two rows of chairs. We had the front one. As well as the family, I asked Mum and Aunt Nancy and her husband Carmen (AKA Herman).

Needless to say the performance was great. Tony Bennett is one of the world's best singers and for most of the concert I was closer to him than his pianist. Being in that position, when he asked the audience to clap or sing along with him, as you are in the spotlight, you just have to give it your best shot. When he'd taken his final bows he then shook hands with us all and even gave a pat to the seeing-eye dog. Uncle Carmen broke into fluent Italian, a language he'd not spoken for sixty years. What a night.

2015

This morning I went to open an art room at the Cammeray Public School. The school was celebrating its centenary and I had been asked by Scott Bevan and his wife Jo to do the job. Scott is an insightful and engaging journalist and writer and can be seen on the ABC most nights. He also has a passionate interest in art, both as a collector and a writer, and has just published a book on William Dobell. His twin boys are at the school and there are almost forty kids and some teachers at the ceremony.

I cut the ribbon and all the kids piled in to start painting. How lucky today's kids are, with all the paint and art material at their disposal. As a boy in Maclean we had slates and chalk to draw with. Now, when kids are spending so much time glued to a screen, it is very important that they use their imagination with papers, pens and paint.

Thinking about kids I recall when we went with UNICEF to East Timor just after the war there. We visited the remains of a burned-out school, and were taken to some sheds where the kids were temporarily being housed. Looking at some of their artwork I first thought they must have been looking at war comics, given all the violence depicted on the pages. But no – that was what they had witnessed.

Even in Zimbabwe when we visited refugee camps there I recall seeing the same kinds of evidence of brutality. Yet when kids were playing in the dirt they still made images of the sun and flowers and nice things scratched in with sticks.

Sydney 2000

A couple of years before the opening of the Sydney Olympics, Ric Birch called me. I'd met him a couple of times before. The first time we met he had been the producer of the Brisbane Expo, where I'd designed the big logo outside the Australia Pavilion for Ken Woolley and the outside of the UNICEF pavilion. He asked if I would be interested in designing the program for the Opening and Closing ceremonies of the Games. I saw this as a great honour and we donated half my fee to UNICEF and half to the Paralympics.

The 'we' was Camilla and me – we designed it and the production was handled very professionally by DNA Creative. It was a mammoth task and I had set out many ideas on my studio floor when Ric first arrived to see what I proposed. He was most enthusiastic and pretty much let us get on with it. There were many, many meetings with the Olympic Committee and many with David Atkins, who worked closely with Ric. We hardly did anything else during those months – the Olympics dominated everything. It was a fast and exciting time.

Years previously we'd been at the Overseas Passenger Terminal when the announcement of Sydney's winning bid sent the city into raptures. I was interviewed by some TV network before the announcement and stated I'd never eat another dim sim if we lost to China. I'd like to think that this food threat might have tipped the balance of the Olympic Committee – but maybe not. We also did our bit during the bid process, when many delegates came to Sydney to be wined, dined and shown around. I was asked to look after a couple of Argentinian ladies on a trip around the harbour. Everybody was on their best behaviour and the whole exercise shows how a city and a country can work together. The night when Juan Antonio Samaranch uttered the words and Rod McGeoch and John Fahey jumped for joy, the whole city united. We were up all night and when we were walking along the beach at dawn people were still celebrating.

When the Opening Ceremony finally arrived we were all excited with the expectation of the night. The program we'd designed was inside a little yellow suitcase like Aussie kids used to take to school; it was filled with a few other goodies too. It was amazing to look around the stadium and see more than eighty thousand people opening that case to see our work. All Sydneysiders and most of Australia will always think the 2000 Olympic Games were the greatest ever. The greatest of all time. Well, we would, wouldn't we?

For those few weeks, we felt the joy that a city and its visitors can only experience during an Olympic Games. The Opening Ceremony showcased many of the best things and people Australia had produced. So many contributors had worked tirelessly for years before and that's not even mentioning the athletes.

I still see Ric Birch on his occasional visits home. He continues to be involved in ceremonies around the world and told me

recently that he'd been asked to direct an Opening Ceremony for a small Middle Eastern country. The president is crazy about martial arts and wants to promote that sport. He has the control of a dictator and suggested to Ric that he was thinking about renaming the first few months of the year after his teenage daughters. Now that's real power.

OLD BONES

To celebrate the end of the century the journalist and TV presenter Mark Day asked Judy and me to travel with him and his wife Wendy to Lake Eyre. Mark and Wendy had been neighbours for many years and he had been an early supporter of my work. We set off from Adelaide to make our first stop at Parachilna to see Opera in the Outback. Under a clear starry sky, we joined an excited audience to listen to the brilliant voice of Dame Kiri te Kanawa and the soulful harmonies of an Aboriginal choir. Out there with the ghost gum ranges providing an eerie backdrop, we shared one of the best musical evenings we had ever had. Ric Birch was in the audience and it was nice to say hello.

The next day we were off to the camel races at Beltana. This was another outback treat with dust, beer and betting. People had come from miles around. Old bushies with the kind of weather-beaten faces only found on people that spend their lives beneath an unforgiving sun. Then across the gibber plains to Marree. Mark had been there to cover the land speed attempt by Sir Donald

Campbell many years before, when he was a young reporter working for Rupert Murdoch. Because of his contacts we were able to camp in the Elliot Price Conservation Park. And able to meet Elliot Price's grandson, Malcolm Mitchell. What a character. We spent the night in his shearing shed. He put on huge bush breakfast and with his guidance we set off towards Lake Eyre.

Mark had organised to take a number of well-known Australians, including Thomas Keneally and Bob Brown, to different parts of the country and write on the experience that all had there. He took us to the giant white salt flats of the lake to see how I felt about that kind of stark landscape.

Our four-wheel drive was packed solid. So solid that Wendy had been instructed to buy six potatoes only at our last shopping spree at the edge of the outback.

You are confronted by a sea when you first sight the lake. A sea of salt and shimmering light stretching to the horizon. Not a cloud. No wind. No people.

We left the security of the dusty track and set off for parts rarely seen. We crossed onto the lake close to where Donald Campbell's Bluebird was taken on to the flat surface of the salt many years ago. Then we headed further north to an area called Dingo Soak. We finally camped in a spot where the nearest other human being was hundreds of kilometres away. Mark is very experienced with outdoor stuff and had to battle bogs and flat tyres to get us there. We all helped a bit to put the tents up and even though Judy and mine was pitched at an alarming angle we all managed a good night's rest.

I did half a dozen pictures on that trip, some in the searing heat of the day, some in the late evening just before sunset. During the middle of the day all you could do was lie very still

on the ground in the tents. Outside was the kind of heat that kills. One night I heard Wendy talking on the satellite phone to Los Angeles. Wendy was Nicole Kidman's representative in Australia and you could hear that it was hard for people in Hollywood to understand just where we were.

Now and then Mark would use the phone to check in with Malcolm and he arranged to drive out and visit us the next evening. When you needed to conduct your morning trip to the loo, you went armed with a shovel and paper to find a discreet spot to build your own bog. On my way out I was disturbed to find some tiny bits of blue plastic among the sand dunes. Maybe three or four. How awful that people should leave bits of litter way out there. I shoved them under some rocks.

Later that day Malcolm arrived. He confided to us that his property was so large he had only been to the spot where we were camped a couple of times in his whole life. He said when he was a kid his grandad made a kind of spinning platform that skidded across the lake when it filled with water. In fact, outside his property was a wonderful collection of old farm machinery and parts of inventions his grandad had made. The property is on the old Sir Sidney Kidman (Nicole's grandfather) cattle route. It's where they sank bores to water the cattle on their dusty drive to the salerooms. We went with Malcolm to some remote canyons. He was kind enough to declare that from now on, one would be called Done Canyon. Very generous. I look forward to seeing it on a map one day. Maybe.

On our last morning we realised that we had probably overstocked on food (we had eaten the potatoes) so Mark cooked up a breakfast for giants. All the eggs. All the bacon. All the bread. It's lucky we could fit back in the vehicle. On the way out

of the area we got lost. For a fair while there were no tracks. No signs. No fences to follow. We'd been given instructions but they didn't seem to make sense. It was only Judy, with her keen eye, who spotted the vague suggestion of a track in the soft sand, so that we found our way.

The painting I did of us walking on the lake is one of our best-selling prints, as is the camp at Dingo Soak. Those paintings I made on location were quite small and produced under very harsh conditions, but sometimes that brings out the best of your abilities, as there is no time for careful contemplation.

Just a note about the little bits of blue plastic I had found on my early morning ablution expedition. I mentioned finding them casually to Malcolm when we got back to his homestead. 'Yeah,' he said, 'a couple of years ago some blokes from America came out to plot the position of dinosaur eggs that they found with their flash equipment. I reckon they will be back next year.' He said I'd probably noticed that there was a tiny number written on each bit of plastic. It was early in the morning your honour and I was in a hurry and did not have my glasses on, sir. Sorry.

On the way back to Adelaide we needed to find a pub with a TV set to watch the last quarter of the Australian Rules Football final in Melbourne. We found a pub. Went into the bar area. It was packed. The motorbikes outside should have given us a clue. It was packed with big, grizzly bikers. Covered in tattoos. Yelling and tossing down bottles of beer. They looked suspiciously at Wendy and Judy and glanced at Mark. Mark is big and a bit hairy himself so he was OK. But me, well, not big, not hairy. Small moustache.

During a commercial break the biggest, hairiest, most tattooed monster pushed aside his mates and stood over me. Here it comes,

I thought. A smash in the face or kick in the nuts. He stared down at me.

'G'day, Ken. I love your work. What the fuck are you doing here?' He grinned, showing the three or four teeth left in his mouth. And embraced me. Art connoisseurs: you never know where you will find them.

2015

I am writing this bit while in a hotel dating from 1830 in
Bendigo. We have been driving around the back of New
South Wales and down into Victoria. Across the Hay Plain.
Old country towns, wide streets, a few boarded-up shops.
And now and then an old abandoned homestead with weeds
and dust covering up some family's dream. The landscape in
Australia has such diversity. I've painted pictures relating to
Hobart in the south, Cairns in the north, Perth in the west
and of course my home Sydney. On the wall of this room
is an outback picture a bit like an early Ray Crooke. He's
a great painter and a really nice bloke. Not so well at the
moment. He and his wife June made many trips to Toberua
Island in Fiji, where we've been for so many holidays. He is
best known for his painting of the tropics. His earlier works
of Thursday Island and the back of Queensland are well
worth studying.

I don't have much to do with other artists. It's not really
a band of brothers (or sisters) that sit around discussing art.
Well not for me. I think it's rather a solitary path where you
need discipline and devotion to work. In saying that, I enjoy
the strangely named 'Book Club' that I attend now and then.
I received a call one day from Noel McKenna, an artist that
I much admire. He said he was getting together a group to
occasionally meet to talk about art and share drawings and
bring a book we liked. The first meeting was at Noel's place.
McLean Edwards, Jo Braithwaite, Patrick Hartigan, Noel
and me. We show each other work and a book or two and
have a drink or two.

At another meeting at my studio, Noel brought along Glenn Barkley, who was then a curator attached to the MCA. The club meets now and then and if I'm in the country I look forward to attending. Noel is one of Australia's best artists, with an unerringly good eye for composition and a quirky intelligence to his line and his work. I'd met McLean's dad when he was attached to the Australian Embassy in Japan and we got on very well. He asked when I returned to Sydney would I go to McLean's first exhibition in Newtown. I did and I'm glad. McLean's paintings are always worth a look or three.

Under the Southern Cross

On the first day of the new century *The Australian* ran a wraparound cover of a hundred people, one born in each year of the century. It was quite a big logistical exercise to put together. We had assembled in the State Theatre in Sydney and were ushered up on stage to take our positions where our birthday year was marked.

I was born in 1940 and when everybody was sort of in place the photographer climbed up the big ladder to check the lighting and the composition of the shot. My position was directly behind the hundred-year-old lady who was to carry the newborn baby. There were lots of familiar faces. Finally Mr 1939 arrived: it was John Howard, the then prime minister.

We were chatting while the photographer adjusted the lights when I noticed the hundred-year-old lady nodding off. Just before each shot I had to lean forwards and gently rouse her. I'm not sure she was fully aware of what was going on but it was great to be in such company.

After the shoot was over I walked back to talk to some politicians, including Kim Beazley, about the prospect of a new

Australian flag. They felt it may be some time off and weren't confident that the then government had much interest. I've been talking about a new flag for many years and looked at many variations. There is no doubt that Australians have already decided that a golden yellow is our colour and that the Southern Cross is an important symbol to us.

The kangaroo is unique to us but I don't think it's quite right. It should be seriously considered though. I think the simplest flag could be the Southern Cross with the stars in yellow. Or even one big federation star. Yellow on blue.

It's such an emotive thing, with so many entrenched feelings, that it will be hard to do. Unless a new prime minister has the will to make it happen as they did in Canada. A design I put forward a few years ago was admired by both Gough Whitlam and David McNicoll, political opposites, in the *Bulletin,* and a series of variations of the design were hung around the city thanks to then Sydney mayor Frank Sartor. I'd been with Frank on an official trip to Japan. Nagoya and Sydney were to sign a sister city agreement and I was asked if I'd give a painting to symbolise the relationship.

Sydney gave Nagoya my painting; Nagoya gave Sydney a grand piano. The painting was a major one I'd done in the Postcard from Sydney series, and was also used as the menu cover for the then President and Mrs Clinton's visit to Sydney.

* * *

Over the years I've been asked to judge quite a lot of things from small local art shows to a special children's competition at the Art Gallery of New South Wales. The Faber Castell family gives a

number of prizes to young artists and the standard is pretty high. When I was in the advertising business I suggested to the count ('call me Andy') who ran the company here that they could start a drawing prize for practitioners of art. He embraced the idea and the Faber Castell Prize for Drawing was first held in my little gallery at The Rocks. It received entries from some of Australia's leading artists. Over the years it changed a bit to become the children's competition. After we did the judging, the entrants were invited to a presentation at the Art Gallery of New South Wales. A very important place for budding artists to visit, and the prospect of prizes of great art materials.

There were drinks for the adults and lollies for the kids and sandwiches for all. The count's daughter made a nice speech, as did a representative of the gallery. Each judge spoke of the section they had judged.

Judy, Camilla and my granddaughter Ava sat in the front row. Ava had just learned to wink and gave me one from her seat. After my speech I was asked to get ready to be photographed with the winning children. Ava silently left her seat and came to stand beside me and hold my hand. After all the winners were announced they came across to line up with me and the other judges for a group photo. I think Ava must have anticipated this so as the numerous photographers got in place for the shot I felt her take one step forwards to be in line with the winners. I am sure some parents looking at the photos of their children will still be wondering who the little girl in the front row was.

Out WEST

In 1999 we took a trip on the *Coral Princess* from Broome to Darwin. One of my cousins, Chris, was the lecturer and guide. It was a great opportunity to spend time with him in a part of the country he knows very well. He'd been in New Guinea as a young man and revelled in the outdoor life. He and his family lived in Kununurra, where he was the head of conservation and land management over a huge area of Western Australia.

It was our first time in Broome and we stayed at the hotel Lord McAlpine had built. McAlpine was a great supporter of Sir Sidney Nolan and many of Nolan's works adorned the walls. It's a great town Broome and we've visited it a few times since. On the way north you see some astounding country. Chris was able to guide us to some wonderfully preserved rock art that can only be viewed after a tough hack through some heavy undergrowth. It was very hot and we would have loved to have swum in the turquoise sea, but crocodiles swim there and they certainly have the right of way. I did quite a number of small works on that trip.

The last part of the trip across the Bonaparte Gulf is very rough so we just had to spend the day lying in the cabin. Seasickness is awful so we were glad to finally reach Darwin. Well worth it though as you see a wilderness most tourists never experience.

Then by small plane we flew over Lake Argyle to the town of Kununurra itself and on further south to the Bungle Bungles. The Bungles are unlike anything I've seen anywhere in the world. We flew over this incredible collection of beehive-shaped striped rocks. Like some fantasy-land rising from the desert floor. Red, pink and orange striped. That night we sat around a campfire, sharing travel stories with a couple who had just flown up from Melbourne in their own aircraft. The fire crackled. The stories got wilder. The drinks just slipped down easily. By the time we had to leave lots of wine had been consumed, mostly by me. We needed to get up before dawn. I was well under the influence. Must be the outback air or something.

Anyway it seemed as soon as I managed to find my way back to the tent, Chris called to wake us up to go. My head was spinning. Chris and Judy, who had gone to bed earlier walked brightly into some of the hidden chasms. I stumbled on behind. No, not feeling too well, in case you're wondering. It's a country filled with spirit people. And I was one of them, filled with spirits.

The path between the giant rocks twists and turns and you find yourself in huge cathedrals of space with towering red-striped walls around and a little glimpse of brilliant blue sky above. I made quite a few paintings about the experience of flying over and walking through the Bungle Bungles. From memory. There was no way I could stop my head thumping long enough to get out my sketchbook on the day.

Chris has two other brothers and one sister. Terry, the youngest brother, was a marine biologist on the Barrier Reef for years and has given lectures in a number of countries on coral reefs and particularly the crown of thorns starfish. The eldest brother Robert is a retired minister of the Church of England and their sister Rosemary is a researcher into sheep biology. That family is from my father's side.

On my mum's side, just about all my cousins worked with us at some stage. Jennifer was the first employee after Kate, then Christine and later Linda. My aunts and uncles worked with us sometimes and my youngest cousin Michael, who is a great art director, now works a bit with Camilla and Oscar. It is a family business. We couldn't have done it without all of them. There is a level of trust and mutual understanding within families and I am often surprised to hear of family break-ups and squabbles. Maybe we are just lucky.

P⊘RTRAITS

When in 2009 I was asked to give a painting of Glenn Murcutt to the National Portrait Gallery, it marked for me a real achievement. For the first time a national institution was interested in having something of mine. I was thrilled. I can't even remember how the first request was made but I remember talking to then senior curator Michael Desmond on the phone. They asked if I would donate the Glenn Murcutt painting that had been shown in Archibald.

Glenn had been a friend for many years. As I related earlier, we first met at dinner a friend had organised and we asked if he would do some renovations to our house in Mosman. We lived in that home for many years and that's where the kids grew up. It's been knocked down now and replaced by a couple of concrete bunkers. Many years later he created our wonderful home above Chinamans Beach.

Like a lot of architects, Glenn wears subdued natural colours. Khaki. Grey. Stone. So when I made a painting of his head that's the palette I used, and I shaped his head a bit like the curved ceiling he often uses.

Towards the end of the conversation Michael casually mentioned a self-portrait of mine he'd seen at the Art Gallery of New South Wales in the 2011 Archibald Prize, and asked would I consider letting them have that one as well? I was doubly thrilled.

Dr Sarah Engledow from the National Portrait Gallery came to Sydney to interview me and here I'll quote a little of what she wrote.

The only living Australian artist who could plausibly be said to be a household name in this country, Ken Done AM, recently made a gift of two striking paintings to the National Portrait Gallery. The first is his spare and restrained representation of his friend, the Pritzker Prize-winning architect Glenn Murcutt. The second, a self-portrait in Done's customarily riotous palette, is the first cubist-style portrait to come into the collection...

Done's self-portrait is a more complicated work, in clashing hues of yellow, red, electric blue, cobalt and forest green. There are spots and stripes; the nose is a cord of yellow paint extruded straight from the tube. A particularly unusual feature of the portrait is its three multi-coloured non-matching eyes: one pink, blue and yellow, one yellow and black, and one blue with a yellow centre. Close inspection of the eye on the right discloses an animal hair trapped in the thick paint. Probably shed from a paintbrush, it just might be a relic of Spot, the much-loved mutt who appears in some of Done's most charming paintings, notably *Spotty and I walking around the rocks I–IV*, 1992. Like the dirt and dog hairs that adhere to some Central Desert canvases, it reminds us that paintings are created in a defined place, in a particular personal context –

in this case the harbourside 'Cabin', occupied, for much of the time, by only Done, painting doggedly, and his pet, who would bark twice, says the artist, if the canvas turned out well.

The three eyes are portals to the cubist character of the self-portrait, in which Done has merged a profile with a full-face representation. Although he has painted his trademark moustache only once, two smiles traverse it, one in full face, a red banana shape, and one in profile, its yellow outlines loosely containing a few slashes of white teeth. Securing the picture a place amongst icons of Australian cubist portraiture are the Opera House on Done's left cheek, and the Harbour Bridge on his forehead, like a set of patriotic wrinkles. The Opera House has been a boon for Done. Many artists have painted the harbour, but none has depicted the Opera House as he has. He says, 'I've drawn [it] straight. I've painted it in white, yellow, blue, pink, magenta, emerald, turquoise…purple and black. I've painted it soft, hard edged, ethereal, misty, blatant and bold. Upside-down, sideways and inside out.'

The degree to which Done personally identifies with the Opera House and the Bridge is indicated in the title of this self-portrait, which is *Me*. Yet the straightforward title of the work belies its more complicated intention. The style and technique are both a blend and a radical extension of the approaches Done took to previous self-portraits, including the stripy profile in *Meeting Michael Jagamarra Nelson*, 1989 and the full face in *Thinking about what to paint*, 1990. Done describes *Me* as at least in part a painting about the difficulty of painting, and there is a feeling of contemplation, wariness or watchfulness about the man in the portrait that he produced. Showing two Dones at once, or two perspectives on one

Done, it can be interpreted as a painting that examines how what a person is famous for entangles and intersects with, overlaps and obscures who he is, who he wants to be, or what he would like to be remembered for.

I was flattered and a bit surprised at the comments Sarah Engledow made about this work. I didn't set out to make it a cubist painting. I just started a self-portrait. I wanted to show that there was a kind of public face, the smiling one, that most people knew, but the other one was much more private, unsure and sometimes sad. The Harbour Bridge and the Opera House had to be there as this was a painting about what I feel, not really about what I look like. The Bridge and the Opera House had become so identified with my work that I wanted to show them as part of me. The colours choose themselves: there is no plan. It's like a jazz performance, an improvisation when you work. Fast, spontaneous, intuitive. I can't say why I put in the third eye – it just seemed like a good idea. And as for the animal hair, it must be from my beloved old dog Spot. I'm sure he was sleeping peacefully while I smashed my way into this painting. I didn't even know the hairs were there. But I'm very glad they are.

2015

I drove to work today and parked at the Park Hyatt Hotel near the gallery, walked through the foyer of the hotel and ran straight into Billy Connolly. Ten seconds earlier and he'd be still at breakfast, ten seconds later and he'd be at the lift on the way to his room. Timing.

We were pleased to see each other and as I've mentioned before we quickly began to compare the experience of prostate cancer. He'd spoken of it in his hilarious show at the Opera House the previous Saturday night. We agreed it changed lots of things. We are still both here, though.

He took me to see his daughter Amy. We had been on the little island of Toberua in Fiji when we last met. Billy was not there, but Pamela Stephenson, his wife, and Amy were. We spent quite a bit of time snorkelling and diving together and I did a drawing of a beautiful tropical white flower as a birthday gift for Amy. It was lovely to see her again, and to talk about Toberua.

We first went in the early 80s and have been there maybe thirty times. The island sits off the east coast of Fiji. It's tiny, about four acres, and we've made lifelong friends there among the staff.

My mum and dad went there a lot too, and took lots of my cousins there. We all loved Toberua and they loved us. Mum, after Dad died, went there with her carer and bought a number of things for the staff. Towards the end she was very frail, and they sent a special boat for her to visit the village. Mum, seated on a special chair under a beautiful umbrella, and the rest of the family and friends behind. We had a

wonderful day and later that week the villagers and their kids all came across to the island to be presented to Mum. I'm sure she felt there wouldn't be many more trips to that idyllic little island. In fact, there was only one.

Billy Connolly and his wife, Pamela Stephenson, were married on the island. They had commissioned a beautiful canoe and Pamela arrived for the wedding ceremony in that. Billy stood in a kilt in the shallow water waiting. We weren't there, but it must have been amazing.

A few years later, Pamela called to say that she and Billy were flying to the island with a couple of friends and it would be great if Judy and I could be there too. It was in November and because of various commitments, we just couldn't go. It turned out that the couple of friends were Eric Idle and Robin Williams. What a missed opportunity to hang around and try and get a joke or two in with those blokes.

CAVEMAN

Even before we owned the Cabin, we would go down to Chinamans Beach every weekend. I used to sit at the northern end and look longingly at the little cabin on the rocks. I think I wrote before about finally being able to rent it and then finally own it. It was around that time that I first met Luigi. He was the gardener at the villa above the Cabin and the house next door. He eventually became our gardener and part of our family for more than thirty years. There was not much Luigi didn't know about the garden or the neighbours. Ours is a big and rambling garden on many levels, tumbling down to the harbour. Judy makes it happen. I look at it. We never take the garden for granted and marvel at it every morning as we walk down to Chinamans for a swim. It's quite big really as there are three blocks of land the two houses are built on. Up in the back corner is a wonderful cave. Most Australian men want a shed. I wanted a cave. When we first got the property there were some overhanging rocks and the suggestion of a cave but not a cave itself. We employed a firm that had made a lot of the rock construction at the zoo and now I

have a wonderful space in which to sit and contemplate. Except I am too busy to sit and contemplate.

But the grandkids love it. We have to speak in caveman language when we are in there. Grunts and 'you go kill 'em dinosaur' kind of stuff.

I look forward to when they are all a little older and we can light a fire and spend the night in there. When it was first built you could look down over the harbour and not see any other houses. Now the trees have grown up it's more secluded. We have a small waterfall that cascades down from the front of the cave and we used to have a dozen or so gorgeously coloured carp swimming in the lower pool. We thought it must have been the kookaburras that attacked them when we first found some had been killed, but one day we spied a big water rat in the area, so we figured it was him. Sad really as they were so lovely gliding among the water lilies. Especially the biggest of all, Goldie. I'll just have to make a painting of them from memory. Our cave was once on the front page of the *Sydney Morning Herald*. They said it was an expensive folly. It is.

From the window of my studio at the house I look down on the garden. Just outside is an old pink magnolia tree that fills the window with magenta and white. A big old palm is to the left and then below jacarandas, oleanders with bright pink flowers, lemons, frangipanis, fig, mandarins, limes. There are a lot of oranges and below a couple of old olive trees. Up against the stone wall are lettuce, eggplant, tomatoes, beans, corn, capsicum, mint, parsley, basil and silverbeet. It's a constant reminder and memory of all the people that helped to make it. And beside the pond lie the graves of the dogs Spot and Indi, and nearby, under an olive tree, the ashes of my beloved mother and father.

AUGUSTA

This morning I looked over to the sand hills to watch a friend practise his golf swing. Usually he just uses a stick, or in winter an umbrella, but today he has a real club. A sand iron. His little dog waits patiently as ever at his feet and I watch him swing the club back and forth through the sand. For my seventieth birthday my son took me to the Masters. What a fantastically unbelievable present. One of the highlights of my life. If you're not a golfer, move on a couple of pages. If you are a golfer, start saving. You have to go.

We arrived late at night in Dallas/Fort Worth Airport after a very, very long trip across the Pacific to LA. Then a long and very, very bumpy trip to Dallas. It must have been 3.30am when we finally landed. We waited silently and sleepily for our luggage to come off the baggage carousel. I felt the first twinges of gout in my foot. Not a good sign, as we had booked to play a course on the way to Augusta the next day.

Suddenly Oscar said, 'Dad, look at this,' showing me his phone.

And there was a message to say my self-portrait had been accepted for that year's Archibald Prize. I was thrilled. Although the Archibald Prize is a bit of a cross between the Melbourne Cup and cracker night, it's still the most important of all the Australian art prizes and it's great to be shown. There were eight or nine hundred entries and only approximately thirty or forty selected so it was a great start to our holiday. I did two versions of the painting, basically a black line drawing on yellow. The work had to be done swiftly, no more than ten or fifteen minutes, but like I've said it's the ten or fifteen minutes that takes you sixty years to be ready for.

We spent an hour or so at a hotel by the airport and in the morning set off for our first tee time. Disappointingly, there was no way I could play as the gout had struck and we were reduced to sitting sadly in the clubhouse with once again my toe in a bucket of ice. The next day it improved a bit and nothing was going to stop me anyway. We had arranged to play a very flash course twenty miles or so from Augusta. It was a private club. It was very, very well maintained, beautiful trees and flowers. It was $1000 a round and you had to take a caddie and pay another couple of hundred for him. As I could hardly walk they allowed me to take a cart, but I still had to be accompanied by the caddie, and he walked beside me. I was so proud when Oscar smacked his first drive down the centre of the fairway. And even I managed to get a reasonable shot away.

We were paired with a couple of blokes from Melbourne whose company had arranged the tour. All played reasonably well. We stopped at the ninth for a drink and a snack. It was there we found that everything was free, included in the green fees. Equally so, at the end of the round, everything in the clubhouse. Drinks, shrimp cocktails, exotic fruits, wine, whatever. Free. Nice touch.

Augusta was packed with golf fanatics. Outside most bars and restaurants there were putting competitions or golf-club demonstrations. In the main street, it's not one of the most glamorous boulevards of the Western world, but at Masters time, it's jumping. The next day we had tickets to the nine-hole competition that precedes the main event. We eagerly awaited our first glimpse of the course. Crowds surge across the highway and police with bullhorns continue to remind the crowd: 'If y'all do not use the crossing, y'all will be runddover. Y'all will be runded over!' Safely across the road, you then have to negotiate some members of the Southern religious right with signs that tell you if you don't repent your sins, you will all burn in hell. Mate, I'm only going to watch the golf! Could you leave the burning until later? Then you join the crowd going through the first set of barriers. We had bought some water from a couple of little kids, and we were stopped by an official, politely telling us to remove the labels as there was no advertising inside apart from the official sponsors. Fair enough. Then through a second set of barriers, like getting on a plane, complete with metal-detector wands and finally, finally you are through. Hallowed ground. It was the year that Jason Day and Adam Scott almost won the Masters. Unfortunately three final birdies from Charles Schwartzel robbed them of that opportunity to win. That's golf.

2015

As I'm writing this, I'm half listening to ABC Jazz. A gentle pianist is playing a haunting piece. I look across the harbour. A swaying palm and the pink frangipani tree in the foreground, the dark emerald shadow of the water below the pale yellow beach at Clontarf opposite. No boats on the harbour. Still, calm, peaceful. Can't it go on forever? No, because my bloody foot is in pain with gout and I've got to see the doctor at 11am.

Late yesterday afternoon when I came home, I walked on the beach. The late afternoon light is different. The last rays of the sun are just reaching Dobroyd Point. Clontarf is in shadow and the sea is a soft, shiny, pale mauve. Seagulls are still feeding on a school of baitfish in the bay. It's late February. I wouldn't be swimming out too far. Even though the channel is closer to the other side, you never know with sharks. In the fifty or so years I've lived here, I've never seen one.

But I've been close. In 1955 when I was fourteen, a schoolboy acquaintance was bitten and died on the beach. I'd been in the same water a half hour before it happened. I'd been spearfishing. So had he. I saw him sitting on the rocks when I emerged from the water. He enquired what it was like. Not much there, I said. A bit murky, I'm going home. I walked along the beach to get the tram. We lived then in Cremorne, about twenty minutes away. While I was on the tram it must have happened. The fatal attack was quickly on the news.

One of my uncles worked at the *Herald* in those days. He instantly called my father. A fourteen-year-old boy has been attacked and killed at Balmoral, he exclaimed. Where's Ken?

My dad called my mum and she told him I'd gone spearfishing at Balmoral. I can't imagine the fear my parents must have felt until I casually walked in the back door. The victim's name was John Willis and we'd attended the same school. Where we'd been swimming was only a few metres off the rocks. Lots of weed, a bit of a swell from the waves coming in from the Heads. He'd speared a rock cod and attached it to his belt. There was blood in the water. I'm sure the shark went for the fish but bit him. He bled to death before help could arrive.

Several years later, a young actor called Marcia Hathaway was mauled when she swam in shallow water in the upper reaches of Middle Harbour. When the ambulance finally arrived, it couldn't get back up the steep rocky road to get to hospital. She died on the way.

A decade or two after that, when we'd returned to Australia, we swam regularly at Chinamans Beach. I knew about sharks. I never ventured too far out. Especially in late January or February, when the sharks would travel up the backwaters of the harbour to breed. Late February. Late afternoon. I'm slowly swimming along the beach. No more than a few metres out. Head down, lazily gliding along. Mind in neutral. Suddenly total fear and panic as something with teeth latches onto my leg. Screaming, I thrash to the shore and a fair way up the beach. I regain enough composure to look back at my leg and I see a very small dog, still attached. The dog's owner is apologising profusely. Like a few Aussie girls in those days, she's topless. This would normally have turned me into a mumbling, staring idiot. But not that afternoon. I just wanted the whole thing, the little dog, the pumping heart, and even her pretty boobs, to go away.

I swam with my first shark in Moorea in Tahiti. For an Australian brought up to fear these things, it's quite a character-building experience. I froze as the monster glided past and couldn't wait to get back to the shore. I know now that it was a harmless white-tipped reef shark, but as they say, you never forget your first.

Once in Fiji, diving with Judy and Camilla, we jumped in to snorkel near some big rocks. It was fairly correctly named: Shark Rock. And not unexpectedly, a big shark was there below us. A big, dangerous-looking one. The girls solved their fear by climbing on top of me, pushing me further under the water and becoming much more dangerous than old Mr Shark himself. Over the years we've swum often with sharks, especially Oscar when diving in such exotic places as Palau and Guam. They are beautiful creatures and deserve our respect. But I've never been in the water with a Great White and I don't want to be. We're not afraid of sharks in Middle Harbour but as I say we certainly wouldn't advise going out too far in the summer months. The only real danger in our area are real estate agents who constantly want to sell our house to some super-rich Chinese or cashed-up expat. Bugger off.

NEVERMORE

There are busy days and there are quiet days. And of course
there are all the days in between. The days when you were
down because of the things all people share. The sadness of
loss. When you understand for the first time the meaning of the
word nevermore. Nevermore will you see that person you love.
Nevermore. And times when you were sick with worry because
your child came home later than he should have. Or someone
was sick or you lost your way. Everybody shares that. But if
you wake up in Australia you have already been blessed with
great luck. There are great inequalities in Australia but for most
people it's the best place I know to bring up a family in peace
and optimism.

Years ago, when we were driving up the coast, we stopped
off at Maclean. We always went around to see where I used to
live. When we drove up from the river to see the old place I
was saddened to see it wasn't there. Someone said it had burned
down. I just stood looking at the block where it had been. Sad.
When we sold our first family house in Fairfax Road, Mosman,

where we'd lived for almost twenty-five years, we were sad to know it was to be demolished for those concrete townhouses. We didn't watch.

* * *

Since the Olympics in 2000 I've concentrated almost entirely on painting. We've had exhibitions here and overseas, and, as far as art is concerned, the critics have been kinder and the paintings are better. At seventy-four I *should* be better than the fourteen-year-old who started art school in 1954.

The business is increasingly run by Oscar and Camilla. It's got a few branches now and a few balls in the air. Judy and her girls have designed some beautiful silk tops and are now doing a small new swimwear range. The paintings are always at my gallery and on the internet. That part of our operation is growing. I still don't own a mobile phone and am being left behind by technology. I make a mark on something like a caveman.

The joy is to continue to paint and to keep working with our children. I want nothing more than to see their faces each time I go to the gallery.

I'm almost seventy-five years old. Looking at that sentence stuns me. How can that be? That's old. I still feel somewhere between twenty-eight and forty. But seventy-five? No. Well, not what I expected to feel when that number came around. Dad was only seventy-seven when he passed away, though Mum was ninety. When will I go? Will it be the grand piano that drops on my head from the sky, or will it be something lingering that leaves me wanting to end it all? Nobody knows. I just hope it's not for a while yet. There are so many more pictures to paint.

So many other countries to see and so many years to watch our children and grandchildren live their lives.

Or maybe I'll simply live forever.

When we get home in a couple of days I've got to finish the painting of Cleopatra for Bell Shakespeare. Late on Sunday night a couple of weeks ago I went down to the studio to start another version of the work. Who knows what it will end up like? That's the adventure, that's the pleasure. Or it could be the disappointment.

I think all the time of visual things. We have driven through wonderful country in the last few days – north-east Victoria. Through those huge stands of gum trees that can bring terror to communities when fire erupts. Then on to the rolling creamy yellow hills, with cows standing under trees to find a little shade. Rocky hillsides, clumps of grass. Trees dotting the skyline like a Fred Williams painting. Nolan. Williams. Olsen. Heysen. Artists who have put images of the country into our collective souls.

I'm writing this in the backyard of an old bank building in Beechworth. Soft dappled sunlight flickers down through the bright green leaves of ancient oak trees. My old mate Ric is glued to his iPad and the girls have gone shopping to check out the latest things in this little Victorian town. Honey, homemade pickles and wine – that's what I think we'll find here. Some little country towns prosper and some fade away. This place has understood the value of the old buildings and streetscape, unlike a lot of seaside towns.

Although I'm a great believer in personal freedom, sometimes I think a bit of design dictatorship is not such a bad thing. Take for instance the green and gold worn by all our sporting teams. Lots of times the yellow is too lemon and the green too bright. The

effect is akin to a pineapple salad. If I were the design dictator of Australia I'd say: 'This is the yellow. This is the green. Full stop.'

The rugby's got it just about right. What a missed opportunity the opening of the 2000 Olympic Games was. Our athletes could have walked in proudly carrying a new Australian flag with uniforms that reflected that image. With some exceptions, most of our Olympic uniforms have looked like bank managers on holidays. Too much compromise. Too many committees. Australia should always be bold, strong and confident.

* * *

We said goodbye to Bexley the dog today. He had cancer. We are all devastated. He had had treatment but there was no miracle cure, so we were with him when the vet put him gently to sleep. We knew we would be seeing him for the last time, as he simply lay there in Camilla's arms looking at us with his beautiful brown eyes.

Every time you lose a dog you vow never to go through it again. Bexley came from a rescue shelter about eleven years ago. He was frightened and scared. He didn't really want to come through the front door. It was clear he'd been through some difficult times as a puppy. He could not have come to a more loving home or a more loving person than Camilla. He had yellow-brown fur like a dingo and he had an underbite with one tooth that stuck out and made him look slightly menacing. But menacing he was not. He gave us all such joy over the years and was Camilla's constant companion.

Most days he'd come to work and spend his time on his special rug beside Camilla's desk. Eloise, Kirstin, Michelle, Janine, Bernie, Bianca and most especially Kyoko were his handmaidens.

When large groups of schoolchildren visited the gallery I would take him out and introduce him as the chairman of the company. Kids loved to pat him and he basked in their attention.

Groups of Japanese were at first hesitant with him but he soon won them over with his crooked smile. The only thing Bex despised was the pool cleaner. Not the man, but the machine itself that glides around and under the water, gathering leaves. Bex was sure it might attack us. Once, as a joke, Oscar took it out of the pool and squirted Camilla.

Bex never forgot. He would bark furiously to keep it at bay and us safe. After all this excitement he'd retire to my black leather Charles Eames chair to gaze across the bay with a glance now and then to the pool cleaner, in case his attack powers were needed again. Or maybe just drift off for a little snooze. He will be buried down in the garden near the olive trees, beside our other loyal friends, Spot and Indi. It's near the park where he would run whenever he stayed here to follow the scent of a fox or two who live down in the bush. Then he would chase a ball at full speed and do a big flying leap across the sand hills on his way for a refreshing early morning dip. That's what he'll dream about and our love will keep him warm for all time.

Afterword

It hasn't all been a bit of talent, hard work, luck and a bit of fun. There have been tears, stupidity, bloody-mindedness, lies, deceit, immaturity, jealousy, pain and soul-seeping sadness. And that's just me.

But most of the time, it's been the pleasure of work, lots of luck and lots of fun and love.

The past feels all mixed together. The hills and valleys, the tears and joy, all scrambled up. I hope I die before anyone else in the family. It's my turn, chronologically. I'm the oldest. But hopefully there's lots more to come first. More love. More joy. More painting. I'd like to be remembered as an Australian artist who has produced some works that stand the test of time. And I know I'll be remembered as a devoted husband, father and grandfather. I love them all unconditionally and I've always felt that love returned in full.

Judy and I have been together for more than fifty years. That's a long time. We share the adventure of a very long relationship. You start off believing it will all be like a fairytale and for lots of

the time it is. You grow together sometimes and sometimes you grow apart. Sometimes it's Judy Done and Ken Done, separate people, and sometimes it's KenandJudy, one intertwined identity. We've celebrated the birth of our two brilliant children and now our adored grandchildren. We are extremely close as a family and our greatest pleasure is to share in their lives as they grow. More than fifty years? That's long-time love. That's a love that survives the pitfalls of life and embraces the joy of all the great times. That's real love.

ACKNOWLEDGEMENTS

With thanks to Kirstin, my PA, who's had the task of deciphering my handwriting and my childhood spelling in the first drafts of this memoir, and offering a word or two when I got into a tangle.

And to Katie Stackhouse, who came to me first and, with Brigitta Doyle, offered me the opportunity to write this book.

And to all the clever and professional team at ABC Books and HarperCollins, especially the discerning editors, Lachlan McLaine, Foong Ling Kong and Kate O'Donnell, who helped shape the narrative, and whose advice on my occasional lapse into bad taste or politically incorrect statements that needed to be addressed.

And to Oscar, whose entrepreneurial skills and creativity continue to drive the business and create so many new opportunities for us, allowing me the time to devote entirely to painting.

And thanks to Camilla for her help and guidance and understanding. Sitting together while we worked on this book, we shared lots of laughs and even a tear or two. The whole process has been a great joy. I hope you like it.

INDEX